THE CRIME OF CHRISTENDOM

THE CRIME
OF CHRISTENDOM

*The Theological Sources
of Christian Anti-Semitism*

By FRED GLADSTONE BRATTON

FITHIAN PRESS : SANTA BARBARA : 1994

This reprint edition is in memory of
6,000,000 Jewish men, women and children
who perished as a result of a long legacy of
European Christian anti-Semitism

Published by Fithian Press
A division of Daniel and Daniel, Publishers, Inc.
Post Office Box 1525
Santa Barbara, CA 93102

Originally published in hardcover by Beacon Press, Boston.
Reprinted here by permission of Beacon Press.

LIBRARY OF CONGRESS CATALOGING-IN-PUBLICATION DATA
Bratton, Fred Gladstone, 1896–
 The crime of Christendom / Fred Gladstone Bratton.
 p. cm.
 Previously published: Boston : Beacon Press, 1969
 Includes bibliographical references and index.
 ISBN 1-56474-122-2
 1. Christianity and antisemitism. 2. Judaism (Christian
theology)—History of doctrines. I. Title
BM535.B67 1994
261.2'6—dc20 94-33139
 CIP

To Else

IN DEVOTION AND GRATITUDE

CONTENTS

PREFACE

ANOTHER BOOK on anti-Semitism at this time calls for some justification. This volume was felt to be necessary because of the almost total failure of modern writers on the subject to recognize the critical significance of religious beliefs as a prominent source for secular anti-Semitism. The original impetus for the anti-Jewish bias was the New Testament and the teaching of the Church Fathers; its continuance to the present day stems from the unchanged Christological doctrine found in the official creeds, literature, religious education, and preaching of contemporary orthodox Christianity. Although leaders have repudiated anti-Semitic attitudes and acts and have in recent years united in expressions of mutual respect and goodwill, there has been no inclination to modify or surrender the Christological dogmas that alienated the Jews in the first place—beliefs that precipitated overt persecution by the early church.

One result of the current ecumenical emphasis has been the partial attempt by Catholic and Protestant churches to expunge from their religious education all invidious references to Jews and Judaism. The teaching that Christianity is the only true faith, that the Jews remain guilty of the crucifixion of Jesus and are destined to eternal punishment for

their rejection of Jesus as divine Saviour, that Judaism and the Old Testament were merely a preparation for Christ and Christianity, that the purpose of interfaith goodwill is the conversion of Jews and therefore ultimately the destruction of Judaism, and that the Jews are avaricious, exclusive, and overbearing has been brought into question and in many instances rejected.

This is laudable as far as it goes but it fails to get at the root of the problem. More serious than explicit anti-Jewish ideas is the traditional theology of Christianity, which is the ultimate source of Jew-hating. This body of Christological doctrine has remained intact except among the liberal churches. Active anti-Semitism is the result of a sequence from formal beliefs to conscious attitudes which in turn lead to hostile action. Christians today who hold beliefs that imply anti-Semitism are not conscious of hostility, but those doctrines, if encouraged, provide the incentive for hatred of Jews. Despite Vatican II, Protestant reform, and interfaith "dialogues," implicit anti-Semitism has continued unchanged. The mythical dogmas surrounding the personality and death of Jesus are still the barrier to any genuine rapprochement; namely, the virgin birth and resurrection of Jesus, the divinity of Jesus as a supernatural creature, the necessitarian death of Jesus as an atonement for the sins of all humanity, polytheistic trinitarianism, the Messiahship of Jesus, and God's intervention in history with the revelation of Jesus. The retention of these New Testament and patristic articles of faith by contemporary Christianity may be only a passive or unconscious form of anti-Semitism, but in the present age such a body of belief can only be regarded as arrogant and bigoted.

Anti-Semitism has traditionally been attributed to ethnic, economic, political, psychological, or sociological causes; but Anti-Semitism is a many-sided phenomenon, a manifestation of collective psychology arising from a variety of mo-

tives and expressing itself in a variety of ways, ranging from those whose hostility takes the form of violent action to those who merely accept traditional stereotypes without giving the matter any thought or to those who hold unwittingly to the Christian beliefs that automatically label Jews as unbelievers. Only recently has endemic Christian doctrine been recognized as the ultimate source of anti-Jewish thought and action. As Thomas Sugrue says, "nothing can be done about anti-Semitism until something is done about Christianity." Genuine rapport cannot come about until the effect of two millennia of mythological brainwashing is discarded.

Among recent attempts to correct this situation by demonstrating the definite connection between religious dogmatism and secular anti-Semitism are four excellent volumes to which I am greatly indebted. Edward H. Flannery's *Anguish of the Jews* is a scholarly and incisive history of anti-Semitism by a Catholic priest whose knowledge of primary sources makes the work an authoritative one. *Judaism and the Christian Predicament* by Ben Zion Bokser, a distinguished rabbi, is a frank discussion of the nonnegotiable differences between Judaism and Christianity. Bernard E. Olson's *Faith and Prejudice* is a study of Protestant religious education and its implications for anti-Semitism. *Christian Beliefs and Anti-Semitism* by Charles V. Glock and Rodney Stark is an analysis of the role religion plays in the collective image of Judaism. The last two volumes lend statistical support to my own thesis as developed in the last two chapters of this book. The first ten chapters trace the history of the religious basis of anti-Semitism from the pages of the New Testament and the teachings of the Church Fathers to the resultant persecution of Jews through the Middle Ages and up to the Emancipation.

In pursuing a theme like this, there is a real danger that the author will turn into a proof-texter, and, in his zeal to press home the point, quote certain writers out of context.

This danger is perhaps present in Chapter Ten ("Anti-Semitism in Literature"), but I hope if I have sinned in this respect, it has not been at the expense of the total spirit of the author quoted.

Like all other authors concerned with Jewish-Christian relations, I must acknowledge my indebtedness to the writings of Jacob B. Agus, Salo W. Baron, Nahum N. Glatzer, Robert Gordis, Malcolm Hay, James Parkes, Cecil Roth, and Abram L. Sachar.

Fred Gladstone Bratton

THE CRIME OF CHRISTENDOM

PROLOGUE

As a result of the growth of modern capitalism, mercantilism, and rationalism, European Jewry experienced what is known as the Emancipation. This revolutionary development, in the second half of the nineteenth century, gave the Jews an improved economic status, civil rights, and increased vocational opportunities. They became an integral part of the European citizenry and in the liberal era that followed they figured prominently. By the 1870's with the nationalization of European states, the Jewish Emancipation was complete, or so it seemed. Jews were no longer strangers in the land, locked behind ghetto walls. They were accepted citizens of the emergent nations, a status they had well earned, for they had fought along with Christian soldiers and had given political and financial leadership to the cause of liberalism. They were prepared to share a common destiny with their Christian neighbors as co-members of a free society. In the field of religion, the liberal movement of the nineteenth century produced both in Judaism and Christianity the historical approach, the weakening of traditionalism, historical criticism, and the evolutionary or scientific outlook. Reform Judaism was the result—an attempt to reconcile the Jewish religion with the modern spirit.

But even as the fruits of Emancipation were ripening and the new freedom was being realized, the dormant anti-Jewish resentment began to reassert itself in its most virulent form. The medieval conception of the Jew as Christ-killer, well poisoner, performer of ritual murder, and incarnation of the devil found a louder and louder voice in the countryside and in the cloister. Such suspicions of the ignorant might have died a natural death were they not nourished by the manipulation of the events of the time. A plausible extenuation had to be found. The instrument for arousing the common people was European Jewry, which, from 1879 to the First World War, served as a political scapegoat. The history of that period is one of conflict between rival groups and the struggle of elected leaders to gain control of the government. In the effort to take over and maintain their power, the leaders exploited an easily deceived electorate, particularly the lower classes. It was in this warfare that anti-Semitism was found to be an effective political weapon. In the liberal atmosphere of the late nineteenth century, feeling against the Jews had subsided somewhat except among the superstitious peasants, the Catholic clergy, and the aristocratic class, who saw in the development of democratic liberalism a threat to their position. These three classes shared the fear of a secular and progressive society in which Jews had become an influential force. Thus anti-Semitism provided a convenient implement in solidifying diverse classes of society against the progressive movement. All liberal tendencies were labeled "Jewish."

An important impetus to organized anti-Semitism was conservative, chauvinistic nationalism. The Jews were identified as the leaders of nationalistic philosophy, liberal thought, capitalism, intellectualism, and internationalism, all of which were feared by the uneducated and the lower middle classes. The Jews in Germany were resented because of their financial and intellectual genius and were opposed by the state-

Lutheran church. In France, anti-Semitism was slower in coming to a head, but in 1894 a made-to-order scandal erupted which gave the rightists an ideal weapon. The machinations of the royalist press, the Jesuit-trained military clique, and the Vatican Secretariat of State combined to concoct the diabolical Dreyfus Affair. Captain Dreyfus, a Jew, was falsely accused and convicted of treason without a shred of evidence and was promptly dispatched to Devil's Island. Later, the real culprit was identified, but in 1899, after being returned to Paris for a retrial, Dreyfus was again found guilty and given an additional ten years' sentence. Liberals like Georges Clemenceau, Aristide Briand, Anatole France, and Emile Zola devoted their efforts to the exoneration of Dreyfus and denounced the anti-Semitic assault for what it was. Seven years later Dreyfus was legally pardoned. Catholic leadership and royalists, counting on gaining complete control through the military, were frustrated, for the time at least, as the liberal forces took over. It was generally thought that the Dreyfus affair marked the end of European anti-Semitism and that a new day was dawning, but this was a will-o'-the-wisp illusion soon to be shattered by the emergence of German racism which ultimately spawned the Nazi holocaust.

German conservative nationalists, finding philosophical confirmation in the writings of Nietzsche and Treitschke, used the growing anti-Semitic feeling to reinforce their doctrine of Aryan superiority and to continue the building of Bismarck's *Machtstaat*. After the defeat of Germany in the First World War, anti-Semitism was revived in a more vicious form than ever as the conservatives used it to explain away the bad economic situation and the racists groups used it to destroy the government. In 1924 Adolf Hitler left the Landsberg Prison with his *Mein Kampf* in his hand and in the fifteen years that followed he was able to form the Nazi party and convince his followers that the political and economic

ruination of Germany was the work of the Jews. In the early thirties the unsuspecting rightists in political and military circles, thinking that they could use Hitler as a tool against the Russian Communists, allowed him to become Chancellor. He had the Reichstag burned, put the blame on the Communists, and, with the death of Hindenburg in 1934, assumed complete command as Führer. The nature and extent of Nazi anti-Semitism is now common knowledge and it is unnecessary to repeat the story of the nihilistic savage extermination of the six million European Jews. Never in history had there been such an unrestrained and barbaric murder of a people.

Russian Jewry began to feel the effects of reactionary nationalism in the middle of the nineteenth century. Systematic restrictions against the Jews started with the May Laws of 1882 through which all rural Jewish communities were obliterated, all Jews were expelled from Moscow and even from the Pale of Settlement, and Jews were terrorized and murdered throughout Russia. At the same time, anti-Semitism with its pogroms became the official governmental policy of Romania. By the end of the nineteenth century most of the Jews were, as in Russia, completely dependent upon charity and their survival seemed doubtful.

The irony of the situation was that modern European anti-Semitism appeared in the precise period when Jews were proving to be worthy citizens of their respective countries, contributing in every field to the well-being of the land, finding their niche in the mainstream of national life, and exerting a cultural influence out of all proportion to their numerical strength. They regarded themselves as Germans, Russians, and Frenchmen and began to see the dawn of a new age; but it was to be a false dawn.

The excuses for the modern upheaval of anti-Semitism in Europe were either political, ideological, racial, or economic. The Jews were the scapegoats for the reactionaries in their attempt to overthrow a liberal government; the lower

classes resented the Jews because of their wealth; conservatives opposed the Jews as enemies of the status quo; extreme nationalists saw in Jewry a foreign race engaged in an international conspiracy; leftists used the Jews as a catalyst in provoking unrest and economic insecurity.

Regardless of the immediate reasons for and use made of anti-Semitism since 1880, the ultimate cause of anti-Jewish feeling, as indicated in the Preface, is primarily a religious one and its roots go back to the first century and early Christianity. Anti-Semitism had appeared in the third century B.C.E. in Ptolemic Alexandria where the Greeks took umbrage at the Jews' claim to be the Chosen People, resenting their loyalty to their God and their elevation of the Law above Greek philosophy. Antiochus Epiphanes, the Syrian general, invaded Jerusalem in the second century B.C.E. and desecrated the Temple. The Romans accused the Jews of holding the pagan gods in contempt and objected to the Jewish observance of the Sabbath. But the pre-Christian persecution of the Jews was comparatively rare; at least, was spasmodic. Under the Ptolemies the Jews had served as army officers, customs inspectors, and revenue officials. In spite of the severity of Roman rule in general, the Jews were the only people in the Empire that were allowed religious autonomy. Be this as it may, it was the Hellenized Christology and the extravagant theological claims of Gentile Christianity that first alienated and then caused the lasting Christian hatred of Judaism. The ancient roots of prejudice were ideological.

The ultimate reason for Jewish-Christian tension was and is Calvary and the mythical dogma built up around it. The Cross, the symbol of salvation for Christians, could only become for the Jews the symbol of hatred as they were made the villains in the drama of salvation. For nineteen hundred years Christian theology—Orthodox, Roman Catholic, and Protestant—has inconsistently held to the necessitarian predetermined death of Jesus as an atonement to God for the

sins of the world and at the same time has placed the responsibility of the crucifixion on the Jews, who supposedly brought it about. The deification of Jesus, a Palestinian Jew, the disconnecting of the crucifixion from its historical context, the early Christian alienation of Jesus from his own people, and the vilification of the Jews as guilty of deicide in a legal execution performed by the Roman government—these were the subtle causes of misunderstanding. The arrogant condescension of Christian theology remains a fact today, in spite of the patronizing and inadequate modifications made in the Catholic position by Vatican II and the friendly overtures of interfaith movements. Good Friday and Oberammergau still exist, as do parochial religious education, the morbid otherworldly hymnology, and the antiquated creeds with their anti-Semitic implications.

There is only one way to actualize the current attempts at rapprochement and that is to make a drastic revision of the ancient doctrine that estranged the Jews in the first place. With a few prominent exceptions, priests and ministers, professors and theologians continue to teach religion from a naive biblical and dogmatic point of view. Until these leaders subordinate theology to history and separate legend from fact, little improvement can be expected in the underlying Jewish-Christian tensions. The intellectual revolution of Copernicus, Galileo, and Darwin did not result in any significant change in the world-view of Christian orthodoxy; but the implications of the developments of the Space Age have left Christianity with an anachronistic thought-system. A theism that conceives God as interrupting history at a particular point in time to send his son to the earth to die for the sins of the world, that attributes cosmic and supernatural significance to Christ, a historical personage, and that assigns uniqueness to the Christian revelation is both presumptuous and intellectually indefensible.

It is a good thing to remind the world of what happened

to world Jewry after 1880, but it is also necessary to go back to the original causes of anti-Jewish feeling—a form of anti-Semitism which today is subconscious but real nevertheless —and it is proper that the attempt be made by a Gentile.

JESUS, THE FORGOTTEN JEW

The Jewishness of Jesus

UNDER THE SHADOW of the Parthenon, Paul, the self-appointed apostle, was addressing a group of Athenians. Some of the Epicureans and Stoics who had heard him talking on the street corners asked him to explain his "new teaching." He took as his cue the inscription he had found on an Athenian altar: "To an Unknown God." With this clever introduction he proceeded to deliver a profound portrayal of God as a cosmic being, author of the universe, an immanent spiritual presence in the life of man. His tactful quotation from a Greek poet added to the effectiveness of the discourse. The Greeks must have been considerably impressed by the universalistic tone of the speech. Suddenly, after repudiating all anthropomorphic conceptions of Deity and pagan idolatry, he launched into what he thought would be the climax by proclaiming Jesus as God's son who had recently been resurrected from the dead. At this localization of his theme the Greeks lost all interest and dismissed him from the Areopagus. God as an all-permeating spirit was an acceptable idea, but the belief that God had a human being as a son and that he had decreed that he die and then be raised from the dead was not for them.

This scene brings into focus the difference between a spiritual universal religious philosophy and a dogmatic, sectarian cult. It provides not only the key to the opposition of the Greeks and first-century Jews to the beliefs of nascent Christianity, but at the same time accounts for early Christian anti-Semitism, which was in turn a reaction to the natural unwillingness of the Jews to accept the rapidly forming Christological thought-pattern of Gentile Christianity. Hence the rejection of Judaism as heresy and the Jews as infidels by the early Christians. Paul's address on Mars Hill also signals the beginning of a change that affected the entire history of Christianity. It was the starting-point of that process by which the Jewish sect of the Nazarenes developed into Gentile Christianity; by which the simple ethics of Jesus was lost in the complicated doctrines of the Roman Church; and by which the moral-spiritual movement, heir to the Prophets of Israel, became the ecclesiastical organization, inheritor of the Roman Empire. It represented a shift from monotheism to tritheism, from history to legend, from ethics to theology, from synagogue to church, and from universality to particularism. Only by a knowledge of this critical transition in the first three centuries of the Christian Era can one get at the roots of prejudice which developed into anti-Semitism.

To understand how the thoroughly Jewish religion of the original Nazarene sect became the anti-Jewish religion of the Christian Church it is necessary to retrace the events of the early centuries, starting with Jesus. As far as we can discern from the earliest records, Jesus was a faithful Jew and taught strict adherence to the Torah. His gospel was typically prophetic; a simple, pragmatic, ethical teaching devoid of all dogma and parochialism. Much of his teaching was Haggadic in character and consisted of parables, legends, and poetic sayings of the great teachers of Israel. He used typically Jewish expressions such as hearing a "heavenly voice" (Hebrew *Bath-Kol*); and designating the deity as "Father"

(Aramaic *Abba*). His expression "Son of God" was a Hebrew idiom referring to the spiritual sonship of every person. The later use of the phrase by Hellenized theologians to indicate Jesus' divinity as God's only Son has no source in Jesus the Semite. Jesus' participation in the culture of his day included his acceptance of the superstitions and prescientific conceptions of the age. He obviously believed in such things as demon-possession, evil spirits, exorcism, the near end of the world, and God's miraculous intervention in the world. Practically all of his sayings, including the Lord's Prayer (Matt. 6:7–13), can be found in Jewish writings before his time—the Old Testament, the Apocrypha, Rabbinical teaching, or the Essene literature.[1] This being the case, the question might well be asked: Wherein then consists his originality? The genius of Jesus lay in his capacity for selection and emphasis. From a heterogeneous mass of moral, ceremonial, and ritualistic material, he selected a few ethical principles and revitalized them for his hearers and sharpened their meaning. He reread the Law, substituting positive principles for negative commandments, redefining religion along prophetic lines. He taught the potentiality and high worth of every individual, the paramount importance of personal moral integ-

[1] Examples of pre-Christian parallels to Jesus' beatitudes: Matt. 5:3—Ps. 34:18; Matt. 5:4—Ps. 136:5; Matt. 5:5—Ps. 25:9–13; Matt. 5:6—Ps. 21:21; Matt. 5:7—Prov. 14:21; Matt. 5:8—Ps. 24:3, 4; Matt. 5:9—Ps. 24:14; Matt. 5:10—Slavonic Enoch 66:6; Matt. 5:11—Slavonic Enoch 51:3. Examples of Rabbinic parallels to the sayings of Jesus: Matt. 5:13—Bechoroth 8b; Matt. 5:24—Yoma 85b; Matt. 5:36—Leviticus Rabbah 19:2; Matt. 5:37—Baba Mezia 49a; Matt. 5:45—Taanith 7a; Matt. 6:3, 4—Baba Bathra 9b; Matt. 6:9—Yoma 85b; Matt. 6:10—Berachoth 29b; Matt. 6:14, 15—Rosh ha-Shanah 17a; Matt. 6:26—Mishnah Kiddushin 4:14; Matt. 6:31—Sota 48b; Matt. 6:34—Sanhedrin 100b; Matt. 7:1—Sabbath 127a; Matt. 7:2—Mishnah Sota 1:7; Matt. 7:5—Baba Bathra 15b; Matt. 7:12—Sabbath 31a; Matt. 7:24—Aboth de R. Nathan 24:39a; Matt. 10:8—Nedarim 37a; Matt. 10:16—Canticles Rabbah 2:30; Matt. 12:34—Genesis Rabbah 84:8; Matt. 12:36—Yoma 77a; Matt. 23:12—Erubin 13b; Mark 10:25—Baba Mezia 38b; Mark 2:27—Yoma 85; Luke 4:23—Genesis Rabbah 23:5; Luke 14:7–11—Leviticus Rabbah 1:5; Luke 24:5—Leviticus Rabbah 6:6.

rity, the conviction that there is purpose in life, the idea of altruistic service as the true test of greatness, and the attitude of goodwill in all human relationships. These abstract principles compiled by Matthew in the Sermon on the Mount were illustrated in his parables, most of which are found in the Gospel of Luke.

In addition to his teaching—and probably more important for the movement which arose after his death—was his remarkable character. His personality was such that people from all walks of life were irresistibly drawn to him. Whatever he thought his mission to be, he was loyal to it. The key to his significance, in fact, was the moral and vocational struggle which he faced throughout his career from Nazareth to Jerusalem.

The historicity of Jesus has often been questioned. As early as the second century of the Christian Era there were sects (such as the Gnostics) which denied his physical existence. Mythical theories about Jesus have appeared from time to time but the Christ-myth school was given its definitive form by Arthur Drews at the beginning of the twentieth century.[2] Drews maintained that Jesus never actually lived but was an imaginary Jewish Messianic figure, an incarnated God-man, elevated by Paul and later theologians to the plane of divinity as Redeemer-Saviour. Around this idealistic figure a Graeco-Roman cult was built.

The Christ-myth problem stirred up scholarly debate in Germany and the liberal school of Harnack, Jülicher, von Soden, Weinel, Johannes Weiss, and Clemen wrote voluminously in attempting to refute the theory. They pointed out that the historical life of Jesus is supported by the Pauline letters, the Synoptic Gospels, and the Apostolic Fathers. Reference to Jesus on the part of Roman historians was hardly to be expected in view of the obscurity and remoteness of Judea, but extra-biblical evidence for the historicity of

[2] Arthur Drews: *Die Christusmythe* (Jena, 1909).

Jesus was found in the writings of Tacitus, Suetonius, Pliny the Younger, and Lucian. Josephus and the Talmud also mentioned Jesus as a historic personage. Aside from literary proof of the existence of Jesus there is, it might be added, the personal equation in history, which cannot be ignored. If Jesus did not live, someone else is responsible for his teachings and for providing the impetus for the Nazarene movement which developed into Gentile Christianity. The myth theory incidentally has also been used in connection with Moses, Zoroaster, and other prophets.[3]

The Alienation of the Jews

At this point the question asserts itself: Why is it that for nineteen hundred years Jewish history has maintained a surprising silence concerning one of the most influential sons of Israel that ever lived? As we have indicated, Jesus was a loyal Jew; he lived on Palestinian soil and never set foot on foreign territory; his following was made up entirely of Jewish people; he was brought up in a Jewish household; and repeatedly quoted the Jewish Bible. Jesus was not an internationalist but a partisan, a Jew preaching only to Jews. Although his teaching in places has universal implications, he gave no thought to appealing to the pagan world but commanded his disciples to go only to Jews.[4] Regardless of the original misunderstanding or rejection of the prophet, posterity usually honors its heroes. Heretics in time usually become saints. Particularly surprising is the paucity of information about Jesus in contemporary Hebrew writings. In answer to this it might be said that the Talmud was concerned only with the Law and its interpretation. It nowhere

[3] The outstanding coverage of this problem is that of S. J. Case: *The Historicity of Jesus* (Chicago: University of Chicago Press, 1912). See also Maurice Goguel: *Jesus the Nazarene: Myth or History?*, trans. F. Stephens (London: T. Fisher Unwin, 1926).

[4] Matt. 10:5, 6; Mark 7:27.

mentions, for instance, the great Hebrew patriot, Judah Maccabee. Nor is mention of Jesus by the Rabbis of the Herodian era to be expected. Jesus could not have been well-known in his own lifetime and Jewish leaders were too preoccupied by the problems they faced under Roman rule to notice such an obscure teacher. The prominence of Jesus in his own day has been completely distorted because of the great significance he had for a later age. The crucifixion—around which the whole Christian theology was later built—was an inconspicuous and unimportant incident in the Roman and Jewish world of the first century.

The real reason for the silence of historic Judaism concerning Jesus is the theme of this book. The Jewish disregard for Jesus had a twofold source. The first was the impossible claims made for Jesus as the new God of the Gentile Christians who spurned the universal God of Judaism. Jesus was the good God; Yahweh was the evil God (a juxtaposition which shows Zoroastrian influence). Marcion, a second-century Gnostic Christian, rejected completely the Old Testament. It was only natural therefore that Jews resented the idea that Jesus, a fellow-countryman, a fellow-Jew, should be considered to be God and a rival of their own God. The alienation of Judaism was the logical result and the exaltation of Jesus as Deity destroyed what interest Jews might have had in his teachings. Thus the name of Jesus was eliminated from the history of his own people.

The other reason for the silence of the Jews about Jesus was the Christian persecution of Jews as infidels. Instead of putting into practice the love, humility, and goodwill taught by their leader, the Christians, coming into power as the church of the Empire, spread a reign of terror throughout the Roman world. For centuries, in the name of Christ, they hunted down the hated Jews and subjected them to cruel torture, shameful ignominies, and death.

The Jesus of History

The rediscovery of Jesus, the Jew—the difficult attempt to extricate him from the accumulation of myth, legend, and dogma—began in the eighteenth century. If the Jews had failed to recognize Jesus as one of their prophets it was because the organized church—both Catholic and Protestant—was concerned only with protecting its official portrait of Christ, the God, and prohibited any scholarly investigaton of Jesus, the man. Its picture of Jesus in the Apostles' Creed, which jumps from the birth of Jesus to his death, completely ignored his life and teaching. The medieval church, with the Creed as its only evidence, had no interest in the historical Jesus. But in the Enlightenment of the eighteenth century the authority of the church was challenged and the Deists of England, France, and Germany demanded an examination of religion in the light of reason and history. The first biblical scholar to place Jesus in his historical setting as a first-century Palestinian Jew was Hermann Samuel Reimarus (1694–1768). He insisted on studying Jesus as one would study any other historical character, as a product of his age, sharing the thought-forms and ideas of that age. Reimarus' book, *The Aim of Jesus and His Disciples,* did not appear until ten years after his death, when the manuscript fell into the hands of Gotthold Lessing, who had it published. The work became known only in scholarly circles, but it was the beginning of a century and a half of historical studies of Jesus and his environment.

As late as 1905, when Julius Wellhausen, the distinguished German scholar, declared that Jesus was not a Christian, but a Jew, the news came to most people as a startling surprise. For almost 1900 years Jesus was considered by the vast majority of Christians in the Western world not as a man, much less a Jew, but as the second person of the Trin-

ity or as God himself. The same holds true today. Some early
Christian schools of thought regarded him as a purely spir-
itual being with no physical life at all. The historical Jesus
had practically disappeared until the Nicene period when
the leaders of the church found it necessary to stress both
the human and the divine. However, the orthodox doctrine
that God had sent his Son into the world to save it and that
his earthly appearance and death were foreordained divorced
Jesus from his environment and the human struggle.

Messiah or Prophet?

The studies that followed in the wake of Wellhausen's
dramatic disclosure made all informed people conscious of
Jesus' Jewishness. Only by taking into consideration Jesus'
participation in the life and thought of first-century Judaism
can one hope to understand him. The dominant Jewish
thought-form in Jesus' career was that of the Kingdom of
God. The term is an ambiguous one at best but generally it
referred to the Messianic expectations of the Jews. Although
Jesus injected a moral and spiritual connotation into the con-
cept, he did share the apocalyptic view that looked to the
universal rule of God on earth with Jerusalem as the capital,
a rule that would be established by the long-promised Mes-
siah. The political and transcendental aspects of the idea of
the Kingdom were intermingled in the belief that if the new
order did not materialize on earth it would be established in
some future heavenly regime. Scholars are divided on the
question of Jesus' major emphasis, some holding that the
eschatological element was purely secondary and that Jesus
used the term "Kingdom of God" to refer to the achievement
of the will of God in individual life and in society at large.
It was, in other words, a moral condition. Others believe that
Jesus was an apocalyptist and regarded himself as a Messi-
anic figure sent by God to announce the near end of the
world and the establishment of a New Age. In Jesus' time the

old Hebrew longing for deliverance from foreign oppression had become an obsession. For centuries the Jews had looked for liberation by a Messiah who would usher in the perfect reign of God. Now it was deliverance from Rome that kept alive the Messianic hope. Jesus, we are told, "went about Palestine preaching the gospel of the Kingdom of God and saying that the time is fulfilled and that the Kingdom is at hand" (Mark 1:14).

Just who and what Jesus thought he was will perhaps never be known, but what evidence we have in the New Testament indicates that he both shared and preached the apocalyptic hope and also placed himself directly in the line of the Hebrew prophetic tradition of Amos, Hosea, and Isaiah. That there was a sharp cleavage between Jesus and his own people and that his mission was to institute a new religion does not accord with the original situation. It must be remembered that the gospels were finally rewritten by Gentile Christians who were opposed to Judaism and who colored the portrait of Jesus to attract Gentiles to Christianity. The Gospel writers were theological interpreters rather than biographers or historians. The presentation of Jesus was a portrait rather than a photograph—a distinction which is to be seen on an increasing scale from Mark to the Fourth Gospel. The anti-Semitic tendency also progresses on the same scale. In the Fourth Gospel the Jews are clearly represented as the chief adversaries of Jesus. The polemic aims of this gospel are written large in every chapter. After the lapse of a hundred years, the particular leaders who opposed Jesus were forgotten and gave way to the generalization "the Jews." [5] Even more significant is the fact that the opposition to Jesus takes on a different character from that which is portrayed in the Synoptics. The controversy no longer concerns Jesus' attitude toward the Law or even his

[5] The date for the composition of the Fourth Gospel has always been debated, but a consensus of modern scholarship would place it at 125 C.E

Messianic claims. The objections of the Jews to Jesus now pointed to a later period when the Christian religion was Hellenized and the theology of deification was already formed. The Jews in the Fourth Gospel were critical of Christianity because it impugned the monotheistic principle by equating Jesus with God and insisted that salvation for all men came only through Christ. The climax of the controversy between Jesus and the Jews now centered in the discussion of the nature of the Eucharist (John 6:32–59), a subject obviously impossible in Jesus' day before the memorial meal had been converted into a magical sacrament. The defense of Jesus made by the author of the Fourth Gospel is based on the Jewish objections of a period much later than the time of Jesus. The author's condemnation of the Jews, therefore, assumes a polemic tone as he tries to reconcile Jesus' humanity with his divinity, his wisdom with his unlettered background, and his predestined death with his voluntary sacrifice. He asserts that the church is the true Israel, that the Jews, by their rejection of Christ, have produced the real schism, and that they are therefore rejected by God.

All four evangelists made it appear that Jesus' task was to repudiate the entire body of tradition and legal precedent. On the contrary, although Jesus was undoubtedly critical of legal casuistry, he also said he came "not to destroy but to fulfill" the Law. If Jesus, as Ernest R. Trattner says, started out with the iconoclastic statements attributed to him by the Gospel writers, "he could not have won even twelve disciples —much less would the multitudes have flocked to hear him." [6] It is true his teaching drew opposition from the priests and Pharisees because of his neglect of petty rules in the Tradition of the Elders. To disparage some of these refinements of the Halakah was tantamount to blasphemy in

[6] Ernest R. Trattner: *As a Jew Sees Jesus* (New York: Scribner's, 1931), p. 49.

the eyes of orthodox teachers. On the other hand, it must be stated that the antagonism of conservatives would not have arisen if Jesus had not criticized their disproportionate emphasis on ceremonial laws. For that he had plenty of precedent. He simply reiterated the prophets' distinction between ritualistic defilement and moral defilement, between tithing mint, anise, and cumin and observing the weightier matters of the law. Jesus the Prophet was loyal to the religion of his fathers. His aim was not to abrogate the Law but to bring out the spiritual and moral implications of it.

Jesus and the Pharisees

One of the distortions of the gospel portrait of Jesus is his relation to the Pharisees. The evangelists portray the Pharisees as the opponents of Jesus, self-righteous hypocrites, who had turned Judaism into such a sterile formalism that it produced, by way of a critical reaction, the prophetic teaching of Jesus. This representation in the New Testament was so overdrawn that Christians for 1900 years have looked upon the Pharisees with utter contempt. An apt illustration of the popular misconception of Pharisaism is reflected in John Singer Sargent's mural in the Boston Public Library. The painting is called *The Synagogue* and portrays a blindfolded woman with a broken scepter in her hand and an unsteady crown on her head, clinging to the dead past. The companion painting, called *The Church,* shows a young woman, erect, forward-looking, and inspired by the nearby figure of Christ.

The Pharisees, along with the Sadducees and the Essenes were descendants of the Hasidim, the staunch supporters of the Maccabean revolt against the Syrians in the second century B.C.E. The Pharisees, following the unwritten laws and post-biblical traditions as well as the Torah, believed in the resurrection; while the Sadducees, holding only to the Torah, rejected the doctrine. Pharisaism arose to save

Judaism from paganism, to reestablish Jewish piety in the face of Hellenistic secularism. After the Maccabean revolt (165 B.C.E.) the Jewish community became more political than spiritual. It was at this time that the Pharisaic party, in a protest bordering on fanaticism, emerged to replace nationalism with religious zeal and patriotism with devotion to the Law. This group which began as a dissent lived to become not only a bulwark against Hellenistic and Roman influences but also, as Israel Abrahams writes, "became a vital force, going on without a moment's break from the centuries before the Christian era to the twentieth century of that era. It has been put to the test of time and life. It has survived throughout an experience such as no other religious system has undergone." [7]

The pendulum swing of antithetic movements in history is always to the extreme right or left. Originating as a correction of worldly and pagan influences in Judaism, Pharisaism came to identify religion with particularism and became more interested in piety than in personality. It is unfortunate that modern interpreters see only the pious ceremonialism of ancient Pharisaism and not its enduring ethical and spiritual contribution to Israel.

The Pharisees were drawn from the laity rather than from the priestly class and were therefore connected with the Synagogue rather than the Temple.[8] From their ranks came the Scribes who copied and interpreted the Law and who later became the Rabbis. The Pharisees were recognized exemplars of Jewish faith and practice. They were really the founders of normative Judaism which contained the religious teachings and ethical principles inherited by

[7] Israel Abrahams: *Studies in Pharisaism and the Gospels* (Cambridge: University of Cambridge Press, 1917–1924), p. vii.

[8] Generally speaking, the Synagogue in ancient times can be characterized as progressive, lay, educational, and democratic, while the Temple by contrast was conservative, priestly, ritualistic, and aristocratic.

Christianity. The main contribution of the Pharisees and Scribes was the interpretation of the Torah and the commentary that accompanied it (later called the Talmud). This interpretation, found in the Mishnah and Gemarah, was a continued application of the Law to practical Jewish life in each succeeding age.[9] "It belongs to the irony of history," writes an authority on Pharisaism, "that the Pharisees should be charged with a bigoted and stiffnecked hardening and sterilizing of the religion of the Jews when it was they, as contrasted to the Sadducees and other literalists, and they alone, who gave it the flexibility and adaptability of spirit that enabled it to live and to survive." [10] To be sure, the Pharisees had their share of speciousness and casuistry, but it must be said that it did not exceed that of the Catholic Jesuits and the Protestant Puritans of a later age.

Jesus was a product of the Pharisaic Synagogue and frequently taught in it. It has even been suggested that he himself was a Pharisee but there is no evidence of it. Nor is it probable that he was an Essene, as some scholars have recently suggested. He was an independent teacher, reserving the right to interpret the Law along less meticulous lines than some of the Scribes. The liberal Hillel and the conservative Shammai had done the same in their respective interpretations of the Law. Many of Jesus' discriminating utterances ("Ye have heard that it was said . . . but I say unto you . . .") were typical of Rabbinical commentary. In his construction of the Torah from a spiritual rather than a legalistic viewpoint he stood in agreement with Pharisaic teaching at its

[9] The Jerusalem Talmud was closed about 350 C.E., the Babylonian Talmud, by 500 C.E. The Babylonian Talmud is usually thought to be superior to the Palestinian, probably because it closed later, was more complete, and afforded more opportunity for scholarly study. At any rate, the Babylonian Talmud was used throughout the Diaspora and the prestige of Babylonian Jewry rose in the Golden Age of Muslim rule.

[10] R. Travers Herford: *The Truth About the Pharisees* (New York, 1925), p. 21.

best. The opposition of the stricter members of the party to Jesus cannot be doubted, but it is also fair to assume that the Gospel writers greatly exaggerated this antagonism and created a breach between Jesus and his own people, a breach that was widened by their injection of the miraculous element in the career of Jesus. This growing tension between the parent religion Judaism and its offspring Christianity was intensified by the theological explanation of the crucifixion and the placing of blame for his death on the Jewish people —a charge that completed the wall of separation.

THE CROSS: HISTORY OR THEOLOGY?

Who Killed Jesus?

PRESENT-DAY studies show that there is a definite relationship between antipathy toward the Jews and the traditional charge that the Jews killed Jesus.[1] This accusation, already having been inferred from the Gospels, produced in the early church a feeling of hostility which in the Middle Ages became the cause of violent revenge. The distorted nature of the tradition that the Jews killed Jesus resulted from several misconceptions and false inferences, one of which is the tendency to hold in mind a collective image of the Jews in placing the blame for Jesus' death. This predisposition belies the actual situation even as recorded in the biased Synoptic accounts. From these narratives it is clear that whatever Jewish participation there was in the conspiracy, trial, and death of Jesus it involved only a few fanatical leaders and not the populace. Jesus' radicalism and claims to Messiahship had offended only the chief priests and the Sanhedrin. The Synoptic writers clearly distinguish between the extremist leaders and the people as a whole. They take pains to point out that the high priest and his colleagues were constantly

[1] See Bernhard E. Olson: *Faith and Prejudice* (New Haven: Yale University Press, 1963), p. 196 ff.

held back in their scheming by "fear of the people" and that
the Jewish people were not involved, and in fact were quite
ignorant of the movement against Jesus. Most of the two and
a half million Jews who lived in Palestine at the time had
probably never heard of Jesus.

> Then the chief priests and the elders of the people gath-
> ered in the palace of the high priest, who was called
> Caiaphas, and took counsel together in order to arrest Jesus
> by stealth and kill him. But they said, "Not during the feast,
> lest there be a tumult among the people" (Matt. 26:3–5).
>
> But when they tried to arrest him, they feared the multi-
> tudes, because they held him to be a prophet (Matt. 21:46).
>
> And the chief priests and the scribes heard it and sought a
> way to destroy him, because all the multitude was astonished
> at his teaching (Mark 11:18).
>
> And they tried to arrest him, but feared the multitude,
> for they perceived that he had told the parable against them;
> so they left him and went away (Mark 12:12).
>
> It was now two days before the Passover and the feast of
> Unleavened Bread. And the chief priests and the scribes
> were seeking how to arrest him by stealth, and kill him; for
> they said, "Not during the feast, lest there be a tumult of
> the people" (Mark 14:1, 2).
>
> The scribes and the chief priests tried to lay hands on him
> at that very hour, but they feared the people; for they per-
> ceived that he had told this parable against them (Luke
> 20:19).

It is the Fourth Gospel that conveys the idea to the reader
that it was the Jews as a people who were guilty of the death
of Jesus.

> The man went away and told the Jews that it was Jesus
> who had healed him. And this was why the Jews persecuted
> Jesus, because he did this on the sabbath. But Jesus answered
> them, "My Father is working still, and I am working." This
> was why the Jews sought all the more to kill him, because

he not only broke the sabbath but also called God his Father, making himself equal with God (John 5:15–18).

It was the feast of the Dedication at Jerusalem; it was winter, and Jesus was walking in the temple, in the portico of Solomon. So the Jews gathered round him and said to him, "How long will you keep us in suspense? If you are the Christ, tell us plainly." Jesus answered them, "I told you, and you do not believe. The works that I do in my Father's name, they bear witness to me; but you do not believe, because you do not belong to my sheep. My sheep hear my voice, and I know them, and they me; and I give them eternal life, and they shall never perish, and no one shall snatch them out of my hand. My Father, who has given them to me, is greater than all, and no one is able to snatch them out of the Father's hand. I and the Father are one.

The Jews took up stones again to stone him (John 10: 22–31).

Once the tradition became fixed it was continued through the centuries. The result was that, as H. A. L. Fisher writes, "the crime of a handful of priests and elders in Jerusalem was visited by the Christian churches upon the whole Jewish race." [2]

To use the generalized term "the Jews" implies that Jesus was not a Jew when the truth is, as we have previously emphasized, that Jesus, his family, and his disciples were Jews. Further, to designate "the Jews" as responsible is to ignore the fact that it was the Romans who executed Jesus. The death of Jesus probably would not have taken place without the instigation of those leaders who saw danger in his Messianic claims, ambiguous though they were, and who, resenting his criticism of the ritualistic refinements of the literalists, must have desired to see him silenced. On the other hand, the crucifixion was impossible without the sentencing and execution of the act by Roman officials.

[2] Herbert Albert Laurens Fisher: *History of Europe* (London: Eyre and Spottiswoode, 1952), p. 3.

The determination to transfer the responsibility for the death of Jesus from Pilate to the Jews is already evident in the Gospel of Mark, the earliest account (70 or 71 C.E.), and usually considered to be the least tendentious of the four Gospels. A clue to the time, place, and apologetic character of Mark's Gospel is found in 12:13–17 where the Pharisees question Jesus about Roman taxation. "Is it lawful to pay taxes to Caesar or not? Should we pay them or should we not?" The emphasis placed by the evangelist on this issue suggests that the attitude of Jesus toward Rome would have a bearing on Rome's attitude toward the Christians in that city. Mark's prime concern therefore was to show that Jesus' viewpoint had been favorable to Rome and that he had indicated that the Jews should pay tribute. In his treatment of the incident Mark aimed to convince Roman readers that Jesus was opposed more to Jewish leaders than to Caesar.

Although it was an obvious fact that Jesus was executed by a Roman official, it was Mark's purpose to shift the responsibility of Jesus' execution from Pilate to the Jews. He builds up his case by describing the plots of the Scribes and Pharisees and their attempts to trap Jesus into treasonable utterances. He is careful to point out that the High Priest regarded Jesus' confession of Messiahship and his statement about the destruction of the Temple as revolutionary and, therefore, supported by the Sanhedrin, he condemned Jesus to death. Such a death would have been one of stoning, as in the case of Stephen, but the Sanhedrin failed to carry out the execution. Instead, it handed Jesus over to Pilate. Evidently the Jewish leaders regarded Jesus' guilt as political and therefore subject to Roman jurisdiction.

Mark next emphasizes the fact that Pilate considered Jesus innocent of any crime. If this had been the case, he would have lost no time in dismissing him. Instead, he offers the crowd the choice of a prisoner to be released: Jesus or Barabbas, a rebel leader who had murdered Roman citizens.

For Pilate to take such a course is inconceivable if he thought Jesus was innocent, for the mob naturally would choose an enemy of Rome to be freed. The question which follows is even more incredible—the arrogant and powerful Roman procurator helplessly asking the frenzied mob what he should do with the innocent Jesus. Unperturbed by this improbable situation, Mark goes on to explain that Pilate, "wishing to satisfy the crowd," reluctantly consented to Jesus' death. He completes his portrayal of the guilt of the Jews by having the chief priests mock Jesus at the crucifixion and the Roman centurion, by way of contrast, exclaim: "Truly this was the Son of God!"

Roman Christians must have felt more comfortable in reading that it was the Jews rather than Pilate who put Jesus to death. Matthew and Luke, writing a decade or more later and using the Markan Gospel as a model, perpetuated the belief, which in the Fourth Gospel and the early Church Fathers became a fixed tradition, with terrible consequences for all Jews in the centuries that followed.

The tendency to transfer the responsibility for the death of Jesus from Pilate, the Roman procurator, to the Jews increased rapidly in the century that followed the crucifixion. Tacitus, writing about 112 C.E., reported that "Christus, the founder of the name [Christian] was put to death as a criminal by [per] Pontius Pilate, procurator of Judea, in the reign of Tiberias." [3] According to this historian, Pilate was the official who put Jesus to death. Justin Martyr, later in the second century, changed the "by" to "under," thus exonerating Pilate of the execution. "This very Son of God," he wrote, "was crucified under [sub] Pontius Pilate *by* your nation." [4] The statement of Justin, one of the earliest Christian apologists, was accepted by all later theologians and by the framers of the Apostles' Creed. Thus throughout the Christian

[3] *The Annals,* 15:44.
[4] *Dialogue with Trypho,* 85.

world today the phrase is repeated: "crucified *under* Pontius Pilate."

The exoneration of Pilate became so complete that by the end of the second century, extra-canonical Christian literature referred to him as a Christian and a saint! Some books speak of him as having served as a defense lawyer for Jesus. But Pilate was far from being a saint. History shows that he was vicious and corrupt, and for him the sentencing of Jesus to crucifixion was just another occurrence in the day's work. For him this Galilean was a revolutionary, claiming kingship, and the sooner he was dispatched the better. Christian imagination, however, soon began to paint a different portrait of Pilate. From Matthew's report of the trial (27:19) it was inferred that Pilate became a Christian because his wife was one, a tradition supported by the apocryphal *Acts of Pilate*.[5] Tertullian, one of the founders of Latin Christianity and the most influential theologian next to Augustine, wrote: "And now, a Christian by his own conviction, Pilate sent word of Jesus to the reigning Caesar, who was at the time Tiberius." Origen stated that "Pilate confessed that Jesus was the Christ."[6] To this day Pilate is regarded as a saint in Ethiopia. In 1897 an Ethiopic manuscript containing the following prayer of Pilate to Jesus was discovered:

I believe that thou art risen and hast appeared unto me, for I did this unto thee on account of fear of the Jews. In no way do I deny the resurrection, O my Lord. I believe upon thy word and thy miracles which thou didst perform.[7]

[5] This lengthy work, purporting to be a record of the official acts of Pontius Pilate and usually dated early in the fourth century, is devoted throughout to the exoneration of Pilate and to his opposition to the Jews in the trial and execution of Jesus.

[6] *Commentary on Matthew*, 118–124.

[7] See Montague R. James: *Apocryphal New Testament* (Oxford: Clarendon Press, 1924, 1926), p. 152.

In 1884 a second-century apocryphal fragment called the *Gospel of Peter* was found in an Egyptian tomb. It was used by Christians living in Syria during the fifth century and was still current in the eleventh century. The author of this document absolves Pilate from all guilt in the execution of Jesus, shifting the blame to the Jews.[8]

The primary source of Jewish-Christian tension, a development that permanently alienated all Jews and resulted in the charge of deicide, was the transformation of a historical event into a theological principle. The death of Jesus was historically conditioned. Prophets who get too far ahead of the crowd usually get shot in the back. It has always been that way. Jesus must have been conscious of the danger to his life midway in his career. He aroused the antagonism of the conservative leaders of the Jews and, to a certain extent, perhaps, the Roman authorities, and was willing to take the consequences. It might be said that he invited his own death. At any rate, it was a self-willed death and not the fulfillment of a foreordained plan of God. Jesus could have decided to live, in fact, at times struggled with the idea. His violent death in his own eyes was simply a result of loyalty to his principles, some of which were too dangerous to the establishment. Crucifixion was a Roman method of punishment, not Jewish, and Jesus was executed on the grounds of sedition. Little if any notice was taken of the event in that obscure corner of the world. But the historical circumstances of the crucifixion were shoved into the background to make room for the dogmatic interpretation, which, originating with the Hellenized Paul and systematized by the Latin Fathers of the church, divorced the crucifixion from human history and gave it a cosmic, universal significance. According to this Christocentric theology, Christ, by the foreordination of the Father, was sent to earth to die on the cross as an expiation for the sins of the world and only through this

[8] *Ibid.*, pp. 90–94.

atoning death can man be saved. Obviously the implication of this plan of salvation is that God is a Christian God, interested only in Christianity, which is the only true religion on earth, and, in the minds of the early theologians, those who do not accept it are eternally damned.

The Death of God

Woven into the Christological formulae of the second and third centuries was the firm belief that the death of Christ was the work of the Jews. From the standpoint of common sense, if Jesus' death was predetermined and was necessary as the culmination of God's plan for the redemption of the world, then those who were supposed to have accomplished that death should be praised rather than blamed. If Christ's death was God's will and the only condition of salvation, it would seem unreasonable to anathematize those who helped bring it about. Rather than be castigated, they should be canonized. As Disraeli said, "Suppose the Romans had not crucified Jesus, what would have become of the Atonement?" This manifest inconsistency persists today as Christians uniformly hold to the theory of atonement as the inevitable climax of the divine scheme and at the same time morbidly lament the passion and death of the slain Saviour. The paradox of celebrating the predestined death of Jesus on the cross and at the same time dwelling on the part played by his enemies in the crucifixion was only heightened by the obsession of the church with his physical suffering. The early church emphasized the humanity and the real suffering of Jesus in order to offset the Docetic view of the Gnostics, who maintained that Christ, being a Deity, existed only in spirit, that his appearance on earth had been only illusory and that his sufferings were only apparent. Consequently much was made of the agony of the passion as something that could have been averted but for the dastardly work of the Jews. This pathological

display of grief over the death of Jesus is carried out today in the Christian observance of Lent with its climax on Good Friday. The Cross early became the central theme and chief symbol of Christianity and so remains. As a result of the theologizing of Calvary, the Cross became a magical fetish and by the seventh century the symbol of the lamb was replaced by that of the Lamb of God nailed to the cross. From that time, the crucifix became a ubiquitous image throughout Christendom, found on prayer beads, charms, amulets, altars, stained-glass windows, ecclesiastical furniture, clerical vestments, bibles, hymnals, coins, spears, shields, banners, crowns, church spires, and gravestones. As for the actual suffering of Jesus, there were thousands of his followers whose death at the hands of the Romans was far more harrowing and torturous than that of Jesus; and millions of Jesus' fellow-countrymen have been put to death by Christians in a slower and more agonizing manner than he was.

In holding to the belief in Christ's deityship, conservative Christians today—Protestant and Catholic—find themselves in the absurd position of admitting that God could be killed. The liberal Christian faces no such problem because he sees Jesus only as a human being and his crucifixion only as that of a typical prophet-martyr. He neither makes the charge of deicide nor does he blame the Jews then or now for rejecting a Christ who had been exalted to the plane of supernatural Lord. Protestant neo-Orthodox theologians, rather than holding the Jews alone responsible, universalize the guilt for the crucifixion and, in line with their theological subtleties, place the blame on all people.[9] Dispensing with the Jesus of history as impossible—in fact, unnecessary—

[9] Neo-Orthodoxy, an intellectual Fundamentalism, reaffirms the Calvinistic doctrines of original sin and atonement and emphasizes revelation rather than reason and doctrine rather than ethics. It is a theological expression of what Van Wyck Brooks called the "eschatological despair of the world," a phenomenon which can be understood only against the background of events since 1913.

they are concerned only with the eternal Christ. The crucifixion is completely isolated from its historical causes and is seen only as the key to the divine plan of salvation. They interpret the death of Jesus as proof of the disobedience of all mankind and the estrangement of man from God. This coincides with the neo-Orthodox preoccupation with sin. All men—Christians and Jews—must share the guilt as evil men hostile to God and under judgment.

The Dispersion—A Punishment

The interpretation of the Cross as a means of reconciling man to God had serious implications for Jewish-Christian relations. The belief of the primitive church that the sacrificial death of Christ healed the breach between man and God meant that the mission of Israel was finally accomplished and as a consequence the Christian Church replaced the Synagogue just as the Old Testament gave way to the New. It was further believed on the basis of a statement in the New Testament that the Jews were thereby placed under a curse and all their subsequent history was a punishment for the crucifixion.[10] This is another illustration of turning historical fact into theological myth. It also illustrates the tendency of superstitious people to regard misfortune, individual or collective, as God's punishment for sin. The Bible is replete with examples, chief of which is the drama of Job, whose friends interpreted his afflictions as the direct consequence of wrongdoing. The early theologians found in the destruction of the Temple in 70 c.e. and the dispersion that followed a cogent confirmation of their theory of retribution. Church Fathers from Tertullian to Augustine dwelt on this theme until it became a fixed tradition. Even the otherwise liberal teacher Origen fell victim to the superstition, writing that "because of the crime of the Jews the city (Jerusalem)

[10] Matt. 27:25: "His blood be upon us and our children." This theory is taught today in many conservative circles.

perished utterly and the Jewish nation was overthrown." [11] Augustine echoed the belief: "But the Jews who rejected him and slew him after that were miserably ruined by the Romans and were dispersed over the face of the whole earth." [12]

The fallacy of this theological fabrication, aside from what it implies for the character of God, is immediately apparent when one considers the Dispersion in the light of history. The Jewish Diaspora was a protracted phenomenon occurring at several points in the pre-Christian era. The first scattering followed the fall of Israel, the Northern Kingdom, at the hands of the Syrians in 722 B.C.E. Sargon II the Conqueror had some 27,000 Hebrews exiled to Mesopotamia. Then, following the conquest of Jerusalem and the Southern Kingdom by Nebuchadnezzar, there were two mass deportations to Babylonia, 10,000 in the preliminary siege of Jerusalem in 597 B.C.E. and a similar number in 586. These exiles apparently adjusted themselves to their new surroundings, intermarried, and settled down as farmers and artisans. When in 538 B.C.E., after the Persians had become the ascendant nation by defeating the Babylonians, Cyrus issued a proclamation permitting the Jews to go back to their homeland, only a few returned. Most of them were so thoroughly assimilated with the Babylonians that they had no desire to leave. Meanwhile Jews from the eighth century B.C.E. on had migrated to Egypt and Arabia. It is obvious, therefore, that 500 years before the beginning of the Christian era there was a vast Diaspora of the Jews in the Middle Eastern world, held together by their loyalty to Yahwehism.

The next significant scattering of the Jews occurred in the wake of the conquests of Alexander the Great in the fourth century B.C.E. Caught in the maelstrom of warfare between Ptolemaic Egypt and the Syrian Seleucids, the Pal-

[11] *Against Celsus*, 4:22.
[12] *City of God*, 18:46.

estinian Jews in great numbers were either forced to emi-
grate or left of their own accord. Thousands of Jews were
sold as slaves, many of whom later purchased their freedom
in the various communities to which they were sent. By the
third century B.C.E. Alexandria, the greatest commercial and
cultural center in the Middle East, had become also the most
important Diaspora city and boasted more Jews than Jeru-
salem at the time. The confrontation of Jew and Greek in
Ptolemaic Alexandria had two different results. It was in-
evitable that the Diaspora community in that city should
feel the impact of Hellenistic culture. This is reflected in the
attempt of the liberal Jews in the third century B.C.E. to tem-
per the Jewish faith with Greek reason, to unite religion with
philosophy. They saw an ultimate affinity between Moses
and Plato, the prophets of Israel and the philosophers of
Greece. This congeniality was evident in the appearance of
the Wisdom Literature, an entirely new kind of writing in
Judaism.[13] The influence of Hellenism also produced the
Septuagint, which was the Greek translation of the Hebrew
Old Testament for the benefit of Greek-speaking Jews in
Alexandria.[14] The outstanding Jewish writer in Alexandria
was Philo, who was known as "the Jewish Plato." He sought
to harmonize Greek rationalism with the Torah and to inter-
pret Judaism in philosophical terms.

The other result of the meeting of Jew and Greek in
Egypt was the outbreak in the second century B.C.E. of anti-
Semitism. For over a century the relationship was amicable
enough, but with the increased emigration of Jews from Pal-
estine to Alexandria, the nationalistic orthodox element at-
tained more power and finally struck out against both the

[13] Job, Proverbs, Ecclesiastes, Ecclesiasticus or the Wisdom of Jesus,
Son of Sirach, and Wisdom of Solomon.

[14] The Septuagint (LXX) contains fourteen books in excess of the
Palestinian Hebrew Old Testament—a natural consequence of the more
tolerant atmosphere of Alexandria.

Greeks and their more liberal Jewish neighbors. The common people, urged on by Jerusalem leaders and influenced by the Maccabean Revolt in Judea, opposed the cultural rapport with the Greeks which they considered to be a betrayal of their religion and their nationalistic hopes. The scholarly and aristocratic group of Jews in Alexandria lost ground as the fanatical nationalists increased in number and militancy. The conservatives scorned the gods of the Greeks and became more isolated in their own religious practices. This produced the first important pre-Christian anti-Semitism, an enmity that was both ideological and ethnic.

Another phase of the Dispersion occurred in connection with the establishment of the Roman Empire. Following the capture of Jerusalem by Pompey in 63 B.C.E., thousands of Jews were sent to Rome as slaves. By the first century of the Christian era there was a substantial Jewish population in the city. In the unification of the Western world and the *Pax Romana*, the Diaspora spread to Gaul, Germany, and Spain, where the Jews not only experienced an acculturation but in turn had a profound impact on the inhabitants of these countries. Historical references make it clear that at the inception of Christianity the Dispersion was widespread, numbering from six to seven million people, and exercised an influence in the empire entirely out of proportion to its numerical strength. We learn from Strabo, the Greek geographer, that about 85 B.C.E. "the Jews have migrated to all cities; and it is hard to find a place in the habitable earth that hath not admitted the people." [15] The wide dissemination of Jews in the early part of the first century B.C.E. is attested in a letter from Agrippa I to Gaius Caligula:

> Jerusalem is the metropolis, not only of the one country of Judaea, but also of many, by reason of the colonies which it has sent out from time to time into the bordering districts

[15] Quoted in Josephus: *Antiquities*, XIV:7:2.

of Egypt, Phoenicia, Syria in general, and especially that part
of it which is called Coelo-Syria, and also with those more
distant regions of Pamphylia, Cilicia, the greater part of Asia
Minor as far as Bithynia, and the furthermost corners of Pon-
tus. And in the same manner into Europe, into Thessaly, and
Boeotia, and Macedonia, and Aetolia, and Attica, and Argos,
and Corinth and all the most fertile and wealthiest districts
of Peloponnesus. And not only are the continents full of Jew-
ish colonies, but also all the most celebrated islands are so
too; such as Euboea and Cyprus, and Crete.

I say nothing of the countries beyond the Euphrates, for
all of them, except a very small portion, and Babylon, and all
the satrapies around, which have any advantages whatever
of soil or climate, have Jews settled in them.[16]

From the Hellenistic period and well into the Middle
Ages, the chief centers of the Diaspora were Egypt, Baby-
lonia, and Syria. It should now be clear that the year 70 C.E.
does not mark the beginning of the Dispersion and that the
scattering at that particular time was not God's punishment
of the Jews for their role in the crucifixion. As a matter of
fact, Palestinian Judaism lived through the sack of Jerusalem
to fight another war of defense against Rome in the second
century. It survived even this devastation to establish the
Rabbinical schools and to publish the accumulated oral tra-
dition as the Talmud. As Jules Isaac summarizes the ques-
tion, there was never a definitive or final Dispersion but a
"progressive impoverishment of Palestinian Judaism" which
reached its climax in the capture of Jerusalem by the cru-
saders in 1099 C.E.[17]

Exaltation by Disparagement

One of the most unfortunate misconceptions inherent

[16] Philo Judaeus: *The Embassy of Gaius*, XXXVI:281–2. English trans-
lation by C. D. Yonge, Bohn Library IV, 161.

[17] Jules Isaac: *The Teaching of Contempt* (New York: Holt, Rinehart
and Winston, 1964), p. 69.

in Christian teaching on the career and significance of Jesus is that Judaism had by Christ's time become a decadent, stilted, legalistic system without ethical or spiritual vitality, a body without a soul. This idea goes hand in hand with the above-mentioned belief that Jesus' appearance signaled the overthrow of the old dispensation, that the Old Testament and Judaism had performed their function, having paved the way for the New Testament and Christianity. Had not Jesus said as much? One cannot, of course, ignore Jesus' sharp criticism of scribal attention to the fine distinctions of ceremonial laws. As any impartial Jewish teacher today will readily concede, there were excesses in the interpretation and application of traditional precepts; there was much pious ostentation among the Pharisees; and there were arrogant reactionary priests. What religion has been without these things? But to think that Judaism had degenerated into a mere ecclesiastical machine with its people blindly following the minute prescriptions of the Law, having no regard for justice, mercy, and humility is to disregard the facts.

On the contrary, the period immediately preceding the Christian era was one of great vitality and enrichment in the religious life of Judaism. It produced an abundance of religious literature, much of which exerted a strong influence on Jesus and early Christian teaching. It was in the so-called intertestamental period that the Synagogue came into prominence as the spiritual and educational center of Palestinian Judaism. The Synagogue, with its prayers, responses, and reading and interpretation of the Bible, became the model for the worship service of the Christian Church. As a non-ritualistic institution it was the one thing that saved the Jewish religion from an arid formalism. The Jewish idea of a sacred canon of Scripture and the institution of the Sabbath were also taken over by Christianity. We have previously discussed the Rabbinic sources for the ethical teachings of Jesus as well as the Messianic hope which occupied a prom-

inent place in his thought. The Dead Sea Scrolls are eloquent
testimony to the spiritual vitality of pre-Christian Judaism
as seen in the literature of the Essenes. The Essene Manual
of Discipline made clear that it is the inside of the cup that
must be clean, that external ritual is of no value unless ac-
companied by inward renewal. The Manual also contains the
homily of the Teacher of Righteousness on *The Two Ways*
—the conflict between the sons of righteousness and the sons
of evil.[18] It is now established that the origins and sources of
primitive Christian thought and organization are deeply
rooted in Judaism proper and its various sects.[19]

Christian education has been grievously at fault in
teaching that Judaism at the time of Jesus' appearance was
spiritually bankrupt, a soulless legalism. In spite of the ritu-
alistic excesses of overzealous teachers of the law, history
attests to the increased spirituality of first-century Judaism.
It was still the religion of the Law and the Prophets. To ex-
alt the religion of Jesus at the expense of the religion which
gave it birth is a presumptuousness which Christian leader-
ship today should repudiate. Such is the result when theology
replaces history.

[18] This doctrine, undoubtedly of Zoroastrian origin, is echoed in the
Didaché and the *Shepherd of Hermas*—two extra-canonical works in early
Christian literature.

[19] It is not within our province in this book to discuss in detail the
significance of the Dead Sea Scrolls. The reader is referred to my *A History
of the Bible* (Boston: Beacon Press, 1959), pp. 76–80, 225, 272.

THE GENTILE SCHISM

Jewish Christianity

THE RELATION of the Nazarenes, as the primitive Christians were called, to their orthodox Jewish neighbors was so close that the rapidly developed breach between Christianity and Judaism calls for an explanation. The earliest Christians had no thought of being anything but good Jews. They were not called "Christians" until after the middle of the first century at Antioch.[1] There are only three places in the New Testament where the word "Christian" is used and in each instance it is used derisively or as a nickname.[2] The first Christian community was the Petrine circle in Jerusalem. The impetus for this movement was the reception by its members of the "holy spirit," the belief that Jesus had risen from the dead and would shortly return to rule as the anointed of God, and the conviction that their task was to spread the Good News (*kerygma*) of his resurrection (however that may have been conceived).[3] As faithful Jews they continued to follow the Law in all its technical requirements including circumcision, the Sabbath, and dietary regulations. These Nazarenes, as they were called, were also known

[1] See Acts 11:26.
[2] Acts 11:26; 26:28; I Pet. 4:16.
[3] Acts 2.

as the company of "those who wait" and their religion has been called an "interim ethic." If there were differences between the new sect and Pharisaic Judaism they consisted in the ecstatic or pneumatic character of the Christians, the recovery of the moral and spiritual emphasis of the older prophetic Judaism, and the following of Jesus as the resurrected Messiah. Otherwise, the essentials of the two movements were identical.

There is a division of opinion as to whether primitive Christianity derived from normal Pharisaic Judaism or from one more of the fringe sects of Judaism. Those who hold to the latter theory regard the Pharisees as extremists and not typical of essential Judaism. If that were the case Pharisaism would not have survived the first century and Judaism would have been perpetuated through some nonofficial form. Christianity then would have sprung from one of these fringe groups. The early Christians were known variously as Nazarenes, Ebionites, the Brethren, Followers of the Way, Sons of Light, and Galileans and among them were diverse points of view. The Ebionites, for instance, were more Jewish than Christian, being sedulously devoted to the Mosaic Law. They held that Jesus was the Messiah but was not divine, and were followers of James. Our information about the Ebionites is scanty. What we have comes from the Patristic writings. The earliest reference to the group is in Irenaeus (ca. 175 C.E.) who regarded them as heretical because they rejected the Virgin Birth of Jesus and the Incarnation.[4] It is not known whether the term Ebionites refers to the founder, Ebion, or to the poverty of the members.[5] According to Tertullian (ca. 200 C.E.) and Hippolytus (third century) the Ebionites were greatly influenced by the Gnostic Cerinthus, a Jewish Christian of the early second century who rejected the deification of Jesus and the

[4] *Adversus haereses.* I, 26:2; V, 1:3; IV, 33:4.
[5] Ebyonim—an Aramaic word meaning "poor."

orthodox theism of both the Old and New Testaments. Origen (185–254 C.E.) tells us that the Ebionites were Jewish Christians who regarded Christ as purely human having been born naturally of Mary and her husband and lived an exemplary life.[6] Epiphanius (315–403 C.E.) speaks of two groups: the Nazarenes and the Ebionites, both of which held Gnostic ideas. From the writings of the Church Fathers (Irenaeus, Hippolytus, Origen, Tertullian, Epiphanius, Eusebius, and Jerome) we learn that these two groups had much in common: they used only the Gospel of Matthew; they rejected Paul; they practiced circumcision; and they observed the Jewish Law strictly. In Christology the Nazarenes were somewhat more orthodox than the Ebionites.

A comparison of the Ebionites with the Essenes of Qumran shows a number of similarities: dualism, the bath or baptism, communal meal, and communistic economy. The view has been expressed that Ebionitic Christians are to be identified with the Essenes, or at least a later development of the Qumran sect, a belief that is rejected by the majority of scholars.[7]

The discovery of the Dead Sea Scrolls tended to confirm an earlier theory that the primitive Nazarene group in Jerusalem under James and Peter was a continuation of the Essenes. Asceticism, apocalypticism, dualism, and Messianism characterized both groups. Both were known as "the people of the New Covenant," Nazarenes, and Sons of Light; both had a baptism and a common meal; and both had "all things in common." When Peter began preaching about the resurrection of Jesus, his small group may have been augmented by the Essenes under James. The existence

[6] *Contra Celsus* 5:61.

[7] For a survey of recent discussion of the Ebionites and their relation to other early sects see J. A. Fitzmyer, "The Qumran Scrolls, the Ebionites, and Their Literature," in Krister Stendahl, ed., *The Scrolls and the New Testament* (New York: Harper and Brothers, 1957), pp. 208–231.

of the Essenic sect in Jerusalem before the Christian era
would help to explain the rapidity with which primitive
Christianity became organized and strongly established after
the death of Jesus. The Dead Sea sect probably remained
faithful to its anti-priestly Jewish faith but the Essene groups
in other areas became Christian.

The identity of the early Christian sects is a hazy and
uncertain question but their close interrelatedness shows
conclusively that Christianity in the first three centuries was
an eclectic and syncretistic movement, that there was no
unified theology, and that there was a difference of opinion
among early Church Fathers on the nature of Christ's per-
son.[8] Even after 325 C.E. and well into the Middle Ages a
form of unitarianism flourished among the Nestorians, the
Arians, and other groups.

The theory that early Christianity arose independently of
Judaism or from a Jewish fringe sect presupposes that first-
century Judaism was completely devoid of spiritual and
moral values. This, we have already shown, was far from
the truth. In spite of the above-mentioned similarities to
heretical sects, it is unlikely that Christianity emerged from
an anti-Pharisaic group but did evolve from typical Judaism.
The breach was the result of the conflict between Peter
and Paul. Peter, the leader of the original Jerusalem circle,
held strictly to ceremonial law and circumcision as obliga-
tory for all followers of Christ. Paul, whose missionary ac-
tivity had been largely in pagan countries where he had
converted Greeks to Christianity, maintained that the Law
was unnecessary for Gentile converts. In other words, ac-
cording to Peter and James, a Gentile had to become a Jew
before he could become a Christian. Paul insisted that to
become a Christian a Gentile needed only to be baptized

[8] Origen subordinated Christ to God and cannot be considered a
trinitarian.

into the name of Jesus. Law or no Law, he considered his Greek converts to be *bona fide* Christians.

The problem became more acute because of the social implications of the conflict. The ceremonial law which prohibited Jews from eating with Gentiles meant that Jewish Christians and Gentile Christians could not participate in the Lord's Supper. Thus, there arose the problem of segregation. The ultimate issue was: Who is a Christian? Is he one who follows Jesus as a Jewish reformer or Messiah and at the same time remains faithful to the Law; or is he one who believes in Christ as divine Lord and is not obligated to the Law? The Christian community at Antioch, which had become Paul's headquarters, decided to send Paul and Barnabas to Jerusalem to confer with Peter and James. There are two accounts of this conference. The first is Paul's own story (Gal. 2) in which, having taken along an uncircumcised Gentile by the name of Titus as a test case, he claims an unqualified victory over the "pillars of the church." The second account is by Luke (Acts 15) who, writing from a more objective and disinterested point of view, reported merely that a conciliatory agreement had been reached. Both agree that Paul won his case for the Gentile constituents. Paul and Barnabas were fully accredited as preachers to the Gentiles while Peter and James continued as apostles to the Jews. Thus the Council of Jerusalem (48 c.e.) established the legitimacy of Gentile Christianity and freed it from the requirements of Jewish Law. In the ensuing campaigns of Paul, Christianity became a European religion and by the third century was flourishing in the great cities of Antioch, Alexandria, Byzantium, Carthage, and Rome. With the death of Peter and James and their followers, Jewish Christianity declined and after the fall of Jerusalem in 70 c.e. no longer existed. Palestinian Jewry was thereafter confined to orthodox Judaism.

The Jesus-Paul Problem

For an understanding of the evolution of early Christianity from a Jewish sect to a world religion it is necessary in the next place to call attention to the relation of Paul to Jesus. Paul's divergence from Jesus constitutes another stage in the transition to Hellenistic Christianity. The Pauline letters and the teachings of Jesus as recorded in the Synoptic Gospels must be compared in order to measure both affinity and disparity.

In basic religious and ethical values we find an unqualified agreement between Paul and Jesus, an identity which reaches its highest and clearest expression in the inseparable connection between mysticism and the moral life. The *summum bonum* is the same for both: the supreme place of love and its moral imperative, brotherhood. An investigation of parallel teachings shows that Paul agreed with Jesus in his conception of God. Both emphasized God's fatherhood, omnipotence, unity, and benevolence. This must be qualified, however, by a divergence in Paul arising from his interest in God's relation to the world of sin and man's reconciliation to God through Christ. Paul's agreement with Jesus in the idea of the Kingdom of God lies not so much in the apostle's use of the phrase itself as in the connotation of the term. The conception for both was a mixed one: they regarded it both as a future Messianic event and also a personal spiritual condition. There is also an undeniable dependence of Paul on Jesus' eschatological ideas of the Parousia, the judgment and the future life. For both, the Law had ceased to have absolute significance. Jesus' attitude toward legalistic Pharisaism was one of discrimination or relative importance; Paul's criticism of the Law was based on his belief in "justification by faith" rather than works.

The subject of soteriology involves first, the meaning and content of salvation and second, the means of its ac-

quirement. Clear agreement is seen between Paul and Jesus as to the actual nature of salvation; it is the Godlike life, the life of fellowship with the divine. In soteriology, however, we see the first serious difference. The divergence occurs, not in the religious conception of salvation, but in the explanation of its accomplishment. In Paul's description of the saved life Jesus himself becomes the object of faith and communion. In regard to the relation of the death of Jesus to salvation, Jesus viewed his approaching death as an integral part of his life, a logical climax to his mission in establishing God's kingdom, self-imposed—as far as predestination is concerned—and not a necessary condition for the securing of God's pardon of man's sin. Paul regarded the death of Jesus as the instrument which secured man's deliverance from sin, as redeeming man from this evil world, and as accomplishing a reconciliation between man and God.

An examination of the two bodies of teaching with reference to Jesus' self-consciousness and Paul's Christological ideas discloses a still wider divergence. Jesus' sonship from his own point of view was ethical and spiritual rather than metaphysical. Such terms as "Son of Man" and "Son of God" are ambiguous and reflect on the one hand the Jewish Messianic connotation and on the other, the later Johannine deification process. The consciousness of Jesus regarding his own significance was gradually developed in an ascending scale, and in a subjective rather than an objective manner. The facts of Jesus' experience as recorded in the Synoptics preclude his possession of foreknowledge and likewise his preexistence. Paul's Christological teaching, on the other hand, was concerned almost exclusively with the exalted and mystical Christ. For Paul, Christ was preexistent in heaven, shared in creation, gave up his divine existence, came to earth as a man, lived and died for man's salvation, was exalted as Lord, and was to return to judge

the world and establish God's Kingdom. It is hard to avoid the impression that Paul regarded Jesus as divine in some way. Yet Paul is neither polytheist nor tritheist. Theologically he subordinated Jesus to God; on the other hand, much of his teaching seems to anticipate the doctrine of the Logos. His idea of Jesus' sinlessness also differs from that of Jesus himself: Paul accounted for Christ's sanctity by his pre-existent and cosmic relation to God, while Jesus' experience from the wilderness to the Garden of Gethsemane is eloquent testimony to the fact that his moral excellence was the result of a profound and continuous human struggle. Paul's theory of Messiahship finds no support in Jesus' own words or experience. The Christological difference briefly comes down to this: Jesus' theology, if he had any, was theocentric; Paul's was Christocentric. This divergence marked the beginning of a process of deification which led ultimately to the Nicene formula.

The analysis of the Pauline and Jesus traditions relative to sacraments offers a self-evident divergence. The best textual evidence in the Synoptics indicates that Jesus in his last supper with the disciples desired to impress upon their minds in a symbolic manner the significance of his approaching death, representing it by the broken bread and the poured wine. That he intended to leave with his followers a memorial institution is doubtful, much less a sacrament. Paul regarded the Lord's Supper as a sacrament in which the believer by partaking of the elements was united with Christ in mystic fellowship. It is not necessary to see in the Pauline conception of the Lord's Supper a magical or physical efficacy; it is merely a figurative participation in Christ's death. Nor can Jesus be regarded as having instituted a Christian baptism, since there is not even a tradition to that effect. That Jesus commanded his disciples to baptize their converts with a trinitarian formula is not borne out by the actual facts, since they baptized only into his own name.

Baptism with Paul assumed a more sacramental character, but he did not regard it as being the means or sole condition of salvation. The act of baptism in the Pauline communities was a sacrament, presupposing faith on the part of the convert and symbolizing mystical union with Christ. Jesus had nothing to say about the Church. (The two Synoptic passages which report Jesus as having used the word ἐκκλησία are most probably editorial insertions.)[9] The idea of establishing a new society as distinct from the Synagogue does not appear in Jesus' teaching. The Pauline divergence in the field of sacraments and church life, then, is simply a matter of historical development.

The foregoing comparative study shows a profound agreement between Paul and Jesus in the definition of spiritual values, the criterion of religious experience, and the ethical import of religion. A divergence no less distinct is found in Pauline material that pertains to the theoretical explanation of the truths in which they agree. Agreement is seen in Paul's religious experience of Jesus' essential teachings; divergence is seen in Paul's theological explanation of Christ's person. Continuity is implied in Paul's quotations of and allusions to the Jesus tradition and his contact with followers of Jesus, a knowledge of the historical Jesus and a dynamic, mystical experience of Christ. Divergence is explained by the Christological and sacramental developments of the primitive apostolic community and by the influence exerted upon Paulinism by non-Christian religions, especially the mysteries.

The recognition of the two elements in Paul, the religious and the theological, the mystical and apologetic, is indispensable for a true estimation of Paul in his relation to Jesus. The failure to give proper accent to the religious conviction which underlies the framework of apologetics explains the "Pauline" character of historic Christianity.

[9] Matt. 16:18, 18:17.

Continuity and divergence in the Jesus-Paul relation-
ship are reconciled by the distinction between content and
methodology. The first great thinker after Christ was bound
to cast the Gospel in a theological mold; there has been no
exception to that phenomenon of progress in any move-
ment in history. Every age has its own logic, which is
transient and good only for that age, and it is therefore
natural that the modern world should rebel against the
theology of Paul. No study of Paul is complete or fair how-
ever until it has penetrated the forms of Paulinism and
seized the religious spirit beneath. Back of his inconsistent
and unscientific explanations lies the object of his explana-
tions, Jesus Christ. The religious Paul was, or should be,
primary and the theological Paul secondary; but all this
having been said, it must now be made equally clear that
it was Paul the theologian who opened the way for the later
development of Christian dogma and sacrament.

Unfortunately it was the divergent element in Paul
that set the pattern for all subsequent Christian thought.
Not that Paul's theology was consistent or systematic. On
the contrary, it was formulated "on the run" and repre-
sented an accumulation of various strata made up succes-
sively of Pharisaic ethics, primitive Christian mysticism, and
Hellenistic sacramentalism. His teaching was a mosaic blend-
ing various elements from his Jewish heritage and his Greek
environment. Paul's speeches in Acts as compared with his
letters reveal a variety of attitudes toward Jewish Law and
toward the place of Jewish history in God's plan of salva-
tion. In spite of his opposition to the requirements of the
Law for Gentiles, he had non-Jewish converts circumcised
and also preached to Jews as his first responsibility. His
Christology was likewise ambiguous. The impact of pagan
thought on his changing intellectual formulations com-
pelled him to see Jesus as something more than human, and
yet as a Jew he could not bring himself to equate the his-

torical Jesus with God. He spoke of Christ as divine Lord but he cannot be considered a trinitarian in the fourth-century sense of the word.

Our concern at this juncture is to show that Paul's divergence from the ideology of Jesus also represented a departure from Judaism and marks the beginning of a theological structure that could not possibly be acceptable to Jews. In Paul's theory of the Atonement, for instance, he identifies Jesus with the scapegoat and the paschal lamb, a sacrifice made to God for man's sin.[10] Such a theory, disposing of the Mosaic dispensation as no longer necessary and making Jewish Law invalid, was not only repulsive to Jews in their conception of God, but was calculated to sever what continuity existed between Paulinism and Judaism. As one Jewish author writes:

> Mingled with the trinitarian doctrine, as still officially expounded, is the doctrine of vicarious atonement—that unworthy, irrational and hateful dogma that the all-merciful and all-just God made an atonement to himself for sins committed against himself by sacrificing to himself a perfect being, an innocent and godly man, richly endowed with the divine spirit.[11]

To the Jews, who already had their solemn Day of Atonement for sin, this pagan idea of expiation was indeed a "stumbling block," especially since the death of Christ was interpreted as a sacrifice reconciling "all men" to God.

These considerations created a tension for Jewish Christians but they accepted a compromise or adoptionist faith, holding to the resurrection, the divinity of Christ in some form, and the Parousia. Were it not for Paul's innovations the primitive Nazarene movement might have survived among the Jews in an atmosphere of coexistence but when

[10] Cf., 1 Cor. 5:7 and Rom. 5:6, 11.
[11] N. S. Joseph: *Why I Am Not a Christian: A Reply to the Conversionists* (1908), pp. 7, 8.

the Petrine leaders in Jerusalem died, Judeo-Christianity disappeared.

Prior to the Jewish wars with Rome (66–70 C.E.) Jerusalem Jews and Judeo-Christians lived together in comparative harmony. Aside from questions concerning the ceremonial laws and the Messiahship of Jesus, there were no great conflicts. At least, the two groups had more in common than otherwise. Celsus and Josephus testify to the amity between Jewish Christians and orthodox Jews. Judaism was fairly tolerant of theological differences as witnessed by its various first-century sects. The separation was caused by the Hellenizing of Christianity and the beginnings of Christological development. The Gospels, written after the cleavage, accentuate the transformation in showing more interest in who or what Jesus was than in what he said and in explaining the reason for his death rather than the character of his life.

By the end of the first century the separation was complete. Christians were asserting that they were "the People of God" and that the Old Testament had no importance except as a preparation for the New Testament. The Christian interpretation of Judaism from the end of the century on is described by Adolf Harnack:

> The Chosen People was the Christian people, which always existed in a sort of latent condition though it only came to light at first with Christ. From the outset the Jewish people had lost the promise; indeed, it was a question whether it had ever been meant for them at all. In any case, the literal interpretation of God's revealed will proved that the people had been forsaken by God and had fallen under the sway of the devil. The Old Testament from cover to cover, has really nothing whatever to do with the Jews. Illegally and insolently the Jews had seized upon it, they had confiscated it and tried to claim it as their own property. It would be a sin for Chris-

tians to say: "The book belongs to us and the Jews." No, the book belongs now and ever more to none but Christians.[12]

The theological accretions already evident in Paulinism offered nothing to orthodox Jews, in fact repelled them. The destruction of Jerusalem by the Romans in 70 C.E. was disastrous for the Palestinian Jews, spiritually as well as physically. The Temple, symbol of national pride and religious unity, was gone. The people were scattered and in despair. The question became one of survival. Under the leadership of Johanan ben Zakkai, Akiba ben Joseph and other Tannaitic scholars, academies were established for the study of the Torah; juristic principles were formulated; and a renewed emphasis on the Talmud was encouraged. The future of Judaism was assured in the Council of Jamnia (90 C.E.) at which the canon of Scripture was fixed and Rabbinic Judaism took permanent form. The spiritual foundation, reinforced at this time, has held Judaism in a bond of unity to the present day—a unity based on the undivided oneness of God and the paramount importance of obedience to his will as taught in the Torah and the Talmud.

The Hellenization of Christianity

The ecstatic nature of primitive Christianity, belief in the risen Christ, and repudiation of the primacy of the Torah were contributing factors in the rift from orthodox Judaism. It is conceivable that these grounds alone were not enough to cause the schism. As previously intimated, the movement, at least in its initial stage, might conceivably have endured as an unorthodox Jewish sect. But by the end of the first century it had divorced itself completely from its Jewish antecedents and was well established in the

[12] Adolf Harnack: *Mission and Expansion of Christianity*, Vol. I (New York: Putnam, 1904–05), p. 34.

Western world. The final factor in the separation was the
Gentile mission of Paul and the subsequent Hellenization
of the Christian religion. This change was not sudden. On
the contrary, for several decades after the Council of Jeru-
salem converts in Corinth and other centers were greatly
confused on the nature and source of their Gospel, some
claiming to be followers of Peter, some of Apollos, some,
Paul, and others of Christ. They also held different ideas on
the Lord's Supper, the resurrection, the second coming of
Christ, and the means of salvation. It becomes necessary,
therefore, to explain how this Judeo-Christian religion was
remodeled along lines quite alien to its original character.

Paul's Christianity was built on an appeal first to up-
rooted Jews in the Diaspora, then to Gentiles who were
attracted both to the Jewish ethics and the apostle's mys-
ticism, and finally to outright pagans who were at home in
the Graeco-Roman rites, which by that time had become a
part of Paul's brand of Christianity.

The radical difference between primitive or Jewish
Christianity and the Pauline interpretation was the thesis
of F. C. Baur. The Tübingen School, as his followers were
called, came into disrepute among English and American
scholars by reason of Baur's late dating of New Testament
documents. More recently, however, the Hegelian principle
(thesis, antithesis, synthesis) of the Tübingen School has
received considerable support as the liberal-historical inter-
pretation regained its status in theological circles. Naturally
orthodox groups feared the Tübingen idea because it de-
stroyed the belief that Christianity in the Apostolic Age
was a complete and unified faith untouched by divisive
elements. It is now recognized by progressive Jewish and
Christian authorities that the soteriological system of Paul
with its Hellenistic ideas flourished throughout the Diaspora
after the fall of Jerusalem (70 C.E.).

It is unthinkable that the Jewish ethic of Jesus could

survive and dominate the Graeco-Roman world without accommodating itself to the thought forms of that world. Such ideas and practices as the supernatural or virgin birth of the religious hero, deification, the idea of Lord and Saviour, miraculous resurrection, last supper, baptismal rites, divine healing, and mystic union with the deity were widespread in the mystery religions which competed with early Christianity. Some authorities are unwilling to see in these pagan forms anything more than analogies, but the fact remains that between primitive Christianity and the early Catholic Church there appears a vast chasm. As we pass from one to the other, we notice a complete metamorphosis: the Gospel of Jesus has become a theological system; the original religion of ethical values has been turned into a scheme of redemption; the spontaneous enthusiasm of the first age of Christianity has disappeared in favor of a highly organized church with episcopal authority, a fixed creed, and a canon of Scriptures; the direct and immediate faith-religion of Jesus has been supplanted by a religion the blessings of which are received only through the agency of sacraments which are mediated only by priests. This divergence, for it is nothing short of that, represents a Christological, soteriological, and sacramental remodeling along lines essentially foreign to the original Judeo-Christian movement. Whence came the change? The key to this transformation is Hellenism. To attribute the changed form of Christianity to Greek influence is simply another way of stating that the household into which Christianity as a child came to live-had its inevitable effect on the growth of its new member. That household was the Graeco-Roman world, and the adult members of the family were the Oriental mystery religions. As the child grew, it began to use the vocabulary of the family. To live in an environment and not be a part of it would be impossible.

The world into which Christianity had come was an

extremely religious world. All men hungered for salvation, yearned for redemption, and sought spiritual satisfaction in Oriental rituals. As Professor Samuel Angus points out, at no point in all history has there been such a universal expectancy and such a common longing for salvation.[13] Never has there been a greater political and linguistic unity than in the Hellenistic Age, following the conquests of Alexander the Great. The Greek language was the universal tongue of the Mediterranean world. Hellenistic Judaism in Alexandria had produced the Septuagint Old Testament, and the later penetration of Hellenism into Palestine accounted for the Greek New Testament. In his missionary travels Paul had no linguistic barriers to overcome, but could speak Greek everywhere and be understood. After the Jewish-Gentile schism a firm contact was made with the Graeco-Roman world that was palpable especially in religious thought. Christianity from Pentecost on was an ecstatic, spontaneous, miraculous type of religion—a fact which accentuated the breach with Judaism and facilitated the psychological union with paganism. At the moment when the Gospel broke the bonds of Judaism it was exposed to a world teeming with Greek, Persian, and Egyptian cults, the most marked characteristic of which was the dualistic idea of redemption. Paul and other preachers of the young religion would naturally and unconsciously utilize accepted terms in propagating the Gospel in Greek centers. The Gentile converts were already conversant with pagan forms, and it seems logical to assume that they carried along with them certain religious conceptions which they employed to give expression to their new faith. Divergent influences are first seen within the primitive Christian community as the fol-

[13] See Samuel Angus: *Environment of Early Christianity* (London: Duckworth and Company, 1914), pp. 225–26; also, same author, *Religious Quests of the Graeco-Roman World* (London: John Murray, 1929), pp. 19 ff.

lowers of Jesus made the attempt to interpret his greatness. But the spiritual energy of early Christianity found expression in more alien ways as it flowed over into the Gentile world. Its externalization was unavoidable, for the catholicizing of a religion is of necessity achieved by an accommodation to the mentality of the age. The medium for the remodeling of the Christian message was the mystery religions which aimed to satisfy the religious demands of the time.

The affinity between the mystery religions and Gentile Christianity can be readily appreciated by calling attention to the distinctive features of the various cults. The chief mysteries were: Eleusinian, Dionysiac, and Orphic (Greek); Isis, Serapis, and Osiris (Egyptian); Sabazios, the Great Mother, Attis, and Cybele (Phrygian); Mithra (Persian); and Adonis or Tammuz (Syrian). These cults offered men soteria (salvation) through faith and sacrament. Their devotees conquered sin by attaining the state of ecstasy or enthusiasm in which they became united mystically with the saviour-god. In partaking of the sacraments they were promised immortality. Their religious experience was called rebirth or regeneration, in which state the adherent became a part of the god; he became a "new creature." It would seem that in the emphasis of the mysteries on the mystical union of the individual with the deity there is a striking resemblance to the Pauline experience called ἐν χριστῷ ("in Christ"). The mysteries were brotherhoods or guilds and fostered a somewhat democratic spirit among the members, although they, like the modern lodge or fraternity, were exclusive, for a man could not be saved unless he had been initiated into the cult and had participated in its sacraments. Like Christianity, they conceived of deity as immediate and immanent rather than transcendent. The deity suffered and died for man's salvation, and the devotee could participate mystically in the death and resurrection of the

god. Religious experience was attested by ecstatic and emotional demonstrations. The mysteries had their heaven and hell, miracles, baptism, Lord's Supper, virgin mother of God, visions, and immortality.

In the Egyptian mystery of Osiris, the worshiper gained salvation and immortality by communion with the god, who died and rose again. The death and resurrection of Osiris were celebrated annually. After his resurrection, Osiris was exalted as lord of the world and heavenly judge who would destroy the evildoers and reward the righteous ones with eternal life. In the celebration of the resurrection of Osiris, the initiate found the assurance of his own resurrection and immortality: "As truly as Osiris lives, shall he live; as truly as Osiris is not dead, shall he not die." Similar beliefs were held by the cult of Adonis in Cilicia and Syria and by Attis and Cybele in Asia Minor. Attis' death was mourned annually, after which his resurrection, which occurred on the third day, was celebrated. "But when night had fallen," writes Frazer, "the sorrow of the worshipers was turned to joy. For suddenly a light shone in the darkness: the tomb was opened; the god had risen from the dead; and as the priests touched the lips of the weeping mourners with balm, he softly whispered in their ears the glad tidings of salvation. On the morrow, the twenty-fifth day of March, the divine resurrection was celebrated with a wild outburst of glee, which at Rome, and probably elsewhere, took the form of a carnival. It was the festival of Joy." [14]

In the cult of Attis there is also the sacramental meal, in which the devotee had communion with deity. In the bath of bull's blood, called the *taurobolium*, the initiate was "born again." This rite probably was not practiced until the second century, but represents a pagan analogy.

[14] J. G. Frazer: *Adonis, Attis, Osiris*, p. 170.

A trench was dug over which was erected a platform of planks with perforations and gaps. Upon the platform the sacrificial bull was slaughtered, whose blood dripped through upon the initiate in the trench. He exposed his head and all his garments to be saturated with the blood; then he turned round and held up his neck that the blood might trickle upon his lips, ears, eyes, and nostrils; he moistened his tongue with the blood, which he then drank as a sacramental act. Greeted by the spectators, he came forth from this bloody baptism believing that he was purified from his sin and "born again for eternity." [15]

The Mithraic worship, antedating Christianity by two centuries, furnished striking resemblances to it. A love feast was observed in memory of the last meal Mithra had had with the other divine powers. This meal consisted of bread and a cup of wine by the consumption of which the worshipers were enabled to establish communion with the god. Mithra was preexistent and shared in the creation of the world, but in the course of time was born in the world. His birthplace was a cave, and shepherds came to worship him as a child. After his death, Mithra ascended to heaven where he became the exalted lord. He was to return to earth to judge the world and establish a kingdom for the blessed. Mithra was regarded as the mediator or Logos and was inferior to the supreme God.

The distinguishing feature of the Dionysiac mystery was the attainment of mystical union with deity. This was effected by a religious ecstasy or frenzy in which the initiate was completely possessed by the god. The one thus possessed was virtually identified with the god and shared in his immortal life. Concerning the nature of this *enthusiasmos*, E. Rhode writes: "But the ecstasies, the temporary *alienatio*

[15] Samuel Angus, *The Mystery Religions and Christianity* (London: Duckworth and Company, 1914), pp. 94–95.

mentis of the Dionysiac cult, were not thought of as a vain, purposeless wandering in a region of pure delusion, but as a hieromania, a sacred madness in which the soul, leaving the body, winged its way to union with the god. It is now with and in the god, in the condition of *enthusiasmos;* those who are possessed by this are ἔνθεοι; they live and have their being in the god." [16]

All the mysteries contained the bath of purification or baptism. We have it from Tertullian that in Isis and Mithra it was by baptism that members were initiated, and in the Eleusinian and Apollinarian rituals baptism resulted in remission of sins and regeneration. Originally the lustrations were regarded as *producing* the rebirth and as possessing magical efficacy, but later the symbolic character came to the fore. Recent discoveries have confirmed both the prevalence of baptisms in the mysteries and the conception that the act of baptism was an accompanying symbol of the spiritual experience.

The Oriental cults, just as Christianity, had a saviour who was preexistent, lived on earth, died a vicarious, redemptive death, was resurrected, was exalted in heaven as saviour and future judge, and was expected to return to establish a kingdom. Further, the mysteries were built around the ideas of regeneration, mystical fellowship with the deity, rites of purification, and immortality. The analogies between the mysteries and the Pauline construction of Christianity can hardly be denied. Nor can Paul's use of the cult language be ignored. But how much further can we go in our conclusions? The general Hellenistic background of mysticism would tend to produce similar expressions in all religions of that world. Certain authors state unequivocally that Christianity became a mystery religion with all the magic and sacramentarianism that the name implies. "Christianity was

[16] *Psyche: Seelenkult und Unsterblichkeitsglaube der Griechen* (Tübingen, Mohr 1921), p. 259.

always, at least in Europe, a mystery religion." [17] "Just as
Jewish Christians took with them the whole framework of
apocalyptic Messianism and set the figure of Jesus within it,
so the Greeks took with them the whole scheme of the mys-
teries with their sacraments, their purifications and 'fasts,'
their idea of a mystical brotherhood, their doctrine of salva-
tion and membership in a divine society, worshiping Christ
as the patronal deity of their mysteries." [18] "The Apostle
(Paul) regards the Lord's Supper as a feast of communion of
the same class as those practiced by the pagans." [19] "The
meals of love of the first church likewise received first from
Paul the significance of strictly sacramental acts of wor-
ship." [20] "Baptism is, for St. Paul and his readers, universally
and unquestioningly accepted as a 'mystery' or sacrament
which works *ex opere operato*." [21]

While there is much to be said in favor of the "Mystery
School," we cannot be entirely certain that Paul, in using the
terminology of the mysteries, regarded the sacraments as
conveying in and through themselves regeneration. That
baptism in Paul's mind was invested with an objective, phys-
ical, or magical efficacy after the manner of the Oriental re-
ligions is also a questionable assumption. He might very nat-
urally utilize the current pagan phraseology in referring to
Christian baptism and at the same time not identify the two
in their nature or true significance. True, he speaks of the
Lord's Supper as the means of participating in the death of
Christ and as a fellowship in the body and blood of Christ.
His description of mystical union with Christ is easily iden-

[17] Kirsopp Lake, *Earlier Epistles of St. Paul*, p. 215.
[18] W. R. Inge, *Outspoken Essays, First Series*, p. 227.
[19] P. Gardner, *The Religious Experience of St. Paul*, p. 122.
[20] O. Pfleiderer, *Hibbert Lectures*, 1885, p. 69.
[21] Lake, *op. cit.* Other advocates of the theory that early Christianity
either became a mystery religion or contained the same ideas as were
found in the cults are Bousset, Loisy, Gunkel, Heitmüller, Dietrich, Wober-
min, and Wrede.

tified with the *unio mystica* of the cults. Yet the question remains: Which was predominant in the mind of Paul—faith-mysticism or sacrament-mysticism?

In any case, we have to recognize that the Christian Church of the second and third centuries *was* sacramentarian, that the visible rites of the Church were central in the religion, and that the Church was more important than the Gospel. If this transformation did not start with Paul, it started within a few years after his death (ca. 64 C.E.). Paul may not have conceived the sacraments in an objective manner as magical and miraculous; but, having employed magical terms, he would in the next generation be open to sacramental interpretation. Between the death of Paul and the end of the century, Christianity made even closer contacts with paganism; the ethical interpretation of the Gospel gave way to the ritualistic; the symbolic usages declined in favor of the magical. These changes were evolved partially from germs found in the Pauline construction of Christianity.[22] While Paul may not be directly and solely responsible for the transition from a moral to a magical religion, his ambiguous pronouncements were at least suggestive; and while his major emphasis may have been ethical, many of his expressions were conducive to the shift toward sacramentarianism.

Concomitant with the growth toward sacerdotalism was the speculative transition relative to the person of Christ. The planks in the Christological platform of the early Church were the Enochian Son of Man, the Jewish idea of the atonement, the Parousia, Jewish-Greek wisdom literature, the Greek Kyrios, and the mysteries. Each of these phenomena

[22] Adolf Harnack recognizes the trend in the first century but clears Paul of any definite participation: "Paul was the first and almost the last theologian of the early Church in whom sacramental theology was really held in check by clear ideas and strictly spiritual considerations. After him all the floodgates were opened, and in poured the mysteries with their lore." —*Mission and Expansion of Christianity*, trans. by James Moffatt (New York: Putnam's Sons, 1904–05), Vol. I, p. 289.

had its natural chronological place in the doctrinal development of the early Church. One of Christianity's debts to late Judaism was the term "Son of Man," a conception the origin of which probably lay in Persia, but one which became most articulate in the Similitudes of Enoch and Daniel. The phrase was used by Jesus himself and by his biographers to designate his uniqueness as the Messiah. The influence of the conception in the New Testament is obvious in the Parousia, or second advent. Jesus at first was identified with the supernatural Son of Man of the Old Testament, and, according to Jewish apocalyptic, was expected to return speedily. Now this, as Albert Schweitzer insists, was well within the bounds of Jewish thought, but from the Enochian Son of Man to the Hellenistic Kyrios is but a short step; at any rate, it was inevitable in such a syncretistic age. Perhaps Jesus in the initial stages of this process was not deified; the next step, nevertheless, would go far toward the deification, and that step was the amalgamation of Jewish apocalyptic with the Greek Kyrios worship, or the idea of a saviour-god. With the bonds of Judaism broken, it would be easy and natural for Paul's converts in Ephesus and Corinth to worship Christ in the same way that they had been worshiping Serapis. Hence the Pauline designation of Jesus as Kyrios (Lord) and the idea of mystical union with him. In the last scene of this first-century drama, that of the Fourth Gospel, the concept of the Logos-incarnation was joined with the Kyrios conception, and Christian theology was thereby potentially complete. Christianity had passed from a local to a world religion.

The Hellenization of Christianity was followed in the third and fourth centuries by its Latinization, a process which not only departed still farther from its Jewish origins but which resulted in a more fanatical expression of the anti-Semitism that was already inherent in its early theology.

THE CRITICAL PERIOD

A Closed Canon

THE TRANSITION from primitive Christianity to the Early Catholic Church had its orgin in Paul's Gentile mission. It was completed in the Critical Period (100–400 C.E.) in which the eschatological premise of early Christianity (expectation of the near end of the world and return of Christ) disappeared and the Christian Church took permanent form. As the death of Jesus and its significance became the essential principle of the new faith, the emphasis of the early disciples on Jewish Law and ceremony decreased. The separation from Judaism was really never complete, the heritage being continued in new forms and symbols. As an organized church oriented to the Graeco-Roman culture, Christianity could and did spread rapidly. For the ethical emphasis of Hebrew prophecy it substituted the mystical experience and sacramental forms. The moral message of Jesus was lost sight of as the mystery of his person became the prime consideration. The activist character of the parent religion also receded in favor of ecstatic experience. The mark of the Christian now became "possession by the Holy Spirit." Christianity flourished in its new milieu chiefly because of its fanatical religious enthusiasm and otherworldliness.

The Critical Period was the period in which the Christian Church acquired its catholic or world consciousness. The emergence as an organized world religion resulted in no small degree from its conflict with heresy from within and the impact of persecution from without. It manifested itself in three forms: the canonization of Scripture, the formation of the episcopacy, and the adoption of the creeds. Such consolidation of canon, creed, and clerical authority always takes place at the crucial juncture in the history of any religion (the Ezra-Nehemiah Reform in the post-Exilic period of Judaism, 444 B.C.E., the Council of Jamnia establishing Rabbinic Judaism, 90 C.E., the Council of Trent, reaction to Protestantism and ratification of definitive Catholicism, 1544 C.E.). The resulting construction of the Catholic Church in the fourth century has been described as "the form in which the early church took out its naturalization papers in the Roman Empire." Indeed, it did not stop until it had replaced the Roman Empire.

The process by which the Christian literature of the first and second centuries achieved the status of sacred and authoritative canon was a long and devious one. During the quarter-century following the death of Jesus, nothing seems to have been written about his ministry or teachings, the chief reason for which was the common expectation of the Parousia or second appearance of Jesus. With the failure of this hope to materialize, there arose the obvious need for written records. The oral Logia or sayings of Jesus were written first in Aramaic and then Greek. Mark's Gospel appeared about 70 C.E., to be followed by those of Matthew and Luke. By the end of the century Paul's letters had acquired scriptural status along with "the words of the Lord."

In view of the fact that the Jewish Scripture was the only Bible for the Christians of the first century, it is logical to ask: What were the motives leading to the creation of a *New* Testament? The primary reason was the growing im-

portance of the words of Jesus. There was also from the earliest days a theological interest in the death and resurrection of Jesus as related to the plan of salvation. The original tradition of the Gospel was supplemented by the apostolic tradition to form two nuclei or criteria for later canonization: "the Lord and the Apostles," tradition and attestation. There were two basic reasons for making a new body of Scripture. One was the natural desire for a document that would distinguish the new faith from the Jewish religion and the current heresies. In the second century the Christian Church was thrown into confusion by the presence of various sects—Montanism, Docetism, Marcionism, and Gnosticism—and a clarification of the Christian beliefs was imperative, although this need was satisfied through the creeds formulated in the same period. A political factor also hastened the process of canonization: the recognition of Christianity as the official religion of the Roman Empire was possible only when there was unanimity in regard to the Scripture as the authoritative doctrine. The other basic reason for canonization was the need to distinguish between the spurious and the genuine, to separate orthodox books from the heterogeneous mass of literature, more or less Christian, that had accumulated in the first two centuries.

The process of canonization was determined by two factors; one was automatic and the other arbitrary. Certain books were being used in the services of worship along with the Old Testament. These books, which were read not because they were Scripture but only for edification, were automatically placed on a scriptural plane. The more deliberate procedure of canonization was the selection or citation by bishops and presbyters of certain accepted works as canonical. But the second process was simply a result of the first. Certain books won their place automatically by their own merit and apostolic character.

Among the books cited as being regularly used in the

period from 100 to 170 were the Four Gospels, Acts, the Letters of Paul, I Peter, and I John. The Apostolic Fathers in this period made no mention of Philemon, II Peter, II and III John, and Jude. Hebrews and Revelation were cited by some authorities. In the second period, 170 to 220, bishops of Lyons, Alexandria, Carthage, and Rome published lists of books which they regarded as canonical. These books were the Four Gospels, Acts, Letters of Paul, I Peter, and I John. The third period, 220–400, saw the acceptance of the above list plus those books which up to this time had been almost universally rejected, or at least were on the borderline— James, II Peter, II and III John, Jude, Hebrews, and Apocalypse of John. On the other hand, several books which had been regarded as New Testament canon by many authorities were generally rejected—Barnabas, Hermas, the Didaché, and I Clement. These books, included now in the extra-canonical list known as the Apostolic Fathers, are of great importance and in many respects are superior in ethical and spiritual content to the doubtful books which were finally accepted.[1] The authorities for this closing period were Origen, the great Christian teacher of Alexandria and Caesarea; Cyprian, the influential bishop of Carthage; Eusebius, the Christian historian of Caesarea; and Athanasius, bishop of Alexandria, who in 367 issued for the first time a canonical list which was the same as the present New Testament. That list was used by Jerome for his Latin translation and was ratified by the Council of Carthage in 397. This virtually settled the question, at least for the West. The Syriac Church did not accept the Apocalypse of John until the sixth century and it is still not used in the liturgy or lessons of the Greek Church. A survey of the history of the New Testament canonization, a brief outline of which has here been recorded,

[1] Barnabas, Hermas, and probably the Didaché were included in *Codex Sinaiticus* (fourth century) and I Clement in *Codex Alexandrinus* (fifth century).

shows the selection of the books to be a purely human and fallible one and should disabuse one's mind of any idea that the New Testament was an infallible revelation from God and divinely predetermined. On the contrary, there was a long period when there was no such thing as a New Testament and a still longer period when there was one, but no one knew which books should be included in it! But like all Scriptures, the requirements of unity and survival in a period of crisis demanded an aura of mystery and revealed truth.

The clergy by 300 was a distinct class and exercised complete authority over the laity. It was organized on a hierarchical basis of deacons, presbyters, and bishops. Until the fourth century the bishops of Rome, Constantinople, Alexandria, and Antioch were considered equal in power and authority. When the Council of Constantinople in 381 designated the bishops of the principal cities as "patriarchs," the Roman bishop refused the title and called himself "pope" and "visible head of the Church." [2] The power of the bishop and the primacy of the Church had received their initial impetus by 200. Irenaeus, bishop of Lyons (120–202), was the first champion of the Church and the episcopacy and has been called the builder of the Old Catholic Church in its emphasis on unity and authority. Cyprian, bishop of Carthage (200–258), was even more insistent on the authority of the Church and the clergy. He has been credited with the much-quoted phrase, "Outside the Church there is no salvation."

Enter the Theologian

The third phase of the Critical Period was the long and bitter struggle that resulted in the adoption of the definitive dogma—a development that accentuated the illiberal char-

[2] The Roman Catholic claim that Peter was in Rome and that the papacy goes back to him has no historical evidence.

acter of Christianity and intensified its separation from the parent religion. The early Followers of the Way accepted Jesus as their master and teacher. There was little or no theologizing about it. But as primitive Christianity evolved into the Catholic Church, its devotees, reflecting on the greatness of Jesus and trying to do justice to his character, began to see him as something more than a man among men, something more even than Messiah. The Jesus of history became the Christ of faith. As Christianity spread into the Graeco-Roman world, its leaders found that all the other cults had their Saviour-Gods, their divine Lords. It then became necessary to define the personality of Christ and a variety of Christological opinion rapidly manifested itself. One type of thought which became influential was Gnosticism which claimed that if Christ was divine and part of the Godhead, he could not have been human. His physical body was merely an appearance; his suffering was only apparent, not real.

Sharing with the Mysteries a prominent place in the spiritual ferment of the Graeco-Roman world, Gnosticism was a syncretistic movement, which emanated from many early religions and assumed various forms, but its chief characteristic was metaphysical dualism. The world of matter, the Gnostics maintained, was intrinsically evil, the creation of an evil deity. Deliverance from the world of evil could be accomplished only through some divine intervention, and was available only to those who possessed esoteric or supernaturally revealed knowledge. Our discussion of Gnosticism must be confined to its bearing on early Christology as a Christian heresy. Its impact on Christianity in the second century is seen in its Docetic view of Christ.[3] Many second-century intellectuals were not content with Jewish and apostolic Christianity. They tried to Orientalize the faith by denying the earthly life of Christ and saying that he had assumed for a time the semblance of a man in order to save humanity from

[3] Docetism—from δοκέω, "to seem."

sin, but then returned to heaven. The contradiction between the physical historical Jesus and the spiritual preexistent Christ was explained by the assertion that his earthly life was not real but only apparent. As Gnosticism reached its most influential position in the middle of the second century, it threatened to destroy the historicity of the Christian faith and was therefore combated as a heresy. The historical Jesus was being lost sight of in the fog of Docetic speculation and his teachings were being perverted by fantastic allegory— a situation that posed a threat to the unity of the growing Christian community. Furthermore, the Gnostics repudiated the Jewish Bible and attributed the creation of the world to an inferior deity, the Demiurge, rather than to the God of the Hebrew-Christian religion.

The Church overcame the Gnostic heresy, but the price of its victory was the formulation of an authoritarian system of government, the adoption of a closed canon of Scripture, and the formation of a rigid statement of doctrine.

The reaction to Gnosticism and other heresies took many Christological forms: Monarchianism—a reaction to the deification of Christ and the resulting tritheism and an attempt to restore the monotheistic principle; Modalism or Sabellianism—an early trinitarian formula designed to stress the equal threefold manifestation of God; Dynamic Monarchianism—a theory that held to Christ's humanity up to his baptism after which he was divine; Monophysitism—the belief that Christ had only one composite nature, a reaction to the human-divine theory of the Council of Chalcedon; Arianism—the belief that Christ the Son was subordinate to the Father, a prefigurement of anti-trinitarianism; Apollinarianism—the Christological doctrine of Apollinaris, bishop of Laodicea, which denied the complete humanity of Jesus on the grounds that it is impossible to combine ideal humanity and perfect deity in one personality and therefore claimed that the Logos took the place of the historic Jesus.

The Latin view of Cyprian and Tertullian was strictly trini-
tarian, identifying Christ with God as co-equal and co-eter-
nal. The Greek or Eastern Church was divided, the Alexan-
drian school holding to the deity of Christ as of the same
substance with the Father; and the Antiochian school sub-
ordinating Christ to the Father. The controversy became so
violent that Constantine was forced to convene the Nicene
Council (325). This was the first general or ecumenical coun-
cil of the Church and was made possible by the recognition
of Christianity as the official religion of the Empire by the
Edict of Milan (313). The Nicene debate was focused on the
nature of Christ's person. Alexander, bishop of Alexandria,
supported by Athanasius, later to become bishop of that city,
rested his case on the word *homoousia*, which he used to des-
ignate the consubstantiality of the Son with the Father, as
against *homoiousia*, which indicated similarity but not iden-
tity. His opponent, Arius, presbyter of Antioch, supported
by Eusebius of Nicomedia, represented the subordination
theory; namely, that the Son, however divine, was created,
and therefore could not be considered equal to the Father.
This was the only position he could take and remain clear on
the unity and self-contained existence of God.

The Alexander-Athanasian formula of *homoousia* won
the day and Arius and his followers were exiled. The so-
called Nicene Creed as used today was the one probably
adopted at the Council of Constantinople (381) but the
question has never been satisfactorily settled. The Nicene
formula emphasized the oneness of Father and Son: "We
believe in our Lord Jesus Christ, the Son of God . . . of the
very substance of the Father, God of God, Light of Light,
very God of very God, begotten, not made, of one substance
with the Father . . ." It pronounced anathemas upon all
those who did not accept its statements. The First Council
of Constantinople restated the position of Nicea, condemned
Apollinarianism and inserted the clause of the divinity of the

Holy Spirit.[4] The Apostles' Creed, the oldest Christian formula, can be traced to the second century and was used by the Latin Church of North Africa. The Creed of Chalcedon (451) was adopted for the purpose of settling the question of the person of Christ and in doing so, merely added to the already redundant statement of the Nicene Creed: "truly God and truly man . . . consubstantial with the Father according to the Godhead and consubstantial with us according to the Manhood; together before all ages of the Father according to the Godhead and in these latter days, for us and for our salvation; born of the Virgin Mary, the Mother of God; one and the same Christ, Son, Lord, Only-begotten; to be acknowledged in two natures, inconfusedly, unchangeably, indivisibly, inseparately, the distinction of nature being by no means taken away by the union but rather the property of each nature preserved and concurring in one Person and one Substance. . . ."

Constantine had brought together at Nicea some three hundred bishops and an army of lower clergy, most of whom were as ignorant of the issues as he was. All he wanted was to unify Christendom and wipe out dissent. The Arians were clearly outnumbered and the outcome was never in doubt. When Arius arose to speak, he was struck down by the angered clerics. Many rushed from the hall, covering their ears as they left. Constantine could see which way the wind was blowing and pushed for a verdict. It is interesting to reflect that if the Arians had been greater in number at Nicea in 325 the Christian Church today would be Unitarian. As it was, Arius was banished and the Church, under a pagan emperor, became regimented into a political power.

Although defeated at Nicea and almost annihilated by the followers of the fanatical Athanasius, Arianism continued

[4] Other councils were Ephesus (431), which condemned Nestorianism and approved the use of the term "Mother of God"; and Chalcedon (451), which declared the presence of two natures in the one person of Christ.

to gain ground in the East. Arius had been influenced in his thinking by his renowned teachers, Origen and Lucian of Antioch, both of whom opposed the tritheism of the Church, the Christian dogma of inherited guilt and human depravity, belief in miracles, and the literal interpretation of Scripture. Both tried to instill into Christian thought the Hellenic spirit of rationalism and recognized the necessity of finding a philosophy for Christianity that would meet the intellectual demands of the day.[5] Arius, while not advancing beyond the thinking of Origen, succeeded in giving greater dissemination to the more liberal monotheistic ideology and helped to lay the foundation for the later unitarian position. Arianism survived among certain barbarian tribes as well as Nestorianism and Pelagianism. Nestorius, a patriarch of Constantinople in the fifth century, took the stand that Mary should be called the "mother of Christ" inasmuch as Jesus the human being came from her womb. He also leaned toward the anti-trinitarian position of the Arians. Mary by this time had become in the minds of orthodox Christians a fertility goddess like Isis, Astarte, and Cybele. It was inevitable that Nestorius should be banished and he died in exile in Egypt. His teaching was formally condemned at the Council of Chalcedon, where Jesus was quoted as saying that "the Virgin Mary *was* the Mother of God." Nestorianism flourished first in Syria, then in Persia, and finally in Turkestan, India, and China. Another thorn in the flesh of the Church was the British monk Pelagius (360–420), whose advocacy of free will, individual freedom of thought, and rationalism aroused a violent controversy throughout Christendom. He is first encountered in Rome, denouncing public and private immorality and preaching an ethical religion, which by the fifth century was a novel idea. The clergy in Rome rationalized the excesses of immorality on the grounds of human

[5] For the semi-Unitarian teaching of Origen see my *Legacy of the Liberal Spirit* (Boston: Beacon Press, 1960), pp. 10–19.

weakness. Pelagius on his part was convinced that the doctrine of human depravity and original sin undermined the human will and insulted God. We are born, he argued, with no bias toward good or evil and there is no such thing as original sin, "sin being a thing of will and not of nature." If sin were natural and innate it would be chargeable to God, the Creator. The heresy of Pelagius lay in his assertion that the determining factor is the human *will* which takes the initiative. The orthodox position was that the initiative was taken by the *divine* will which offered grace to fallen man. Using as his motto the words "If I ought, I can," Pelagius maintained that man is able to live without sin, if he wills it, because God gave him this ability. In denying original sin and the fall of man, Pelagius came into conflict with Augustine, whose own experience had probably satisfied him that man is inherently sinful and can be saved only by reason of a special act of divine grace. Pelagius replied that men are not necessarily evil and that salvation or destiny depends on the free choice of the individual. Augustine found it necessary to write fifteen books in refutation of Pelagianism and called two councils which condemned the heresy.

A Theology of Fear

In this period of conflicting theological patterns the Latin theologians of the Western Church prevailed over the Greek or Eastern leaders and cast Christian thought permanently into a theology of fear and authoritarianism. The founders of Latin Christianity were Tertullian, Cyprian, and Augustine. Tertullian (150–225), presbyter of Carthage and trained for the law, approached everything from the legal point of view, which made for precise expression but also rigidity. As contrasted to Origen's conception of God as a purely spiritual non-corporeal Being, Tertullian's God was a personal power, a sovereign ruler over all men. Man's only at-

titude must be that of fear. Salvation or the blessed life does not come from the realization of one's best self as a child of God, the acceptance of God's love, and the achievement of the good life. It is only through obedience to God's law through fear of punishment. God's laws must be obeyed, not because they are right and reasonable but because he demands obedience. In this idea of sovereignty is found the source of the theology of Augustine and Calvin and of both the Catholic and Protestant faiths. According to Tertullian all the Christian's thoughts must be under the rule of faith revealed by the Church. Divine revelation, not reason, is the source of all truth. Sin therefore is not disintegration of personality or willful perversion but violation of divine law, the penalty for which is eternal damnation. Everyone is born in sin through the fall of Adam. Salvation is escape from hell. Only those who were baptized and followed the prescribed course of penitence could hope for release from punishment.

Cyprian (200–258), the pupil of Tertullian and bishop of Carthage, continued the teaching of his master and instituted the observance of the Lord's Supper as a magical rite and the practice of celibacy.

Augustine (354–430), bishop of Hippo in North Africa, was the transmitter of Latin theology from the formative period to the Middle Ages and became the father both of Roman Catholic and Calvinistic thought. His philosophy was thoroughly Neoplatonic. Man's citizenship is in the City of God and the present life is only a prelude to the heavenly life. But heaven is only for those whom God chooses. Some are predestined to salvation; others, forever damned. Augustine, like Tertullian, had difficulty reconciling the idea of free will with predestination and conceded inconsistently that man has enough freedom to be responsible for his own actions. The doctrines of Tertullian and Cyprian—original sin, the primacy of the Church, the sacraments as the means

of grace, sanctity of the office of the clergy rather than the man—were continued by Augustine.

With Leo the Great in the fifth century and Gregory the Great in the sixth century the teachings of Augustine were given the official stamp of approval; the doctrines of papal supremacy and the Petrine theory of apostolic succession were firmly established; and the typical cultic ideas of angelology, devilology, transubstantiation, penance, and purgatory were officially adopted; the Church was rigidly organized with an episcopal system of government and the doctrinal controversies were subsiding. The transition from primitive Christianity to the Catholic Church was fairly complete. In some respects the emergence of the Catholic Church might be considered an apostasy from the primitive Christian faith just as apostolic or Pauline Christianity, in its shift from the paramount importance of the Law to the significance of the death of Jesus, can be seen as a schism from Judaism and Jewish Christianity. The rise of the Catholic Church meant that sacrament was central in the Christian religion; that the institution took the place of the religion for which it stood; that belief was to be held because it had always been held; that religion was now grounded on authority and any inquiry into the basis of the faith was not permitted; that for the Jewish Law, from which early Christianity had broken, a more binding and less ethical-legal system was imposed on all; that for the form and ritual of the Temple a more superstitious formalization was substituted; and that in place of the here-and-now ethic of Judaism the Church embraced an unhealthy otherworldliness.

The rise of the Catholic Church was a triumph of Africanism over Hellenism. By the fifth century the Christian Church had decided which way it would go. It chose the formalism of the Latins rather than the rationalism of the Greeks. Christianity from the first had been exposed to the Greek culture in the Alexandrian school, just as Judaism had,

but it did not take full advantage of the contiguity. In rejecting Origen, Arius, and Pelagius and accepting Tertullian, Cyprian, and Augustine, Christianity turned its back on tolerance, culture, and rational thinking and embraced dogmatism, legalism, and sacramentalism. Christianity could have profited by the wisdom of the Greeks, but instead it cast its lot with the supernaturalism of the Latins. Had it appropriated some of the pagan culture of the Graeco-Roman world rather than its cultic rites, it would have been spared many of its modern ideological troubles. The rejection of Hellenism brought on a thousand years of darkness, broken only by the Renaissance. Greek paganism, being assimilative and eclectic, attempted to absorb the worthy elements in its environment; African Christianity, ascetic and exclusive, scorned the life of culture. Paganism had medicine and physicians; Christianity, believing in demon possession, resorted to incantation. Paganism, with its profound belief in man, would have benefited Christianity a thousand times more than African sacramentalism, with its distrust of man. When Christianity turned a deaf ear to Origen, who would have baptized religion with reason, and elected instead to follow Augustine, who plunged it into the dark night of superstition, it stooped to conquer.

Since Christianity catered to the masses, it had to submit itself to their mentality, a phenomenon recognized in a saying of Dean Inge: "A religion succeeds, not because it is true, but because it suits its worshipers." Latin Christianity with its infallible authority was welcome to the populace; it was an opiate; it enabled the people to conduct themselves with a "maximum of intellectual frugality." Religion paid the price of success when it coincided with the prevalent antipathy of the lower classes toward mental activity. It was easier to partake of the benefits of religion by participation in mysterious rites than by moral self-realization. It was easier to believe in the worthlessness of man than in his

divinity. Myths are more romantic than cold facts. Pageantry, miracle, and magic appeal to the senses and are therefore (to the untrained mind) *real*.

The most significant contribution of the Hebrew prophets and Jesus to civilization was the belief in the divine worth of human personality. Practically all of Jesus' principles and parables revolve about this axis. But when the religion of Jesus became the religion *about* Jesus, and Christianity had changed from a personal, moral experience to a theology, the divine in man was lost sight of. The victory of Carthage over Alexandria for the hand of Christianity meant a defeat for the *genus homo*. Enter Augustine with the official pronouncement that "God created man upright, but man having of his own free will become depraved and having been justly condemned, begat a posterity in the same state of depravation and condemnation." Christianity preferred Tertullian's delight in the torture of the damned to the universalistic faith of Pelagius. It adopted Cyprian's dictum that "without the church there is no salvation" rather than the heretical teaching of Antioch that all pre-Christian souls who loved God were redeemed. In the victory of Carthage over Alexandria the Christian Church chose to be sensational and morbid rather than rational and sane.

THE ANTI-SEMITISM OF THE FATHERS

Ideological Persecution

THE TOTAL EFFECT of the transformation of primitive Christianity into Catholicism was to create an ideology that automatically estranged all Jews and brought on a flood of anti-Judaic sentiment that has persisted to the present day; and the student of history cannot find much satisfaction in the current belated retraction of anti-Jewish statements by the Roman Catholic Church. The unbridled utterances of bigotry and hate coming from the venerated fathers of the early Church raise some doubt as to both their sanity and their saintliness. The unreasonableness of holding to the predetermined and necessitarian character of Christ's sacrificial death and at the same time blaming a whole people for that death did not deter these leaders of the Church from their denunciation of the Jews as a condemned race, hated by God. It is necessary at this point, however, to recall that from the days of Paul onward there had been a strong anti-Christian hostility among orthodox Jews, arising from their resentment of Christian claims. It is entirely possible that the Roman persecution of Christians in the first two centuries was aided and, in some instances, instigated by Jews. The Council of Jamnia had pronounced a malediction on

Christianity as an apostasy. Allowing for a natural Christian exaggeration of Jewish hatred, we must conclude that hostile acts were not confined to the Christians. History shows that in the Bar Kokba revolution (132–135) Christians who refused to repudiate Christ were put to death. The records of these times are not always trustworthy but it appears that in the martyrdom of Polycarp, Pionius, Philip of Heraclea, and other Christian leaders, the Jews, although not directly responsible, gave their enthusiastic approval. The rapidly growing Church became a real threat to Judaism and it is not surprising to find a fear and hatred of Christianity by the Jews.

From the end of the first century, with the refusal of the Jews to accept the growing Christological beliefs, references to Jews by the apologists took on an increasingly pejorative tone as Christian theology became more and more obsessed with Jewish guilt. The Jews were repeatedly accused of violence against Christians. Justin Martyr wrote to Trypho, "You hate us and whenever possible kill us. You cast out every Christian . . . and permit no Christian to live." [1] Tertullian called the Jews "the seed-plot of all calumnies against us," and the Synagogues, "fountains of persecution." [2] Many of the anti-Judaic utterances of the Fathers arose from the Jewish refusal to acknowledge the divine character of Jesus' person. Even the generally tolerant Origen (185–254) echoes the growing hostility:

> On account of their unbelief and other insults which they heaped upon Jesus, the Jews will not only suffer more than others in that judgment which is believed to impend over the world, but have even already endured such sufferings. For what nation is in exile from their own metropolis, and from the place sacred to the worship of their fathers, save the Jews alone? And these calamities they have suffered be-

[1] *Dialogue with Trypho,* Chaps. 110, 133.
[2] *Ad Nationes,* 1:14; *Scorpiace,* Ch. 10.

cause they were a most wicked nation, which, although guilty of many other sins, yet has been punished so severely for none as for those that were committed against our Jesus.[3]

The anti-Jewish polemic became an integral part of Christian apologetics, in fact, seemed to dominate patristic literature as theologians turned out volumes to prove that the Church was the true Israel, that the Christians were the people of God, that Judaism was only a prelude to or preparation for Christianity, and that the Law was abrogated with the appearance of Jesus, the Messiah, Lord and Saviour. The historic fact that Christianity broke away from Judaism was reversed with the claim of Christ's universality as the part of the Godhead in the rejection of which the Jews were regarded as apostates from the true religion. The prototype of this argument was, as we have suggested, Justin Martyr, whose obsession was that the Jews were receiving and would continue to receive God's punishment for having murdered "the Righteous One," a theme elaborated by Hippolytus (170–236). His *Expository Treatise Against the Jews* begins as follows:

> Now, then, incline thine ear to me, and hear my words, and give heed, thou Jew. Many a time does thou boast thyself, in that thou didst condemn Jesus of Nazareth to death, and didst give him vinegar and gall to drink; and thou dost vaunt thyself because of this. Come, therefore, and let us consider together whether perchance thou dost boast unrighteously, O, Israel, and whether that small portion of vinegar and gall has not brought down this fearful threatening upon thee and whether this is not the cause of thy present condition involved in these myriad troubles.[4]

He continues with the charge that the eyes of the Jews are

[3] "Against Celsus" in *The Ante-Nicene Fathers* edited by Alexander and James Donaldson (Grand Rapids, Michigan: W. B. Eerdmans Publishing Company, 1956), Vol. IV, p. 433.

[4] *Ibid.*, Vol. 5, p. 219.

darkened, unable to follow "the True Light," that they wander aimlessly, stumbling on the road, having forsaken "the One who is the Way."

The Treatises of Cyprian (200–258) make the same charges; i.e., that the Jews misunderstood the Scripture, that they were rejected by God, and that the New Testament and Christ invalidated the Law and the Priesthood. A more conciliatory attitude—reminiscent of Irenaeus and Origen—is found in a third-century Christian document called the *Didascalia* which refers to "our brothers who have gone astray" but which nevertheless condemns the Jews for the death of Christ.

The critical events of the fourth century, which we reviewed earlier in the fourth chapter, widened the chasm between the two religions. The Church, drunk with power as the favored religion of the Empire and obsessed with its newly formulated fanatical creeds, turned on the Synagogue with more ferocity than ever. The deteriorating civil and religious status of Jewry at this time seemingly served to corroborate the Christian theme of divine punishment. The bishops were not reluctant to use their influence in political circles to the detriment of European Jews. Through this influence a law was passed making it a capital offense for any Jew to make a convert. Equality before the law was no longer a fact. Jews were discriminated against in every way. They were excluded from various professions, denied all civil honors, and their autonomy of worship was menaced. The fourth and fifth century apologists carried on the theme of Jewish unbelief but enlarged the field of anti-Judaic propaganda to include a generalized castigation of Jews *as* Jews. The theological polemic by scholars who were otherwise friendly with Jews continued but the attack was now launched on diverse fronts to create an image of the Jews as a perverse people, murderers, Christ-killers, enemies of all goodness, rapacious criminals,

scheming proselyters, degenerates, and partners of Satan—
an image which was to prevail for over a millennium.

Hilary of Poitieres characterized the Jews as a people
who "had alway persisted in iniquity and out of its abun-
dance of evil gloried in wickedness." [5] Ambrose defended a
fellow bishop for burning a synagogue at Callinicum and
asked: "Who cares if a synagogue—home of insanity and un-
belief—is destroyed?" Eusebius of Caesarea (260–340), the
great historian of the early Church, surprisingly wrote a vol-
ume to prove the priority of the Church which, he said, ante-
dated the Synagogue! The Jews were simply an aberration
or temporary insertion in history, intended to be superseded
by Christianity. One of his purposes in writing his *Church
History* was, as he says in the introductory paragraph, "to
relate the misfortunes which have come upon the entire Jew-
ish people as a result of their plots against our Saviour." [6]
Gregory of Nyssa (331–396) is famous for the following in-
dictment:

> Slayers of the Lord, murderers of the prophets, adversaries
> of God, men who show contempt for the law, foes of grace,
> enemies of their fathers' faith, advocates of the Devil, brood
> of vipers, slanderers, scoffers, men whose minds are in dark-
> ness, leaven of the Pharisees, assembly of demons, sinners,
> wicked men, stoners, and haters of righteousness. [7]

Even Jerome (340–420), who was versed in Hebrew and
knew a number of rabbis, could not refrain from reviling the
Jews in general as "haters of men," "vipers," and "cursers of
Christians."

[5] Commentary on Psalm 51.

[6] Eusebius: *The Ecclesiastical History,* English trans. by Kirsopp Lake,
2 vols., Loeb Classical Library (Cambridge: Harvard University Press,
1949), Vol. I, p. 7.

[7] Quoted in Malcolm Hay: *Europe and the Jews* (Boston: Beacon
Press, 1961), p. 26 (from *Oratio in Christi resurrectionem*: XV, p. 553).

Homilies of Hate

The most virulent attack on Jews and Judaism by the Church Fathers is found in the homilies of the "silver-tongued" Chrysostom (344–407), the most famous preacher of the early Church. No more acrimonious invective has ever appeared in Christian history than we encounter in his Antioch sermons. His discourses were prompted by the fact that many Christians were meeting on friendly terms with Jews, were attending the Synagogue, and were visiting in Jewish homes. There seemed to be no contumely too venomous to heap upon these people. "The Jews," he said, "sacrifice their children to Satan . . . they are worse than wild beasts . . . the synagogue is a brothel, a den of scoundrels, the temple of demons devoted to idolatrous cults, a criminal assembly of Jews, a place of meeting for the assassins of Christ, a house of ill fame, a dwelling of iniquity, a gulf and abyss of perdition." In one sermon against the Synagogue he said: "The synagogue is a curse. Obstinate in her error, she refuses to see or hear; she has deliberately perverted her judgment; she has extinguished within herself the light of the Holy Spirit." Chrysostom's statement that future generations would only add to this vituperation was all too prophetic, for these homilies were used in seminaries and schools for centuries as model sermons, with the result that the message of hate was heard by congregations from one generation to another and Christians came to regard this anti-Semitism as an integral part of their religion. As Father Edward H. Flannery writes, "A generalized popular hatred of the Jew was now rapidly under way, and among the literati the tone of Chrysostom's diatribe found an echo in and out of the Church for centuries." [8]

From the Synagogue Chrysostom proceeded to the Jews

[8] Edward H. Flannery: *The Anguish of the Jews* (New York: Macmillan, 1965), p. 49.

themselves who, he said, "had fallen into a condition lower than the vilest animals. Debauchery and drunkenness had brought them to the level of the lusty goat and the pig. They know only one thing: to satisfy their stomachs, to get drunk, to kill and beat each other up like stage villains and coachmen." [9] Chrysostom was the first to use the term "deicide." The Jews, he said, have become a degenerate race, because of their "odious assassination of Christ for which crime there is no expiation possible, no indulgence, no pardon, and for which they will always be a people without a nation, enduring a servitude without end." One of Chrysostom's favorite themes was God's punishment of the Jews:

> But it was men, says the Jew, who brought these misfortunes upon us, not God. On the contrary, it was in fact God who brought them about. If you attribute them to men, reflect again that, even supposing men had dared, they would not have had the power to accomplish them, unless it had been God's will . . . Men would certainly not have made war unless God had permitted them . . . is it not obvious that it was because God hated you and rejected you once for all?

The excoriation of the Jews seems to have been the leitmotiv of Chrysostom's entire corpus of New Testament exegesis, the variations of the motif all reiterating the theme of perfidy and guilt. Chrysostom's malicious attitude was not only theological; it was personal. "I hate the Jews," he preached, "because they violate the Law. I hate the Synagogue because it has the Law and the Prophets. It is the duty of all Christians to hate the Jews." [10]

Subsequent extenuation of Chrysostom's revilement on various grounds has been offered but the fact remains that the total effect of his preaching was not only the perpetuation

[9] Quoted in Hay, *op. cit.*, p. 29.

[10] All the above quotations are from Chrysostom's eight "Homilies Against the Jews," in *Patrologia Graeca* (Paris: Garnier, 1857–1866), 48:843–942.

of a theological bias with its charge of deicide but the immediate translation of this fanatical ideology into restrictive legislation which ultimately led to the life of the ghetto.

Augustine's anti-Judaism seems to have been more or less incidental and theological rather than personal. Nevertheless its influence on the Christian Church of the Middle Ages cannot be ignored. In his *On the Creed: A Sermon to Catechumens* he says:

> The Jews hold him, the Jews insult him, the Jews bind him, crown him with thorns, dishonor him with spitting, scourge him, overwhelm him with revilings, hang him upon the tree, pierce him with a spear. . . . The Jews killed him.[11]

Augustine's explanation of the survival of the Jews through all their vicissitudes is that they were used by God as an instrument to bring about good. "But when the Jews killed Christ, though they knew it not, they prepared the Supper for us."[12] But in spite of their guilt they must be preached to and prayed for. In another sermon he characterized the Jews as "wilfully blind to Holy Scripture," "lacking in understanding," and "haters of truth."[13]

Anti-Semitism Legalized

The marriage of Church and State in the fourth century made it possible for the bishops to bring their influence to bear on imperial legislation, a power which they were quick to exercise. The result was that in the century following the Edict of Milan the theological charges against the Jews were implemented by the enaction of numerous laws with their penalties and restrictions. As Father Flannery puts it, the

[11] Philip Schaff (ed.): *Nicene and Post-Nicene Fathers of the Christian Church* (Grand Rapids: William B. Eerdmans Company, 1956), Vol. III, pp. 373–74.

[12] *Ibid.*, Vol. VI, p. 447.

[13] *Ibid.*, Vol. VI, pp. 397, 477, 496.

legislative measures taken by the Church and the Empire were in a sense "the translation into statutory form of what the patristic teaching seemed to call for." [14] The first discriminating law, enacted in the first quarter of the fourth century, made it a capital offense for any Jew to make a convert. Other legislation followed aimed at Judaizing on the one hand and, on the other, prohibition of Christian participation in Jewish rites.

The dilemma facing the imperial government was that of appeasing the Church and at the same time holding to its commitment of toleration and protection of Judaism. The latter position was a reflection of the Augustinian doctrine that the Jews, although outcasts, were to be permitted to survive because they were witnesses to the Messianic expectation and part of the divine plan. The survival of Judaism was due also to the peculiar Catholic dogma that the Jews, regardless of their guilt, must be protected since in due time they are destined to accept God's mercy and be restored to the true faith. This was the "mystery" of the Jewish refusal to accept Christ as the Messiah as taught by Paul, who said that ultimately "all Israel will be saved." [15] Thus the Church-State attitude was a dualistic one: the Jews were to be recognized as "witnesses of the Lord" and at the same time were considered outcasts, wandering across the face of the earth, bearing the divine curse. By this inexplicable mystery the suffering of the Jews became an integral part of the Christian faith. They were despised for their deicide and respected for their uniqueness as the "holy seed." The pattern of hostility that was being formed as a result of patristic writings revolved about the theological and historical role of the Jews rather than any contemporary misdeeds or socio-economic causes.

The imperial legislation enacted in the fourth and fifth

[14] Flannery: *op. cit.*, p. 52.
[15] Romans 11:25, 26, 30.

centuries was compiled in the Codex Theodosianus (438).[16] These laws aimed at the protection of both Jewish and Christian rights, but close examination shows that while they were intended to guarantee justice to all under Roman rule, they did reflect, as Father Flannery says, "the spirit and often the letter of the canons of the Church councils and in many instances implemented them in the capacity of a secular arm." [17] The Code confirmed the reality of the Church-State alliance in terms that were palpably ecclesiastical rather than juridical. Christianity is referred to as the "venerable religion" while Judaism is a "superstition" and a "wicked sect." [18] On the other hand, under the Theodosian laws Judaism retained its status as a *religio licita;* rabbis were given the same privileges as the Christian clergy; Jews were not to be harassed; their services of worship were not to be disturbed; and their synagogues were guaranteed against molestation. The Code contained similar laws in regard to the Christians. But the major portion of the Code favored the Church, which, considering the turn of events, is not surprising. Conversion to Judaism was prohibited as criminal but Christian proselyting was permitted. Although the Code ostensibly protected synagogues, it forbade erecting or repairing one without permission. Jews were excluded from administrative, legal, and military positions. Jewish courts were not recognized except in religious matters.

In this pre-medieval period acts of violence were numerous among both Christians and Jews. The reports of Socrates Sozomenus and other Church historians indicate numerous instances of Jews burning churches and killing Christians. In an uprising in Alexandria (414) the Jews, provoked by Cyril,

[16] Other Codes containing discriminatory laws against the Jews were The Laws of Constantine the Great (315), The Laws of Constantius (399), and The Laws of Justinian (531).

[17] Flannery: *op. cit.,* p. 56.

[18] Marcel Simon: *Verus Israel* (Paris: De Boccard, 1948), p. 267.

the patriarch, put many Christians to death. The Christians responded by murdering all the Jews they could find and finally liquidated the Jewish colony in that city. It was Cyril also who incited the mob that killed Hypatia, the Jewish Neoplatonic philosopher, in 415. In many cities throughout the Empire, Christians, encouraged by the clergy, destroyed synagogues and converted them into churches. The hostility of Christians toward Jews in the fifth century was instigated partly by ecclesiastical authorities and partly, but not so frequently, by the people. The common resentment of Jewish prosperity and success in business came later, although there is some mention of it in patristic literature of the times. The restrictive laws were already beginning to force Jews into the field of commerce. The laws prohibiting intermarriage, proselyting, and occupation of administrative posts can be seen as defense measures on the part of the Church, which was threatened by the strong attraction of Christians and pagans to Judaism, by the reputation of Jewish men as good husbands and good providers, and by the superior education of Jews and their rise to top positions in every country.

It should be said in this brief summary of the fourth and fifth centuries that, compared to later periods from 1096 on, persecution of Jews was not as serious as some historians have made it appear. There was no systematic program of anti-Jewish action. In an age of violence and hatred, both sides were guilty of sporadic outbreaks. In the first five centuries Christian leaders were preoccupied with the consolidation of their religion and the formation of their apologetics in the face of heresy and Roman persecution.

In spite of that, however, harassment and restrictions increased and thus we find, as we now enter the medieval period, that the dominant Christian Church had greatly reduced the influence of Jewry as a potential spiritual and cultural force in the Western world. In spite of the conciliatory attitude of some of the emperors, the Jews had become

a rightless minority, tolerated as a theological necessity but condemned as perfidious unbelievers. Discouraged in the losing fight to gain their proper status in Europe, they retreated to the spiritual world of the Talmud and shifted their cultural home to Babylonia.

PEACEFUL INTERLUDE

The Talmud—Key to Survival

GREAT ERAS in the history of Western civilization did not start and stop on a certain date. The interaction of men and movements which produces a juncture in history passes through several stages, and while a specific crucial event helps to determine a new direction, the change requires time to gain momentum. The periods, in fact, overlap, as the old gradually gives way to the new. It might be said that the Middle Ages started with the downfall of the Roman Empire in 476 and ended with the discovery of America in 1492. On the other hand, it can be argued with some justification that the Middle Ages did not start until the end of the sixth century, with the reign of Pope Gregory the Great, and ended not later than the thirteenth or early fourteenth century, when the Renaissance spirit was already making itself felt.

As far as the Jews are concerned, the Middle Ages must be divided into two distinct periods: the first was from the fifth to the eleventh century, "the tranquil centuries," climaxed by the Golden Age of Moorish Spain; the second was from the twelfth to the fifteenth century, the truly Dark Age of the Crusades and the Yellow Badge, inquisition and expulsion. To understand the continuity of world Jewry

through these two chaotic periods it is necessary to shift our attention momentarily to Palestine, Persia, and Babylonia, where the instrument for Jewish survival was forged. By the sixth century the accumulated oral tradition was put into written form and called the Talmud. This was the means for the unifying of all Jews into a cohesive spiritual and civic community and it determined the course of Jewish history for a thousand years. A résumé of the history of the Talmud is appropriate at this point, in view of the derogatory interpretation of it made by many contemporary critics both Jewish and Christian. Rather than being the saving medium of medieval Jewry it has been regarded as a deadening influence which froze Judaism into a legalistic form and inhibited its growth. This point of view has some truth in it, for it cannot be denied that much of the Talmud is made up of trivial, petty, incoherent, and unedifying material, totally irrelevant to any situation. Fortunately, later codifiers like Rashi, Alfasi, Maimonides, and Caro reinterpreted and amended the Talmud so as to apply its provisions to changing times and thus it became a useful and inspiring guide.

The seeds of the Talmud were sown in post-Exilic times with the Midrash or sermonic interpretation of the Torah. Even in this early period it was seen that the canonized Pentateuch would become outmoded if it were not constantly explained in terms of the current culture. The disastrous events of the first two centuries of the Christian era compelled Jewish scholars to codify the oral traditions that had formed over the centuries. The compilation of laws is ascribed successively to Rabbis Akiba, Judah Hanasi, Meir and finally the scholars known as Tannaim who edited the material into six departments of law. The Palestinian Mishnah was closed about 350 and the Babylonian in the fifth century. The Mishnah was an enlargement of the Law and became the official text for use in the Rabbinic schools and served as the basis for juridical decisions throughout the

Middle East. It was supplemented by the Gemara, a commentary clarifying and illustrating the provisions of the Mishnah, and its authors were called the *Amoraim* (lecturers). The Mishnah and the Gemara together form the Talmud, which received its final redaction by the *Saboraim*.[1] The Babylonian Talmud was superior to the Palestinian and was used throughout the Diaspora. It contains two types of material: the *Halacha* or laws and the *Haggada* or philosophical treatises dealing with ethical problems. Although the complete Talmud was closed at a specific time (Palestinian in the fifth and Babylonian in the sixth century) it was continually subjected to recodification by Jewish scholars. As a secondary canon supplementing the Bible and continually revised, it testified to the idea that the revelation of divine truth did not stop with the Torah. That in itself is a progressive idea and one which was not found in Christianity, which, after the official closing of the New Testament canon, excluded all additional literature as unworthy. No further truth from God was permitted and the Christian revelation became a finished book. The Jews were wise enough to avoid such a predicament. Their second or continuing Scripture made it possible for its interpreters to modify its legal precedents and to keep pace with the changing world. The Jews are commonly called the "People of the Book," meaning the Old Testament. This characterization does not do justice to the developmental nature of the Hebrew religion and the interpretative conception of Scripture. Although the Bible is primary in the Jewish faith, it is not the sole basis of authority. Many of the rites and institutions of historic Judaism, such as the Synagogue and the rabbis, are not mentioned in the Bible. By the same token many biblical teachings and statutes have no meaning for contemporary

[1] For a nontechnical but comprehensive description of the Talmud see Ben Zion Bokser: *Judaism and the Christian Predicament* (New York: Knopf, 1967), pp. 41–180.

Judaism. Every great literary document, such as the Constitution of the United States, for example, must be reinterpreted and amended to retain its vitality. Such has been the attitude of Jewish scholars regarding the Bible.

An objective evaluation of the Talmud is rarely found either among Jewish or Christian scholars. The most frequently expressed opinion is that the Talmud cast Judaism into a mold of legalistic sophistry which rendered it lifeless for over half a millennium. For most critics the absence of any creativity on the part of such a productive and cultured people as the Jews from the second to the tenth century is inexplicable unless it was due to the influence of the Talmud. "During that long period," writes James Parkes, "we know of no independent historical, poetical, religious, prophetic, or other work from an individual Jewish hand, except a few synagogal poems, written in Palestine after the Arab conquest."[2] A more farsighted view, however, recognizes in the Talmud universal elements as well as parochial, latent ideas and ideals with which later interpreters brought on a Renaissance in European Jewry.

The Talmud served to save and unify Judaism through the chaos of the early Middle Ages, but the price of unity is always uniformity. Consolidation of forces, crystallization of belief, and canonization of Scripture and tradition always mean conformity in thought and insulation from the outside world. This is what resulted from the Critical Period of early Christianity and this is what happened, but to a lesser degree, to Judaism in the same period. Like Christianity, it was protected from pagan influences but it became ingrown. Later, in the Golden Age of the Western Caliphate, the Talmud, in the hands of great scholars like Maimonides, was to broaden men's horizons to encompass economics, poetry, astronomy, jurisprudence, social theory, and medicine, in

[2] James Parkes: *The Foundations of Judaism and Christianity* (Chicago: Quadrangle Books, 1960), pp. 280–281.

which fields the Jews excelled all others. It must be added, however, that the impetus for this self-renewal and broader interpretation of the Talmud came largely from the contact of Jewish philosophers with Arabic learning in Moorish Spain.

Palestinian Judaism declined after the fourth century and the center of Jewish intellectual life moved to Babylonia, where Jews had lived since the Exile. By the fifth century Babylonian Jewry numbered about a million. The Jews lived under the rule of a prince called Exilarch whose office was hereditary and carried with it great wealth and power. The spiritual leaders were called Geonim, but they also exercised legislative powers. Under the peaceful Moslem rule in Babylonia, the Geonim became highly influential in matters of state and enjoyed a prestige rivaling that of the Exilarch. They were also the heads of Academies at Sura, Pumpaditha, Nehardea, and Mahoza, where Jewish learning was compiled to form the Talmud. The most famous of these schools, the Academy at Sura, was founded by Abba Arika (Rab) in the third century.

The Sassanian dynasty, which came into power in 226, had been unfavorable to the Jews and had inaugurated a century of persecution during which Jews were not permitted to bury their dead, synagogues were burned, and the Academy at Nehardea was destroyed. The persecution, however, did not destroy Jewish learning and the compilation of the Talmud continued underground.

In the seventh century the Persian and Byzantine empires fell at the hands of the Moslems and the faith of Islam took the ascendancy throughout the Middle East. Under Moslem rule the Babylonian and Arabian Jews enjoyed a semi-autonomous existence and were free of any severe persecution. The Talmud did not fare so well. Rebellion against its authority arose in several quarters, chief of which was that of the Karaites, a back-to-the-Bible movement founded

by Anan ben David in Baghdad in 750. This revolt against Rabbinism and the Talmud sought the restoration of the Torah as sole authority in Judaism. The name Karaites derives from their strict adherence to the written word of the Bible unaccompanied by the pedantic intricacies of interpretation. This was reminiscent of the teaching of the Sadducees, who by the second century had disappeared. As a purist movement Karaism no doubt appealed to many intelligent people to whom the Talmud represented confusion worse confounded, a cumbersome conglomeration of hairsplitting legislation that required a legal mind to fathom. Ironically, the freedom gained by the Karaites from the restrictions of Talmudic dietary and ritualistic practices was counterbalanced by the greater fidelity to the Mosaic code, which, when literally followed, produced many inconveniences in daily life. The movement spread rapidly to Egypt, Persia, Palestine, and Spain, reaching its greatest development in the twelfth century. Thereafter it lost its influence, having shown itself to be too static for a changing world. It did, however, have the beneficial effect of instigating new biblical studies. It further encouraged individual interpretation of the Scripture. This also was a mixed good, for, while the spirit of individual inquiry was an admirable idea, it prevented the movement from becoming unified. With each person acting as his own authority on the Bible, chaos resulted. Karaism gradually disintegrated, but not without demonstrating that Rabbinism, like all religious movements, could profit by occasional revolts.[3]

Of much greater importance for the history of the Jewish religion in general and biblical interpretation in particular was Gaon Saadia (892–942). He was born in Egypt and received a good education in Islamic and Talmudic literature. After extended periods in Palestine and Syria, he set-

[3] A remnant of the Karaite movement, numbering some ten or twelve thousand persons, exists today, chiefly in Russia.

tled in Babylonia, where he became head of the Academy at Sura. Under his direction this school became the most important center of learning in the Middle East.

As a reaction to Islamic theology, Saadia undertook a thoroughgoing clarification of Judaism in his chief work, *Beliefs and Opinions.* In this volume he attempted to interpret Judaism in the light of scientific and philosophical criteria. His harmonizing of reason and revelation set the pace for all later rationalistic philosophers from Gabirol to Maimonides.

Much of Saadia's biblical studies must be seen as a reaction to Karaism and were, along with the disunity of that movement, the chief reason for its dissolution. He showed that the Karaites, like most revolutionists, by developing a set of impractical traditions of their own, had brought about the very thing they set out to abolish. His anti-Karaite polemic succeeded in removing the threat of the movement and restored Talmudic supremacy in Judaism.

The Babylonian era of Jewish history deteriorated in the tenth century. The authority of both the exilarchate and the gaonate was greatly weakened and the Academy at Sura was closed. The center of Jewish intellectual life shifted to Spain, particularly to Cordova, where the tolerant and scholarly Abd al Rahman III was the caliph. But before following the fortunes of the Jews among the friendly Arabs of Andalusia, we must describe briefly the Jewish settlements in other parts of Europe.

European Jewry

During the second half of the first millennium in the Eastern and Western empires, relations between Christians and Jews were relatively good. Anti-Semitism in the East was of a juridical nature rather than theological, but it affected all areas of Jewish life. The Justinian Code of the sixth century was the chief irritant among Jews because it not only eliminated many of the provisions of the Theodo-

sian Code that were designed to protect the rights of Jews but added further restrictive measures. The new Code barred Jews from having Christian slaves, excluded them from all public meetings, and limited their rights at the courts. Justinian's administration included supervision of the Jewish cult as well as the Christian. The Passover could be celebrated only after the Christian Easter; the Bible was to be read in Latin or Greek rather than Hebrew; and reading of the Talmud was prohibited. Such laws were not only inimical to Jewish-Christian relations but they established precedents which later evoked more violent persecution. In many areas in the sixth century Judaism was made illegal, synagogues were burned, Jews were forcibly baptized and deprived of any legal recourse. The Jews retaliated by killing Christians and joining forces with the Persians in the invasion of Palestine. After taking Jerusalem from the Persians and the Jews, the Eastern Emperor Heraclius, in an attempt to unify the empire, ordered that all Jews be baptized. Forced baptism was also decreed by the Emperors Mauritius, Phocas, Leo the Isaurian, Basil I, and Romanos I.

Turning to the West, we find the Jews faring well under some rulers and badly under others. Theodoric the Great (454–526), Arian king of the Ostrogoths in Italy, held to a policy of toleration, insisting that religious heretics "would not be denied the benefit of justice," and opposing the forced conversion of Jews. In Ravenna and Rome, where synagogues were destroyed, he ordered the Catholic authorities to rebuild them and to punish those responsible.

Gregory the Great (540–604) was the first great pope. Although he was zealous in propagating Christianity, he adhered strictly to the protective laws of the Theodosian Code and established a policy of fair dealing with the Jews. He issued a decree forbidding forcible conversion and interference of bishops in the internal affairs of the Jews. They were

allowed to observe their holidays and all religious rites without molestation. On the other hand, although strictly opposed to Judaizing, he encouraged the conversion of Jews to Christianity, not by forced baptism but by gentle persuasion. In his sermons Gregory held to the traditional view of Jews as perverse unbelievers, but in his letters he took a more conciliatory position in enforcing the Roman Code. On the whole his policy toward the Jews in the period under consideration was benevolent and humanitarian.

Jews had settled in France in the last years of the Roman Empire and by the fifth century were found in great number in Marseilles, Orleans, Clermont, and Paris. During that period they were regarded as Roman citizens and lived peaceably with the Gauls. The Christian rulers of the Frankish kingdom in the sixth and seventh centuries revived the policy of forced conversion on penalty of expulsion from the country. Following the Councils of Orleans (533–541) intermarriage and conversion of Christians to Judaism were strictly forbidden and Jewish rights were greatly curtailed. The Frankish king Hilperic together with Bishop Gregory of Tours are well known for their aggressive attempts to convert Jews by force. Dagobert, the seventh-century Merovingian king, pursued an even more hostile policy toward Jews. He expelled from his kingdom all Jewish refugees from Visigoth Spain and all those who refused to be baptized. Relief came with the founding of the Carolingian Empire in France and Germany. Charlemagne (742–814), resisting pressure from the bishops, not only protected Jews throughout the empire but furthered their commercial interests and appointed them to diplomatic posts. This favorable attitude was continued by Charlemagne's son, Louis the Pious, under whom the Jews were given equal social and legal status with Christians, occupied high positions in government, and became leaders in commerce and medicine.

Louis instituted the office of *Magister Judaeorum* through which Jews were guaranteed civil rights and protection from any form of persecution.

On the death of Louis, the Carolingian Empire dissolved. Italy, France, and Germany became separate kingdoms and the Jews were subject to the individual whims of the various kings, depending on the power of the bishops. In Toulouse, we are told, a custom was established whereby "once a year, before the Easter holidays, the elder of the Jewish community had to appear before the count in his castle and submit to having his face smartly slapped as a reminder of the sufferings of the crucified Christ." [4] Each year during Passion Week the Catholic clergy of Béziers incited the mobs to avenge the death of Christ by beating the Jews and destroying their homes.

Agobard, archbishop of Lyons, was opposed to the emperor's amicable policy toward the Jews and urged the bishops to disregard his orders. During the protracted dispute he wrote several letters to Louis the Pious on the superstitions and the insolence of the Jews and demonstrated by the proof-text method their inferiority. He accused them of seducing women, and stealing Christian children and selling them into slavery. In a letter to the bishop of Narbonne rebuking him for associating with Jews, he concluded with a series of harsh invectives reminiscent of Chrysostom:

Knowing therefore, Venerable Father, that "as many as are of the works of the law are under a curse," and consigned, as to a garment, to a curse which entered into their very bowels, like water, and into their bones, like oil: cursed also in the cities, and cursed in the fields: cursed in their going in, and cursed in their going out: cursed the fruit of their wombs and of their lands and of their flocks; cursed their cellars, their granaries, their warehouses, their food, and the

[4] S. M. Dubnow: *An Outline of Jewish History* (New York: Max N. Maisel, 1925), Vol. III, p. 26.

very remnants of their food: and that none of them may escape that curse, so monstrous and so horrible, except through Him who for us is a curse.[5]

Charles the Bald, Louis' son, and Bishop Amulo, Agobard's successor, continued the conflict. Once again the emperor's pro-Jewish policy prevailed over the heated polemic of the bishop, who published documents charging the Jews with the usual blasphemies and proselyting. The Carolingian protection of Jews stopped with Charles' successors, the first of whom, Charles the Simple, gave all lands owned by Jews to the bishop of Narbonne. This turned the tide. Having lost their property rights in the countryside, the Jews in France were forced to migrate to the cities where they entered the field of business.

Arab-Jewish Renaissance

The Jews had lived in Spain as a part of the vast Diaspora in the Roman Empire. By the time the Visigoths swept across the peninsula there was a good-sized Jewish population, mostly in rural areas. The *Lex Romana Visigothorum* of 506 prohibited Jews from holding public office, intermarrying with Christians, and building new synagogues; but there was only a token enforcement of these restrictions.

Persecution of Spanish Jews became more systematic with the accession of King Sisebut, whose decree in 612 sought the prevention of proselyting by Jews and encouraged their conversion to Christianity. This was followed by another decree which compelled Jews to accept Christianity or leave the country. The Council of Toledo in 633 modified this rule by stating that conversion by force would not be tolerated but that all Jews who had converted should remain Christian in every sense of the word. The fact was that the converts were not trusted and later councils curtailed

[5] Quoted by Hay, *op. cit.*, p. 34, from "Monumenta Germaniae Historica, Epistolarum," V, pp. 200–201.

all their activities and exacted severe penalties for any vio-
lations. But it was impossible either to convert all the Jews
or to be sure that those who were converted were true to the
new faith. The nobles for the most part were Arian and pro-
Jewish, while the bishops, notably Isidore of Seville and
Julian of Toledo, were decidedly anti-Semitic.

King Ervig in 681 added more and harsher restrictive
laws. The Church Council of Toledo in 694 anticipated later
fanatical accusations in claiming that the Jews were at-
tempting to undermine the Church, seize political control,
and massacre all Catholics. This propaganda led to the ec-
clesiastical decree that all Jewish property be confiscated
and the Jews themselves be treated as slaves. The anti-Sem-
itism of seventh-century Visigothic Spain foreshadowed a
still darker age but it was held off for over two centuries, at
least in Spain, by the Arab rule.

The great cultural progress of the Abbasid rule in Bagh-
dad shifted to Cordova, which became the cradle of learning
in the West. Here Arab physiology, hygiene, and medicine
reached a highly advanced stage. Arab mathematicians in-
vented algebra and the decimal system; astronomers built
observatories and made extensive astronomical calculations;
scientists invented paper. Arab architects built magnificent
mosques, palaces, schools, and libraries in Cordova, the Gi-
ralda and Alcazar in Seville, and the incomparable Alham-
bra in Granada. It was in these three Andalusian cities that
the Moorish genius reached its peak, each serving in turn as
the artistic and intellectual capital of the West. Cordova be-
came the "Athens of the West." Its famous library boasted
400,000 volumes and its scholars were busy translating the
Greek classics into Arabic. To the Moors, beauty and truth
were equal. They joined the artistic and the scientific in per-
fect harmony. Religion was not the ascetic, fearful thing of
medieval Christianity. It was a joyous and positive expres-
sion of the soul. The unending symmetrical design of Arabic

characters in the mosques created the feeling of infinity and became the visible expression of the divine spirit. The Arabs recognized the equal importance of logic and insight, science and religion, Greek rationalism and Moslem monotheism. They rediscovered Hellenic philosophy, especially Aristotelianism.

Such was the broad tolerant atmosphere in which the Jewish scholars found themselves in Cordova, Seville, Granada, Elvira, and Toledo, where they had settled. The rabbis were influenced greatly by Arab learning and the impact once again precipitated the problem of the Talmud: how to reconcile the ancient laws with the new science. Clearly the answer to the dilemma was a rereading of the Torah and the Mishnah in a way that would be relevant to the times. At any rate, this was the solution of the rationalists. Revelation must be harmonized with reason, mysticism with empiricism, belief with knowledge. For Jewish orthodoxy, the Torah and the Talmud, representing the written and oral word of God, were equally inspired, infallible, and authoritative; but for the rationalist, the testimony of the Bible was ambiguous and at times contradictory. It could be quoted on either side of the questions of authority versus private inquiry, determinism versus freedom. The Bible, moreover, was inconsistent in its teachings on ethics, teleology, the nature of God, and God's relation to man. It appeared therefore to be incumbent upon the more progressive thinkers among the Jews to study philosophy and science in order to make a more intelligible interpretation, one that was consonant with reason and the facts of life and history.

Because of Islamic influence, the chief ingredient in Jewish thought was Aristotelianism, a system which gave to Judaism—at least to its leading thinkers—a more speculative turn. Biblical theology was purely ethical. There was no abstract analysis of the essence of created things, the nature of nature. Aristotle delved into the world of elements

that made up the universe, both the seen and the unseen, concepts as well as things. His genius was classification and that led to logic. He discussed the relation of change to motion, form to matter, mind to body. All the problems of God, man, and the universe comprised his province. The distinctive element in his moral philosophy was the concept of the "golden mean," nothing to excess, perspective in all things. This stream of thought brought to Judaism a new diversity and greater dimensions.

The dualism of Aristotle (spirit and matter) was supplemented by the monism of Plotinus as a further influence on medieval Jewish thinking. The Neoplatonic philosophy amounted almost to pantheism in relating everything to God, the world ground, and primal cause. It shared with Gnosticism the belief that God is unknowable, that matter is the origin of evil, and that the universe consists of emanations from God.

The importance of the Spanish Jews is that they arrived at a less particularistic and more universal conception of God. They saved Judaism for the nineteenth and twentieth centuries and went a long way toward making it consonant with secular learning and not contradictory to it. They were the transmitters of Hellenism to the West. They were discussing Plato and Aristotle, Epictetus and Plotinus, the nature of God and man, good and evil, freedom and authority, while Christian Europe, for the most part, was stagnating in intellectual barbarism.

Under Abd-al-Rahman III (912–961), the illustrious caliph of Cordova, Moorish Spain experienced a Renaissance which was to last two centuries, a period which was perhaps the happiest one in Jewish history. The congenial attitude of the Arab rulers, providing a stimulating environment and a complete absence of persecution, allowed the Jewish genius in medicine, philosophy, and poetry to flour-

ish unhindered in the most prosperous country in Europe. It was in this cultural setting that the Jews became the great intermediaries between the Arabic civilization and the Christian world and also made their own lasting contribution to Western civilization.

The ascendancy of Cordova as the center of Jewish learning was given a great impetus by the caliph's Jewish advisers, Hasdai ibn Shaprut and Moses ben Enoch. Hasdai was the court physician as well as the minister of foreign affairs. He founded the Academy at Cordova and Moses ben Enoch became its head. Hasdai's eminent position at court, one that corresponded somewhat to the Babylonian exilarch, enabled him to improve the condition of the Spanish Jews, who now became wealthy and influential. As head of the Academy in Cordova, Moses ben Enoch attracted students from all parts of Spain and North Africa.

Such was the political milieu in which the Jewish genius flourished in the eleventh and twelfth centuries. The flowering of Arab-Jewish learning was the link between the Golden Age of Greece and its rebirth in the Italian Renaissance. In an otherwise dark age these medieval Jewish thinkers led men to a more profound and comprehensive conception of their relation to God, other men, and the cosmos. They created the intellectual climate that prepared the way for Descartes, Bacon, and Spinoza. We can here only mention the names of the most prominent thinkers: Solomon ibn Gabirol (1021–1058), Halevi (1085–1140), Ibrihim ibn Daud (1090–1165), Abraham ben Ezra (1092–1167), and the greatest of them all, Moses ben Maimon (1135–1204). They were universal thinkers—poets, mathematicians, physicians, philosophers, astronomers, biblical critics, and Talmudic scholars. Maimonides' greatest achievement was to clarify the Hebrew religion for all time by a simplification of the complex Talmudic literature, to in-

corporate the Greek ideal of beauty and truth into Hebrew thought, and to reestablish Judaism on its prophetic, ethical foundation.

The halcyon days were not to last, however. In the eleventh century Andalusia broke up into several small principalities or republics which became subject to political tyranny or invasion. The fanatical Almohades of North Africa, rabidly opposed to the liberal culture of the ruling Almoravids, spread into Andalusia and in 1148 captured Cordova. They destroyed both synagogues and churches. Jews and Christians alike were given the choice of apostasy or death. Many Jews emigrated; others suffered martyrdom or adopted for the time a lip service to the Moslem religion; still others, while not accepting the Islamic faith, wore Moslem clothes and spoke Arabic in order to escape detection, but were really loyal to the Jewish religion. Maimonides himself followed this dual course of conduct. Islam and Judaism shared a strict monotheism and had many things in common. His scholarly associates, to whom he owed much, were Arabs. It did not strike Maimonides that it was a mark of infidelity to take the position of accommodation and outwardly follow some of the Moslem customs. His famous *Letter Concerning Apostasy* was a defense of the Anusim, who were guilty of "an ostensible conformity" to Islam but privately were faithful Jews.

The Almohades went on to conquer Seville and Granada and the pressure to "convert or leave" increased. Some Jews became Anusim; others fled to Egypt and North Africa. The happy days of the Almoravid rule were gone, but compared with what was to follow in the period we are now about to investigate, life in the Moslem world was quite tolerable. Generally the second half of the first millennium was a peaceful interlude. Anti-Judaism was, as we have said, juridical rather than personal and was aimed largely at proselyting. Jews, especially in Spain, held influ-

ential posts in civic and commercial life. Aside from the Almohavid extremism, the Jews under Moslem rule were not only tolerated but enjoyed full equality before the law.[6] In Morocco, Egypt, and Spain they knew that they would not be persecuted as Jews. They were free to move about and enjoyed the rights of a protected minority under the tolerant Moslem legal system. They looked forward to a promising future in the Western world.

[6] See Salo W. Baron: *A Social and Religious History of the Jews,* 2nd ed. (New York: Columbia University Press, 1964), Vol. III, pp. 120–122.

THE MEDIEVAL MIND

The Crusades

BY THE ELEVENTH CENTURY the Jewish communities of
France, Germany, and other European countries, benefiting
by the tolerant atmosphere of the Carolingian era, were
growing in number and influence. They were assured of
their existence as a protected minority with certain civil and
religious rights and were playing an important role in the
expanding nations of the West. One had every reason to
believe that they were on the way to obtaining the same
position and prestige as their coreligionists in Moslem Spain.
But their hopes were short-lived. European Jewry was sud-
denly engulfed in an upheaval of hate and bloodshed that
undermined all their achievements, shattered all sense of
security, and destroyed all possibility of negotiation with
church and state for peaceful coexistence.

In 1095 Pope Urban II convened a church council at
Clermont which declared holy war on Islam. The call met
quick response as Christians in France and Germany joined
forces to wrest the Holy Land from the Moslems. The march
started in 1096. The motley army consisted of knights whose
object was plunder, peasants who were offered freedom
from serfdom, devout common people who were guaranteed

remission of sins by enlisting in the spiritual pilgrimage, and riffraff of all kinds to whom the expedition was a glorious adventure. Failure of crops and economic chaos in France contributed to the recruiting of desperadoes who relished the prospect of plunder. The promise of expiation for sins and the conviction that the pilgrimage was God's will, were sufficient justification for the Crusaders to ignore what opposition to violence the bishops may have expressed. They were convinced that the time had come to wreak vengeance on the people who had taken the holy city. Weakness in the central government did not help matters, since law and order were largely in the hands of local authorities who were unable to control the mobs. The Crusades were encouraged by the papacy as a means of furthering its world domination, especially over the Eastern churches.

But although the purpose of the Crusaders was to wrest the Holy Land from Islam, they did not wait until they arrived in Jerusalem to give vent to their fanaticism. Prompted either by the supposed complicity of Jews with the Moslems in Spain or by a recrudescence of fourth- and fifth-century anti-Jewish feeling, the bloodthirsty soldiers of the Cross acted on the theory that hatred as well as charity begins at home. They shouted: "We have set out to avenge ourselves upon the Moslems, but here in our midst are the Jews who crucified our Saviour; let us be avenged on them first. Let the name of Israel be mentioned no more, or let the Jews become like us and embrace our faith." [1] The savage onslaught started in Worms, where the Crusaders burned the Jews' homes, stole their possessions, and destroyed the sacred scrolls in the synagogues. Many committed suicide rather than submit to the brutalities of the invaders or be baptized. A number of Jews took refuge in

[1] See S. M. Dubnow: *An Outline of Jewish History* (New York: Max N. Maisel, 1925), Vol. III, p. 75.

the palace of the bishop of Worms. He begged them to consent to baptism. Dubnow describes the incident:

> They asked to be given a little time to consider their decision while the crusaders stood outside ready to lead them either to church or to the place of execution. When the delay they asked for had expired, the bishop opened the door of the hall where the unfortunate people had hidden, and found them all lying in a pool of blood: they had made their decision. The infuriated crusaders mutilated the martyrs' corpses, then they slew many of the surviving Jews of Worms and forcibly baptized the rest.[2]

The Messianic martyr-complex was undoubtedly an influential factor in many cases of self-immolation as the alternative to forced baptism.

In Mayence, after a meeting in the synagogue in which they exhorted and comforted each other, fathers killed their children and husbands killed their wives in a ritualistic immolation, using sacrificial knives sharpened in accordance with Jewish law.[3] The synagogue leaders fell at their own hands in a scene vividly reminiscent of the last hours of Masada.

At Cologne the bishop had many Jews sent out of the city and gave them shelter in the surrounding villages, but they were discovered and put to death. The hordes marched on through Austria and Bohemia leaving behind the dead, the maimed, and the forcibly converted ones. Thousands of the Crusaders died en route to the Holy Land. After three years the army of Godfrey of Bouillon reached Jerusalem (1099). Of the 300,000 Franks who started out with Godfrey only 20,000 survived to enter the city. After a three week siege, the frenzied Christians, followers of the Prince of Peace, swept into Jerusalem and slaughtered all in sight.

[2] Dubnow: *op. cit.*, p. 76.

[3] See Salo W. Baron: *A Social and Religious History of the Jews*, 2nd ed. (New York: Columbia University Press, 1965), Vol. IV, p. 104.

The Jews, who had fled to their synagogues for sanctuary, were burned to death as they prayed. The Moslems were beheaded wherever they were found. "They cut down with the sword everyone whom they found in Jerusalem," wrote the Archbishop of Tyre, "the victors were spattered with blood from head to foot." According to Raymond of Agiles, an eyewitness, "the blood of the massacred reached to the very knees and bridles of the horses." The carnage continued until sundown when the gory conquerors proceeded to the Church of the Sepulchre "sobbing for excess of joy." They knelt in prayer and recited together: "This is the day which the Lord hath made. Let us rejoice and be glad in it."

The paucity of historical records makes it impossible to ascertain the number of Jews killed in the First Crusade. One sixteenth-century chronicler, Gedaliah ibn Yahya, estimated that at least 5000 German Jews were martyred. Nor is there any way of knowing how many died by their own hands or how many survived by reason of compulsory baptism. Many were closely guarded to prevent suicide, after which they were forcibly baptized. We do know that massacres occurred in England, France, Spain, Germany, Italy, Bohemia, and Hungary.

After the First Crusade, the emperors Henry IV of Germany and William II of England and Normandy permitted all Jews who had been baptized to return to their own faith and they were welcomed and encouraged to participate in all rituals. The emperors also placed the blame for the massacres on ecclesiastical authorities. It is true that some bishops had attempted to protect Jews but most of them found it inexpedient to do so. Bishop John, of Spires, Germany, a supporter of the emperor, rallied a military force, overcame the invaders, and had their leaders punished. He sent many Jews to castles where they were safe for the duration. Naturally he was accused of being in collusion with the Jews, but the historical evidence indicates

that he acted from his own convictions. The burghers in the various cities, having had some commercial contact with Jews, and not being too favorably disposed toward the bishops, found shelter for the victims.

The Jews in some instances could be expected to defend themselves to the best of their ability. In a town near Prague, for instance, 500 Jews along with 1000 soldiers from the duke's forces thoroughly defeated their assailants. In many cities the Jews were even prepared to pay tribute and supply food and equipment for the Crusaders. Some invading groups were mollified by this gesture and passed through with a minimum of violence, but it was only a temporary relief. Where cooperation with the Crusaders was of no avail and the hoped-for divine intervention failed to occur, the Jews recognized their plight as an opportunity to suffer martyrdom in fulfillment of God's will and "for the unity of his name."

Under Christian control the Jews remaining in Palestine surprisingly enough were fairly well treated and in some instances held responsible commercial posts. The tolerant attitude of the Christian rulers in the period of the First Crusade—in contrast to the Church—may have been due to the fact that the Jews were so few in number or to their usefulness in business and commerce.

After the First Crusade, Christian-Jewish relations in the West ostensibly were more amicable but there was much confiscation of property, exorbitant taxation and pressure on involuntary converts. Meanwhile the Kingdom of Jerusalem was again threatened by the forces of Islam. In 1146, under the leadership of the French king Louis VII and the German emperor Conrad III, the Second Crusade was launched. Bernard of Clairvaux urged the new Crusaders to proceed directly to the Holy Land, but there were other churchmen, such as the German priest Radulf, who revived the slogan of the First Crusade, which was to ex-

terminate the Jews at home before going to war with the Moslems. Bernard intervened often in the slaughter of Jews and continually admonished the German bishops to put an end to the atrocities, but the impression persists that his mediation in their behalf was prompted solely by his desire to convert them rather than from any moral conviction. He shared the common belief that the Jews were condemned to the condition of servitude and were fated to endure suffering as an evidence of the truth of the Christian gospel. There was a general feeling that for this reason a prosperous Jew was a contradiction in terms and could not be tolerated. Bernard's sermons reveal his belief that it was God's will that Jews reject the Christian teachings. Their blindness was "as marvellous as it was miserable." The Jews, he preached in one sermon, were "a degraded and perfidious people," cursed by God. A contemporary, Peter the Venerable of the Abbey of Cluny, held the same views, saying that "God does not wish to exterminate the Jews; they must be made to suffer fearful torments and be preserved for greater ignominy, for an existence more bitter than death." Also, like Bernard, he regarded the Jews as less than human, on a plane with animals.

The Second Crusade attracted a different following from its predecessor. Its leadership was drawn from the nobles and the recruits were professional soldiers rather than angry mobs and desperadoes. The result was that the Jewish population suffered much less and was in fact protected by political and ecclesiastical authorities, although this protection in many cases was paid for in bribes. In Nuremberg, Cologne, and other cities the Jews were given shelter in the castles and fortresses; but in Treves, Speir, Würzburg, Charlenton, and Ramerupt some deaths occurred. In practically every instance the victim had ventured outside the castle to which he had been sent. Bernard did all in his power to prevent violence to the Jews and accused Radulf of inciting

to murder and had him returned to his monastery. Here again his action in protecting Jews was based on the ancient theory that they were the witnesses to Christian redemption through the Cross and ultimately would be saved.

In 1187 Saladin, the Egyptian Sultan, captured Jerusalem which had been held by the Christians for almost one hundred years. He was not called "the Magnificent" without reason, for when he took the city no such butchery occurred as was the case in the Christian invasion. The Christians were given their freedom and were permitted to leave the city unmolested. Priests were allowed to remain and offer masses in Jerusalem, Nazareth, and Bethlehem. He later opened the city to the Jews, gave them complete autonomy, and permitted them to rebuild their synagogues and schools. As Sultan of Egypt, Saladin respected the sincerity of all people who were of other faiths. Many incidents are related of his generous attitude toward the Jews and his defense of individuals who had been mistreated. In the five years that followed the recapture of Jerusalem the armies of Richard the Lionhearted and Saladin met face to face in various places in Palestine. On one occasion, Richard, with only 2000 men, had withstood the attack of 7000 Turkish cavalry. Saladin, from the rear, had watched Richard's counterattack, in the course of which the king's horse was killed under him and he lay helpless on the ground. Saladin promptly sent his groom with two horses and the king was rescued. Later, upon leaving Palestine, Richard sent a message to the Sultan that when the truce was over he would return to conquer Jerusalem. Saladin replied that he would try to hold the city, but if God willed otherwise, Richard was the one man most worthy to take it. The action of both leaders is one of the few bright spots in that prolonged conflict.

The Third Crusade (1189–1192), becoming more of a political struggle rather than religious, held less danger to

European Jews. Its leaders were Frederick I of Germany, Philip Augustus of France, and Richard the Lionhearted of England. Anti-Jewish riots occurred in England, where Jews had become prominent in finance and industry and enjoyed royal patronage with the right to travel and trade wherever they wished. Many wealthy Jews who lived in large stone mansions aroused the envy of Christians, with the result that all Jews came to be regarded as rich. This misconception, coupled with the fanaticism generated by the Crusades, naturally produced a situation conducive to popular outbreaks of violence. When Richard was crowned King, a Jewish delegation came to the coronation in London with gifts. The archbishop prevailed upon the king to refuse them admission either to the church or the palace where the banquet was held. The delegates insisted upon entering, whereupon they were forcibly ejected. This touched off a riot which spread through the city. Jewish homes were burned and pillaged and some thirty Jews were slain. The background of the London massacre seems to have been secular rather than religious, for there was already a widespread resentment of Jewish success in usury.

More devastating were the massacres at York, Norwich, Lynn, and St. Edmunds where, in the absence of King Richard, Jews were attacked by peasants who were being recruited for the Crusade. Elsewhere the Jews were sheltered in castles. At York the defenders held out for six days, after which many took their own lives. The assailants, rushing into the castle, killed all those who had survived. During Richard's absence the condition of English Jews grew progressively worse. When the king was informed of the York incident he ordered an investigation, but by that time most of those responsible for the outbreak had fled.

The few existing records of the period conflict, but it seems clear that on the whole conditions improved in France and Germany during the Third Crusade although there

were sporadic flare-ups here and there. Largely because of the influence of Frederick Barbarossa, the German Jews were given protection and new laws were enforced providing for the punishment of offenders. In the East the Jews were not seriously affected. Perhaps the hostility spawned by the Crusades exacted a worse toll among Jews after the Crusades than during them. The preaching that justified the murder of the infidel as an act of merit could only fan the flame of fanaticism and superstition among the masses for a long time to come. In the centuries that followed the conviction prevailed that all Jews were obsessed with a diabolical hatred which found expression in the most fantastic ways.

Mass murder and the blessing of the Church on war were the heritage of the Crusades. Sanctified by religious zeal, acts of violence and killing of Jews became the accepted thing, the prevalence of which gave them a pious exaltation rather than a mark of infamy, with the perpetrators held in high esteem. The Crusades left in their wake a mutual hatred and suspicion in which Jew and Christian saw the other as a bitter enemy to be avenged. On the other hand, the martyrdom of the Jews in the face of the Crusading spirit was just another factor in the survival of European Jewry.

Ritual Murder

Typical of the ever-increasing belief among the Christian masses that Jews in their hatred were committed to do violence to Christians was the popular myth of ritual murder and "blood accusation." It required only a few rumors to convince the gullible minds of medieval peasants that the murder of Christians was an integral part of Jewish rites. The charge that the Jewish ritual required Christian blood to be used annually in the Passover was first made in Norwich, England, in 1144. The indictment read that "the

Jews of Norwich bought a Christian child before Easter and tortured him with all the tortures wherewith our Lord was tortured, and on Good Friday hanged him on a cross in hatred of our Lord and afterwards buried him." This accusation seems to have sprung from the testimony of a Jewish convert, Theobald, who reported that "the Jews, without the shedding of human blood could neither obtain their freedom nor ever return to their fatherland" and therefore observed the custom of sacrificing a Christian, preferably a child, every year to ridicule the death of Christ. The story connecting the Jews with the death of the boy, whose name was William, was circulated by Thomas of Monmouth. It soon gained acceptance among the clergy and a cult developed with William as its object of veneration. Miracles were said to occur at his shrine, which attracted many pilgrims and, incidentally, considerable revenue for the church. The incident and those that followed were destined to affect subsequent Jewish history, for Philip Augustus, later in the century, expelled the Jews from France "because of their custom of kidnapping and crucifying Christian children."

In 1168 a child was found dead and mutilated in Gloucester. A local Jewish family, observing the feast of circumcision at the time, was blamed for the death of the boy, who was buried in the Church of St. Peter near the altar of Edward the Confessor. Here also for many years miracles were reported to have happened. In the same decade rumors of ritual murder circulated in Bury St. Edmunds, Bristol, and Winchester. Similar stories spread to the continent, where so many cases were recorded that Emperor Frederick II issued a bull prohibiting the accusation. At the same time, Pope Innocent IV published a decree absolving Jews of the charge. The document stated that the Jews were "falsely accused that in the same solemnity (Passover), they receive Communion with the heart of a murdered child. This, it is believed, is required by their Law, although it is

clearly contrary to it. No matter where a dead body is dis-
covered, their persecutors wickedly cast it against them." [4]
Other popes down through the fifteenth century exonerated
Jews of the charge, but it persisted. Malcolm Hay calls at-
tention to the fact that although the popes repeatedly de-
nounced the anti-Semitic conduct of their people, "they
did not renounce the doctrine which made it excusable in
the eyes of the criminals concerned—the doctrine that Jews
were outcasts, slaves who were permitted to live only on
sufferance." [5]

One of the more prominent incidents took place in
Blois, France, in May, 1171. A servant reported that he had
seen a Jew drowning a child in the Loire River. The veracity
of the accuser was ascertained through the "water test" by
which he was submerged in a tank of holy water. If he
floated and survived the ordeal, he was judged to be telling
the truth. On this ridiculous evidence the accused was found
guilty and the Jews of the town—some forty in number—
were burned to death. No evidence of the crime was ever
produced, but the story spread throughout Europe as proof
that the Jews celebrated their Passover rites by crucifying
a child.

This libelous blood accusation, starting thus in the
twelfth century, continued into the nineteenth. It was kept
alive in Hungary by the story of a girl named Esther Soly-
mossi who disappeared April 1, 1882. Giza von Onody, the
parliamentary representative of the town of Tisza Eszlar,
where the girl had lived, declared that Esther had been
murdered by the Jews for ritualistic purposes. The head of
the synagogue was arrested and his two children were brain-
washed into testifying to their father's guilt. The trial pro-

[4] See Solomon Grayzel: *The Church and Jews in the Thirteenth Cen-
tury* (Philadelphia: Dropsie College, 1933), pp. 269–271.

[5] Malcolm Hay: *Europe and the Jews* (Boston: Beacon Press, 1960),
p. 120.

duced no evidence that the girl had been murdered. Later, a girl's body was found in a river and the case was reopened. Medical examination showed that the girl found was much older than Esther and her body had not been touched. The trial proceeded notwithstanding and it was several months before the case was dropped with the withdrawal of the prosecutor. Despite the obvious absurdity of the case there were plenty of prominent persons who perpetuated the myth of ritual murder and anti-Semitism in general.

The blood accusation was an inheritance of the Crusades and it was readily believed by fanatical people who saw it as a reprisal for their own anti-Semitic actions. To them it seemed entirely plausible that Jews, the allies of Satan, would resort to such fantastic measures to express their hatred. Today, the charge of ritual murder can only be seen as one of the most infamous forms of persecution in history. The widespread charge of kidnaping children, torturing them, and then killing them and using their blood for religious rites became one of the chief instruments for the instigation of atrocities and for the propagation of hate. In spite of the denial of the Papacy that there was any truth in the legend of ritual murder of Christian children, the atrocity stories continued. In the eighteenth century the Jewish communities of Europe requested Cardinal Ganganelli to conduct an investigation by the Vatican into the origin and validity of the accusation. The results of the inquiry, published in 1759, indicated that at no time in the history of Europe had there been any evidence that the story was anything more than a myth.[6]

Hated Moneylender

By 1200 the Jews had not only moved from the East to

[6] See Cecil Roth, ed.: *The Ritual Murder Libel and the Jew*: the report by Cardinal Lorenzo Ganganelli (Pope Clement XIV), London: The Woburn Press, 1935.

the West, but had also begun the movement from farm to city and were rapidly becoming a predominantly mercantile population. The Crusades opened up trade routes to the Orient and borrowing money became a necessary part of the expanding economy. Being barred from most occupations, including foreign trade, Jews were almost compelled to enter the field of banking and usury. Another factor in this transformation of the economic life of the Jews was the Christian and Moslem prohibition of moneylending, added to which was the ever-present danger of living in the countryside rather than the city. In Spain and Moslem countries, however, Jews remained prominent in the medical and scientific world.

The Talmud and Old Testament forbade usury except with strangers and foreigners (Deut. 23:21). This qualification was sufficient to justify the lucrative business of moneylending and the practice soon lost whatever stigma had been attached to it. The numerous legal restrictions involved were easily bypassed, as, for example, Jewish debtors borrowing money in the name of their Christian servants. Both Christians and Jews, rich and poor, sought the services of Jewish moneylenders. What led to the excessive interest rates was the pressure placed upon Jewish usurers by the nobility. On the theory of Jewish serfdom the kings and lords confiscated their property, expropriated their fortunes, and taxed them into bankruptcy. A vicious circle resulted. Jewish bankers charged higher and higher interest and the more money they acquired the more were the bishops and kings able to profit in the end. This tendency in the twelfth century to charge exorbitant rates, especially from the poor, accounts for the later characterization of Jews as hated moneylenders. It was not so much the excessive interest rate itself that was resented, but the fact that it was being exacted by "unbelievers." The Jewish usurer was forced to charge inordinate rates in order to stay alive, and in the end the king confis-

cated his money and property and the common people branded him as a public enemy and expelled him from the country.

It must be added that the Jews had no monopoly on usury in the Middle Ages—a myth which has been refuted by many historians.[7] The credit system of the Italian Christians exceeded the Jewish by far not only in Italy but in England, where, as agents of the Pope, they combined usury with trade and drove the Jews completely out of business. The result was that the Jews became impoverished and, since their financial services were no longer needed, they were denied all protection but were not allowed to leave the country. The idea that Jews were peculiarly talented in moneylending and were, moreover, more grasping in their practice than other people was fostered in England unfortunately by some of its greatest literary figures. There were undoubtedly many instances of unconscionably high rates of interest charged, but there is no evidence that they took money from people by force as Christians often did.

The Black Death

In 1347 a terrible plague from Asia descended upon Europe and raged for three years. The Black Death, as it was called, took some twenty-five million lives—over a fourth of the population of the continent. With people dropping dead by the thousands, it was next to impossible to bury them. The crazed populace, mad with fear and desperation, were ready to believe anything regarding the cause of the terror. The extent to which the medieval mind could go in its devilish imagination and blind credulity is to be seen in

[7] Notably Thomas Wilson, Thomas Witherby, and H. Pirenne. See also Israel Abrahams: *Jewish Life in the Middle Ages*, 2nd ed. (New York: Meridian Books, 1958), p. 243; Salo W. Baron: *A Social and Religious History of the Jews*, 2nd ed., Vol. 4 (New York: Columbia University Press, 1965), p. 207; Abram Leon Sachar: *A History of the Jews*, 5th ed. (New York: Knopf, 1965), p. 257.

what occurred at this time. A monstrous rumor swept over the land that the plague was caused by the Jews, who had poisoned the wells and the food of every community. It was reported that the poison—a mixture of spiders, lizards, frogs, the hearts of Christians, and the dough of the sacred host— was concocted by Jewish sorcerers in Toledo, from which city it was carried by messengers throughout Europe. The rumor quickly spread from France to every country, and with it the inevitable massacre of Jewish people. The efforts of pope, kings, city rulers, and nobles to curb the hysteria were fruitless, as Jews were systematically burned alive and hanged. Pope Clement VI issued a bull condemning the action of the people and reminding them that the Jews also were victims of the plague and that the Black Death was just as virulent in localities where Jews had never lived. But there was no place for reason here and his warning went unheeded. Everywhere Jews were captured, put on "trial," tortured until confessions were forced from them, and then were consigned to the flames. City authorities tried to intervene but were ignored by the frenzied mob. The Jews of Strassburg—eighteen hundred in number—were taken to a cemetery, locked up in a wooden building and burned alive. A similar massacre took place in Cologne. In Worms and other cities the Jews, anticipating the same fate, set fire to their own houses and died in the flames. Six thousand perished in Mayence and three thousand in Erfurt. Some fled Germany and went to Poland; others died in defending themselves or by self-immolation; and still others in desperation survived by changing their religion. In some areas of Germany and France groups of Flagellants moved among the people provoking violence against the Jews as an act of expiation.[8] The massacres were not without their economic advantages to the ecclesiastical and political rulers. Confis-

[8] Flagellants—members of a medieval religious sect who scourged or whipped themselves as a means of religious discipline.

cation of properties and financial assets usually followed the death of Jews.

After almost three years the orgy of bloodshed ceased, and those Jews who had survived were allowed to return to their homes. But their return, although they were guaranteed protection, was none too reassuring. It was, in fact, a hollow guarantee, for they were invited to return in order "to be taxed and held under civil control by their guardians." Louis IV, in 1343, thus addressed the Jews of Nuremberg: "You belong to us, body and belongings, and we can dispose of them and do with you as we please." [9] They were herded together in a reserved section of the city and were restricted in their occupations and cultural activities. Even their business of usury was greatly curtailed. In many cities in the latter part of the fourteenth century debts to Jews were remitted and their credits canceled. Reduced to destitution, the Jews were regarded as parasites and were expelled from many communities. In Prague in 1380 the synagogue was destroyed and 3000 were killed.

The suffering and humiliation of European Jews in the latter part of the fourteenth century took its toll. Their intellectual life came to a standstill, and Rabbinical and Talmudic learning degenerated into a narrow uncreative repetition of older writings. Home and synagogue were now their only refuge. The Jewish community, shoved into a corner, became of necessity ingrown and clannish. But the woes of this period could not destroy the Jewish hope in the future and the will to survive. That innate faith would be needed in the years ahead, years which held for them the horrors of insecurity, inquisitorial torture, and expulsion.

[9] *Monumenta Zollerana*, Vol. 4, p. 10.

THE INQUISITION

Papal Decrees and Councils

IN 1959 the liberal Pope John XXIII dropped the word "perfidious" from the liturgical prayer *Oremus et pro perfidis Judaeis* ("Let us also pray for the perfidious Jews")—a prayer that had been used on Good Friday for many centuries. When the term *perfidis* was originally embodied in the liturgy it meant "unbelieving," "unfaithful," but in modern usage the word "perfidious" carries the ignominious connotation of treachery and it is with this offensive meaning that the Church has used it for the last two centuries or more. From the Patristic period on, Christians were taught to pray for the Jews as a "witness-people," a living testimony to Christian truth. This view was held alongside of the more influential one that the Jews should be persecuted in punishment for their rejection of Christian truth and for their crucifixion of Christ. As time went on, the basis for anti-Semitism widened to a hatred for Jews as a treacherous and evil race, as the enemies of Christians—poisoners, murderers, and moneylenders. This generalized anti-Semitism reached its climax, as we have seen, in the massacres of the Black Death (fourteenth century). From that time on, the Jews were tolerated in France and Germany only for pur-

poses of taxation and confiscation, but when Jewish bankers became paupers, the security of all was threatened. Their residence was held on uncertain terms and always limited in time. At the expiration of the time limit they were often expelled from the community. The expulsions were neither general nor permanent and pertained only to individual cities. But the total effect was that from the fourteenth century onward the Jews were in reality a wandering people without a home. It might truly be said that the second half of the fourteenth century marked the beginning of definitive or classic anti-Semitism. Generally speaking, hatred of Jews in this period was worse in Germany than any other country. By 1500 what Jews were left in Europe were confined to the ghetto.

It has been said that the medieval Popes were the Jews' best friends. This was true to a certain extent, at least from the standpoint of decrees and edicts. As early as 1120 Pope Calixtus II issued the *Constitutio pro Judaeis,* which purported to place the Jews under the protection of the Church. During the Crusades, when the Jews appealed to Pope Innocent III, he reissued the *Constitutio* as a renewed recognition of the right of a Jew to live. The fine print of the document, however, defined Jewish rights only within a state of degradation and suffering, which was the original position of the early Church. The protection of the Jews by the Papacy through this decree could hardly be effective when the document itself approved a certain amount of persecution, but "not to be excessive" (*non sunt a fidelibus graviter apprimendi*)! The *Constitutio* of Innocent was nevertheless an attempt, however feeble, to guarantee to the Jews freedom from forced baptism, robbery, personal injury, desecration of their cemeteries, and molestation of their festivals. These freedoms applied only to those Jews "who have not plotted against the Christian faith." Since the Crusaders and Christians in general assumed that all Jews were conspiring

against Christians, there was little guarantee of protection after all. The five freedoms carried little weight with local ecclesiastical authorities, and forced baptism, extortion, and personal violence continued unabated.

As for Innocent's personal attitude, he wrote continually to kings and bishops, warning them against treating Jews kindly, stating that the Jews were permitted to live "only by the grace of Christian piety," prohibiting Jewish employment of Christian female servants, forbidding Christians "to engage in any commercial relations with Jews," accusing Jews of unmentionable secret crimes, and charging them with murder and blasphemy. Obviously the Pope was determined to destroy, or at least greatly weaken, Judaism, which in his mind was a hindrance to the unity of European Christianity. He brought to bear all possible pressure by urging commercial boycott, social ostracism, exclusion from all positions of public trust, and common contempt of these enemies of the true faith.

The hostile attitude of Innocent III was reflected in the action of the Fourth Lateran Council which he convened in 1215 and which was attended by over a thousand delegates. By the measures adopted Jews were forbidden to exact "immoderate usury"; they were not allowed to appear in public at Easter; they were dismissed from public offices; and they were ordered to wear some distinguishing form of clothing or badge. The decision as to the kind of distinctive mark was apparently left to secular authorities. The provision applied also to Saracens and later to lepers, heretics, and prostitutes. In France the special insignia was a yellow circular patch called the *"rouelle."* Between 1215 and 1370 the prescription was enforced in France by twelve councils and nine royal edicts.[1] Under Philip the Fair *rouelles* were sold as a source

[1] For names of councils see Léon Poliakov: *The History of Anti-Semitism*, trans. by Richard Howard (New York: Vanguard Press, 1965), Vol. I, p. 66.

of revenue by merchants who were assigned the franchise. When in 1361 King John the Good permitted the Jews to return to France he had the color of the insignia changed from yellow to red and white.

In Germany the "badge of shame" took the form of a conical hat. This red and yellow hat later gave way to the *rouelle*. The Polish Jews wore a pointed green hat; in England they wore a strip of cloth, resembling the Tables of the Law, sewed to their garments on the chest. In Spain and Italy, a Jew could be released from the burden of wearing the badge or the *rouelle* only through conversion to Christianity. In some respects the badge was the most odious and intolerable stigma endured by medieval Jewry. It aggravated the mutal hatred of Christian and Jew and created the legend in the credulous medieval mind that Jews were physically different from other people, a nonhuman species.

The impact of the Fourth Lateran Council was lasting and it fostered an official image of the Jews as a slave race, a lower order of creatures not far removed from the status of domestic animals, a people who were to be hated and kept in servitude, but not killed. "As murderers of the Lord," wrote the Bishop of Lincoln, "as still blaspheming Christ and mocking his passion, they are to be in captivity to the princes of the earth." But this last provision that they were not to be killed meant nothing to those who wanted Jewish money and property or to Crusaders whose aim was to wipe the unbelievers off the face of the earth. Pope Gregory IX repeatedly protested the anti-Semitic actions of kings and prelates as going beyond the provisions of the Council, but his letters usually ended with the traditional qualification that, although all excessive violence should be prohibited, the Jews were to live in a state of misery "as witnesses to the Christian faith."

Another concern of the Papacy was the fraternization of Jews and Christians. Many Christians were turning to

Judaism as a result of their discussions with Jews. Popes and bishops were well aware that it was not safe for simple-minded Christians to talk about religion to the more sophisticated and less superstitious Jews. As a result, the Council of Paris (1223) forbade Christians to serve in Jewish homes; the Council of Breslau (1266) prohibited Jews from living in the same neighborhood with Christians; and the Council of Vienna (1267) confirmed the policy of isolating the Jewish population.

Ironically enough, it was the Jews themselves, or certain ones, who added to the woes of thirteenth-century Jewry. In 1239 Nicholas Donin, an apostate Jew, having become a Dominican brother, presented to Pope Gregory IX a formal complaint against the Talmud as a blasphemous and immoral book and offensive to the Church. Donin, a former Talmudic scholar, had been excommunicated by the Rabbinate for his pro-Christian activities, especially his participation in the propagation of the ritual-murder legend. The Pope wrote to the kings of France, England, Spain, and Portugal and to the bishops ordering them to conduct an investigation. A hearing was held in Paris with the chancellor of the Sorbonne and Donin representing the Christian party. The defense was led by four rabbis with Jehiel, the Rabbi of Paris, as their leader. It was not difficult to detect statements in the Talmud derogatory to Christ and the Church. It was to be expected that the idea of a first-century Jew being deified—a Jew who supposedly was born out of wedlock—would be ridiculed in Jewish writings. The fact is that the Talmud is noted for its silence on the question. Anti-Christian references to Jesus are rare and altogether inconsequential. The Jewish defense showed that the Talmud presented both sides of every question and that its typical teaching was not anti-Christian but charitable toward all people. But the verdict was apparently predetermined; the Talmud was condemned, and the judges ordered all

copies to be confiscated and burned. This order was revoked by the Archbishop of Sens, but at his death it was enforced.

Innocent IV, a few years later, requested a reexamination of the sentence, with the result that a second commission, presided over by a Dominican, met in 1248 and confirmed the action of the former hearing. This was the beginning of a crusade against all Jewish literature, a crusade which continued for several centuries. Donin's original accusation had a lasting effect, as the opinion became widespread that the Talmud was anti-Christian. It was used by the Church as an instrument for Jewish isolation and degradation.

Jewish and Christian Heresy

Coincidentally in the early part of the thirteenth century European Jewry was split over the interpretation of the Talmud—a situation that played into the hands of the anti-Semites. The rift within Judaism was the result of a new rationalism, the chief exponent of which was Maimonides (1135–1204). The Rambam, as he was called, had led the revival of Aristotelianism and Greek learning in the Golden Age of Moorish Spain.[2] Maimonides' achievement was the clarification of the Talmud—an intricate and incomprehensible collection of teachings—in the light of Greek rationalism. He distinguished between the casuistical and the prophetic, between the purely legalistic and the ethical, with the resulting perfect synthesis of Hellenic reason and Hebrew piety. He challenged Judaism with the demands of universal humanism, a wide fellowship rather than a ritualistic and ethnic isolationism. Such an innovation was anathema to the separatists; and the anti-Maimunist party joined the Dominicans in their condemnation of Aristotelian rationalism. At the instigation of two French rabbis, Solomon ben Abraham and Jonah Jerondi, the Dominicans in

[2] See my *Maimonides: Medieval Modernist* (Boston: Beacon Press, 1967).

1234 burned the works of Maimonides in Paris and Montpellier. The anti-Maimunists succeeded, for the time at least, in having a ban placed on all scientific study and philosophy. Ultimately Judaism was reunited by the increasing influence of Maimonidean rationalism but the detection of heresy and new thought became the overwhelming purpose of the Church, if not the Synagogue.

The infiltration of Aristotelian thought in Europe through the writings of Arab and Jewish philosophers was augmented by the appearance of the Catharist movement in provoking a new implement for the counteraction of heresy in Christianity—the Spanish Inquisition.[3] Catharism—chiefly made up of Waldenses and Albigenses—was a lower-class revolt against medieval authoritarianism and constituted a pre-Reformation Protestantism within Christianity. Adopting their name from the Greek *katharos,* meaning "pure," the Cathari attempted to revive ancient Manicheeism, a dualistic religion of Persian origin and an earlier rival of Christianity. They practiced outright pacifism; opposed the civil oath; rejected all the Old Testament but the Prophets, the Psalms, and the Wisdom Books; and replaced the Latin Vulgate with their own translation of the New Testament from Greek texts. They were Arian or semi-Unitarian in their Christology, subordinating the Son to the Father. They rejected biblical miracles and vigorously denounced the sacerdotalism of the Catholic Church. They rejected the sacraments of baptism and the Eucharist in favor of a dedicatory laying on of hands and a memorial meal consisting only of the bread. They insisted on noninterference of civil authorities in matters of religion. In their belief in the separation of Church and State, their substitution of symbolic observances for sacraments, their anti-clericalism, and their doctrine

[3] The Spanish Inquisition, instituted by Ferdinand and Isabella in 1482, was really a resurrection of the older medieval Inquisition which had existed in Aragon since 1238 but had become defunct.

of pacifism, the eleventh-century Cathari appear to have been not only a form of medieval Protestantism but a harbinger of twentieth-century liberalism. Their hostility to the Catholic system challenged the common people and even won the favor of William, Duke of Aquitaine. In eleventh-century France they took the name of Albigenses (from the town of Albi, one of the strongest centers of the movement). In Milan they were known as Patarenes, and in Bulgaria, the Bogomiles. The prominence of the Cathari in the vicinity of Toulouse aroused the Church and, in 1208, Pope Innocent the Third's religious *blitzkrieg* practically wiped out all traces of the movement in Southern France. Survivors of the dreadful massacre fled to other countries. The heretics were killed but their heresy spread.

Similar in their anti-clericalism, their use of the vernacular New Testament, their opposition to sacramentalism, and their strict morality was the Christian sect called the Waldenses, followers of Peter Waldo, a merchant of Lyons who, in 1176, sold his business and began preaching to the poor. The "Poor Men of Lyons," as they were called, were more distinctly Protestant than the later Lutherans. They repudiated indulgences, purgatory, the mass, and the sacrament of baptism. They defended lay preaching and held that prayer is more effective in secret than in church. They were opposed to capital punishment and oath-taking and were communistic in their social and economic organization.

The Albigensian heresy is of particular interest to us because it provoked the Inquisition and also led to the expulsion of the Jews from Spain. Heresy, whether Christian or Jewish, was financially profitable for the nobility and the Church, since all property was confiscated upon death. In one town in France 20,000 Albigenses were put to death and their property seized. Some historians estimate that over one million Albigenses were slain in France in thirty years. The Papacy finally prohibited the deliberate

hunting of heretics and established the Inquisition, the original purpose of which was to determine whether the accused *was* a heretic or not. Those convicted were burned at the stake.

Reference to twelfth-century heretical movements must include the name of Peter Abelard (1079–1142), one of the few voices of dissent in the wilderness of medieval anti-Semitism. He vigorously opposed the attitude of the Church, which, he insisted, was wrong in its claim that the Jews were responsible for the death of Christ. Through the offices of his opponent, Bernard, the condemnation of Abelard was secured from Innocent II.

The Marranos

Two other factors were involved in the beginning of the Inquisition. One was the increasing prestige of the Spanish Jews, whose intellectual attainment and commercial ability aroused the enmity of both the populace and the aristocrats. The kings of Aragon and Castile, appreciating the talents of the Jews, had appointed them to important political offices. Every court had Jewish officials—ministers of finance, tax collectors, physicians. These Jewish courtiers, like their Christian counterparts, were not interested in their coreligionists but only in their own comfort and prosperity. As the Christian citizens became aware of the situation they expressed their resentment, although the fact was that the majority of Jews were poor and lived frugally.

Practically all of the court-Jews were converts to Christianity, but secretly were faithful to the Jewish religion. To faithful Jews the converts, whether secretly Jewish or completely Christianized, were guilty of compromise and were despised. The growing hostility of the Jews toward their renegade brothers was joined by that of the Christian clergy, the Old Christians, and the nobility, who were incensed at the idea of "foreigners" holding the highest posi-

tions in the kingdom. The Dominicans saw the situation as a flat contradiction of the traditional doctrine that the Jews were to be tolerated only as a race in servitude.

What stirred up clergy and nobility alike was the way Jews maintained their separateness as Jews and at the same time wielded such influence in high government circles. The Jews of Toledo, Cordova, Seville and smaller communities enjoyed civil autonomy and were governed by their own rabbis, but they also participated in the administration of the Christian state. The spark of persecution was kindled in Seville by the fanatical priest, Ferdnand Martinez, who in his sermons denounced the blasphemies of Judaism and exposed the prosperity of the Jewish aristocrats as a danger to the nation. As assistant to the archbishop he circulated his propaganda throughout the Seville diocese, urging the people to "demolish to their very foundations all the synagogues wherein those enemies of God and of the Church, called the Jews, conduct the idolatrous rites of their religion." [4]

On March 15, 1391, Martinez, addressing a great crowd in the public square of Seville, incited the people to violence against the unbelievers. The riot which followed was suppressed by city authorities, but Martinez continued his agitation until, a few months later, new and larger outbreaks occurred and those were impossible to overcome. On June 6, 1391, the Jewish quarter was invaded, the buildings were burned, and 4000 Jews fell victim to the attack. Most of them were murdered; others were sold into slavery, and still others consented to forced baptism. The Seville massacre set off similar outbreaks in Toledo, Cordova, Valencia, and other cities, with the same results. In Barcelona the Jews locked themselves inside a fortress where they thought they were safe, but the mob set fire to the fortress. In their desperation some took their own lives, jumping to their death

[4] S. M. Dubnow: *An Outline of Jewish History,* Vol. 3 (New York: Max N. Maisel, 1925), p. 143.

from the towers, while others surrendered and were baptized.

After the Spanish massacres many Jews fled to Portugal, where those who had been baptized returned to their own faith and openly observed Jewish rites. They were saved from punishment by the chief rabbi of Portugal who reminded the king of the Papal edicts which protected Jews who returned to their former religion. This fortunate situation did not obtain in Spain, where the rule was that only those baptized Jews who had gone to Africa were permitted to reembrace their own religion. Baptized Jews in Spain were forced to attend church and remain Christian. These unfortunate people were greatly distressed because secretly they held to their Jewish faith. Their fellow-Jews called them *anusin* (slaves) and the Spanish Christians called them *marranos* (outcasts) or *conversos* (new Christians). The marrano population in Spain increased not only through the zeal of the Catholics in forcing Jews to embrace Christianity but also through the missionary work of certain Jewish apostates who hoped to profit thereby. One Talmudic scholar, Solomon Halevy, was baptized and took the name of Paul. He later became the Bishop of Burgos and tutor to the prince of Castile. He preached against "the false doctrines of the Rabbis" and cultivated the friendship of the Pope.

By the middle of the fifteenth century there were tens of thousands of *marranos* in Spain. They had intermarried and were hardly distinguishable from the Old Christians. To understand the reasons for both the Inquisition and the Expulsion it is necessary at this point to elaborate somewhat on the place held by *marranos* in fifteenth-century Christian Spain. We have already indicated the influential role of Spanish Jews as physicians and their prominence in the financial services of the Crown. The kings, in fact, were totally dependent upon the *conversos* in their commercial transactions. *Marranos,* or crypto-Jews, were despised by the old Christians not only for their prominent role in the

world of finance and in court positions, but for their aversion to manual labor. The belief that Jews refused to engage in hard work such as digging or farming, a belief that may have some justification, became a further factor in anti-Semitic propaganda, especially in modern times. The Jews were, and continued to be, strictly an urban population. The Inquisition lists show that all the Jews who were punished by the Tribunal had been in professional and commercial positions.[5]

By the fifteenth century the middle class and the aristocracy in Spain were composed largely of *marranos*. Practically every family of the nobility was of Jewish blood, including the ancestors of the king. *Marranos* held the highest offices at court. In the reign of Ferdinand and Isabella four bishops, Cardinal Juan de Torquemada, and the Grand Inquisitor himself were of Jewish descent. Other prominent *conversos* were the second Inquisitor General, the Archbishop Hernando de Talavera, and three royal secretaries— Fernando Alvárez, Alfonso de Avila, and Hernando del Pulgar; also the Vice Chancellor of the kingdom of Aragon, the Comptroller General, the Treasurer of the Kingdom of Navarre, and the Vice Principal of the University of Saragossa. Solomon Ha Levi, Chief Rabbi of Burgos, was converted and changed his name to Pablo de Santa Maria. He later became Bishop of Cartagena, tutor to the son of Henry III of Castile, and papal legate. His two sons also were bishops.[6]

Enough instances have been cited to demonstrate how completely the *marranos* had infiltrated aristocratic Spanish society. For the Old Christian nobility the situation was both

[5] In the effort to distinguish *conversos* from Old Christians it was reported to the Emperor, Charles V, that several of the important members of the Royal Council were *conversos*, but among the exceptions was one Palacios Rubios, "a man of pure blood because he is of laboring descent." Henry Kamen: *The Spanish Inquisition* (New York: The New American Library, 1965), pp. 18, 21.

[6] *Ibid.*, p. 20.

paradoxical and intolerable: the descendants of the Jews whom the Christians had forced to become Christian were now the leading nobles of the land. Moreover it was well known that the *conversos* secretly were more Jewish than Christian.

The clergy found to their dismay that converting the Jews was one thing but making them practice the new religion was another. The more disturbing fact was that many of the *marranos* had intermarried with Spanish nobility and had gained prestige as court ministers, bishops, and military leaders. Most of these distinguished converts, however, still observed Jewish rites privately. Their homes were still Jewish in every way and their children were brought up in the religion of Judaism. This was known by the Catholic clergy, who denounced the apostates and aroused the populace. Violent outbreaks occurred throughout Spain. On one occasion in Cordova, during a religious procession, it was noticed that all the windows of the *marrano* homes were closed and had none of the customary decorations. Rumor had it that a girl in one of the *marrano* houses had thrown dirty water out of the window as the procession passed and splashed the image of the Virgin. This precipitated a riot in which all the *marrano* homes were plundered and set afire, the women were raped, and many men put to death. Another impetus in the rapidly increasing enmity against the crypto-Jews was the publication of Alfonso de Spina's *Fortalitium Fidei* ("Fortress of the Faith"), which furthered the tendency to lump *marranos* and true Jews together as a degraded and impure race. This hostility, based on the idea of "bad Jewish blood" seems to have shifted the emphasis of Spanish anti-Semitism to an ethnic or racial form.

The Grand Inquisitor and the Crown

This was the background for the Holy Inquisition which was launched with the twofold purpose of stamping out

Christian heresy and destroying the *marranos,* who were regarded by the clergy as heretical Christians. The systematic attempt to exterminate Spanish Jewry began with the uniting of Aragon and Castile through the marriage of Ferdinand and Isabella (1474). The king and queen were completely under the domination of the clergy, who by this time were out to annihilate all unbelievers. They obtained from Rome permission to establish a tribunal which would seek out and punish all people suspected of heresy and freethinking. Their special object of attack was the *marranos.* The first meeting of the Inquisitorial Office was at Seville in 1480. All Christians were compelled to report every *marrano* they saw observing the Sabbath or any Jewish laws, however trivial. The prisons of Seville were soon filled, and the suspects were tortured until they confessed to a secret observance of Jewish rites. At the first *auto-da-fé* ("act of faith") which took place in Seville on January 6, 1481, six *marranos* were burned at the stake. By November of that year over 300 had been similarly put to death in that city. Their property was confiscated by the government, so that the Inquisition proved to be a considerable source of revenue for the king's exchequer. Some Jews fled to Africa and other countries, while others remained to accept their fate as the will of God.

In 1483 Thomas Torquemada became the Grand Inquisitor. Because of the monstrous tortures introduced into the inquisitorial procedure by this Dominican monk, his name became synonymous with all that is diabolically cruel. In the absences of witnesses against the accused, *marranos* were subjected to such torment that they were ready to confess anything the inquisitor wished them to confess. It was inevitable also that in order to be spared further pain the victim would reveal the identity of other suspects, with the result that each trial was followed by another search and arrest. The chief inquisitor of Aragon was the priest Arbues,

whose emulation of Torquemada was so thorough that some influential *marranos* finally stabbed him to death as he knelt at the altar of his church. Needless to say, the conspirators were put to death in the most fiendish manner and the Inquisition became more powerful than ever. Torquemada's tribunal was so ruthless that Pope Sixtus IV issued a strong protest, accusing the Grand Inquisitor of operating purely for monetary reasons rather than for the defense of the faith. The inquisitorial arm even reached into the grave, exhuming the bodies of dead suspects, condemning the victims, and then confiscating the property and financial assets of their descendants.

EXPULSION

Spain

THE TENDENCY of the inquisitors to class *marranos* and or-
thodox Jews together was due in part to the increased ac-
cord of the two groups. Whereas the faithful Jews had for-
merly despised the apostates, toward the end of the fifteenth
century, as the *marranos'* observance of Jewish customs be-
came more obvious, the true Jews mingled with the *conver-
sos* and tried to win them back to the true faith. Torquemada
attempted unsuccessfully to bring the orthodox Jews into his
jurisdiction and punish them as "Judaizers." Failing in that,
he demanded the expulsion from Spain of all Jews. This was
opposed by Ferdinand and Isabella as well as the Pope. Sub-
sequent events combined to favor the demand for expulsion
not only of Jews but of Moslems. New rumors of ritual mur-
der again fomented hatred of Jews and the fall of Moslem
Granada to the Crown not only brought to an end the last
phase of Arab domination in Spain but furthered the idea of
Spanish unity and the expulsion of all non-Christians. After
700 years the power of Islam was broken. Torquemada was
quick to remind the king and queen that the presence of
Jews was an equal hindrance to the cause of national and
religious unity. Spurred by these developments and the dom-

inating influence of the Grand Inquisitor, Ferdinand and Isabella on January 2, 1492, issued an edict expelling all Jews from Spain under penalty of death. They were given six months in which to leave and were permitted to take with them all their property except precious metals.

Immediately following the edict of expulsion a group of influential court Jews went to the king with a petition. Their leader was Don Isaac Abarbanell, who was administrator of the royal exchequer. He had formerly served Alfonso V of Portugal in that capacity, but when the king died he was forced by his enemies at court to leave the country. Ferdinand, only too glad to get such a famous person in his employ—Abarbanell was well known in both Jewish and Christian circles for his theological and philosophical knowledge—disregarded the existing law prohibiting Jews from holding positions of trust. Don Isaac offered the king the sum of 30,000 ducats for the revocation of the expulsion edict. As Ferdinand was about to yield to this tempting bargain, Torquemada, we are told, rushed into the audience chamber, holding a crucifix and shouting, "Judas sold Christ for thirty pieces of silver. You would sell him for 30,000. Here he is. Take him and sell him." Flinging the crucifix to the floor before the monarchs, he rushed from the room. Again intimidated by the Grand Inquisitor, the king and queen dismissed the Jewish leaders and issued a second announcement that the Jews must leave the country or be baptized.

There was little time in which to settle their affairs. The Jews were forced to leave their homes or sell them for a pittance. Their desperation was used by the Dominicans to persuade them to turn to Christianity and be saved. It is not known how many left the country. Conservative estimates place the number at 250,000. They fled to Portugal, Africa, Italy, and Turkey. King John II of Portugal allowed the Jews to remain there for a short period of time, but they

were expelled in 1488. At least 50,000 remained and accepted baptism rather than go into exile and die in a strange land. They were sold into slavery and their children were taken from them, baptized, and distributed among Christian families. The immediate result of the expulsion was that Spain lost much of its wealth and its upper middle class. Deprived also of the presence of its industrious and educated citizens, Spain began to decline as a European power. In Castile and Aragon at least half the Jews remained to join the ranks of the *conversos*, who now became more numerous than ever. Thus the Crown by the expulsion had actually increased the *marrano* population, and the apparent purpose of the expulsion to unify the country in race and religion had been defeated, with the result that the problem of heresy became more pronounced than ever. The older *conversos* were still in high posts in the government and the Church. The fact that Muslims also were found in great numbers after 1492 leaves some doubt as to the motive of religious purity. If this was the aim of the expulsion, it failed. Both the Expulsion and the Inquisition were supposedly enforced because of the *"converso* danger," but it is a question whether the purity desired was for the Catholic religion or the nobility. In either case the aim was not achieved. The Inquisition continued to function until the eighteenth century but Judaizing by the middle of the sixteenth century began to subside as Jews became assimilated in Christian society and Jewish children were brought up as Catholics.

England and France

The persecution of Jews in England took a turn for the worse after the Council of 1215. They were assessed enormous taxes for the support of the Church; they were compelled to wear the badge; and were prohibited from holding public offices. Under King John conditions were so bad that many Jews begged to be allowed to leave the country but

were refused because of their value as a source of income. Contrary to what one might suppose, England had its share of guilt in the persecution of Jews, for it was here that the ritual-murder accusation originated. From the eleventh to the thirteenth century English Jewry, having come mainly from France and Spain, probably did not exceed 15,000 in number. Under Edward I there was a renewed effort by the Dominicans to convert Jews to Christianity. Children were taken from their parents and brought up as Catholics. In 1290 the king issued an edict expelling the Jews from the country and by the end of the year most of them had left for France and other lands. Thus it was England that set the precedent of banishment which was subsequently followed with such fatal effects in European countries.

Unlike the later expulsions on the continent, the edict in England was enforced with a certain degree of fairness and humane consideration. A royal decree guaranteed Jews immunity from injury or grievance in the interval before departure. Those who could pay for it were given personal escort to London. Port authorities were commanded to provide the exiles with safe passage by ship and travel rates were reduced for the poor. They were allowed to take with them all their money and personal effects, but their real estate was held for the Crown. Some prominent Jews, however, were permitted to sell their property.

Certain reported incidents show that all was not well in the crossing. One grievous incident occurred at the mouth of the Thames, where the ship carrying London Jews had anchored and at low tide was grounded on a sandbar. The captain of the ship gave permission to the passengers to disembark and take some exercise. When the tide began to rise the captain shouted to the Jews to call upon their prophet, Moses, to rescue them, then lifted anchor and sailed away. The entire group was drowned and their goods were divided among the sailors. The news of the tragedy reached London

and upon the return of the ship those responsible were hanged. In other instances some of the ships, encountering severe storms, were lost with all on board.[1]

The Puritan movement of the early seventeenth century produced a new interest in the Jews and encouraged their readmission into England. As an articulate Protestant reform, the Puritans represented a shift to the Bible as the basis of religious authority; so it was natural that "the People of the Book" should share in the new religious fervor. The philo-Semitic tendency went so far in some instances that instead of trying to convert Jews to the biblical religion of Protestantism, certain Christian groups took over the Jewish observance of the Sabbath and circumcision. Some Arians were put to death for their purely monotheistic (Hebrew) idea of God.

In addition to the Bible-centered philo-Semitic tendency there developed among the new sects, especially the Baptists, a strong demand for freedom of conscience and religious toleration. Several tracts appeared advocating readmission of the Jews and the right of public interfaith discussion (the latter perhaps with a view to converting the Jews through argument).[2] Roger Williams, Hugh Peters, and Thomas Brown wrote pamphlets supporting the principle of toleration.

As a result of the decline of the national church in England, the rise of the sects, and the sympathy aroused for the persecuted Jews on the continent, a conference of representative leaders in all walks of life was held at Whitehall on De-

[1] See Cecil Roth: *A History of the Jews in England,* 2nd ed. (Oxford: Clarendon Press, 1949), p. 86.

[2] Leonard Buscher in 1614 published a pamphlet called *Religious Peace or a Plea for Liberty of Conscience,* probably the first printed argument for religious liberty to appear in England. This was followed in 1615 by John Murton's *Objections answered by way of dialogue wherein is proved that no man ought to be persecuted for his religion;* and in 1636 by John Wemyss' *A Treatise of the Foure Degenerate Sonnes.*

cember 4, 1655, to consider the legality and method of readmitting Jews to England. Thomas Cromwell, the Lord Protector, presided. As the meetings continued, the opposition came chiefly from the clergy and theologians, who viewed the presence of Jews as a blasphemous idea. They were joined by the business interests who feared the loss of trade to "foreigners." Gradually and without benefit of any official legislative act, *marranos* began to settle in England and periodically the Diaspora community expanded with immigrants from Spain, Holland, and France. During the Restoration the Jews became increasingly influential in British affairs. Charles II pursued a liberal policy of naturalization and appointed Jews to high posts in the government. New laws were enacted giving them greater legal rights. By the end of the seventeenth century the economic position of the Jews in England had greatly improved. They were employed chiefly in foreign trade and the wholesale business. This led in the following two centuries to a similar status in social and political fields.

The Jews who were expelled from England in 1290 fled mainly to France, where they found that they had jumped from the frying pan into the fire. The French kings of the fourteenth century ruined the Jews through taxation and confiscation. In 1306 King Philip the Fair ordered all Jews to leave France and to take only the clothes they wore. About 100,000 left the country and all their property was seized by the king and sold to Christians. Most of the exiles fled to the independent provinces along the Spanish border in the hope that they would later be able to return. In 1315 Louis X did restore them to their homeland but they returned only to face the bandits and desperadoes of the "Shepherds'" Crusade, whose first aim was to annihilate the unbelievers. The onslaught, affecting over one hundred Jewish communities, resulted in the usual holocaust. After the Crusade the situation in French Jewry became just as

unbearable as elsewhere. The order for expulsion came in 1394 under Charles VI. The Jews migrated to Germany, Italy, and Spain. Entering Germany they encountered the same conditions: fanatical priests, avaricious rulers, and a superstitious populace.

The Ghetto

In 1516 the Venetian Republic ordered the Jews to be segregated in a special quarter which became known as the Ghetto. Here the Jews were sealed off and isolated from the rest of the city. By the middle of the century the ghetto was a compulsory establishment throughout Italy and all of Europe.[3] Its gates were locked at night and the inhabitants were allowed to use the city streets only by day. Behind the ghetto walls the Jews inevitably became more ingrown and exclusive. Reduced to abject poverty by taxation and inability to engage in the professions, they led a monotonous life, rearing their children in the traditions of Judaism and observing the ancient rites in minute detail. The ghetto existence resembled the monastic life of Christian religious orders. It was an isolated society dedicated to the study of the ancestral beliefs and the practice of piety. But as Cecil Roth observes, "the Ghetto walls, though originally intended to keep the victims in, were no less useful in keeping their enemies out." [4] The ghetto served not only as a sanctuary but as a means of preserving racial and cultural unity. There was in fact in some Italian cities an annual festival to celebrate the establishment of the ghetto. Both of these favorable aspects, however, were not without their disadvantages. Occasionally the sanctuary was invaded and practically wiped out by Christian mobs and also its

[3] In France it was known as the *Carriére des juifs;* in Germany, the *Judengasse* or *Judenstadt.*

[4] Cecil Roth: *A Bird's Eye View of Jewish History* (New York: Union of American Hebrew Congregations, 1954), p. 274.

value as a preserver of Jewish solidarity was offset by the process of inbreeding with its accompanying physical and mental devitalization.

The insulation of ghetto life made it inevitable that European Jewry would be untouched by the cultural changes brought about by the Renaissance, the Reformation, and the Enlightenment. The emergence of Europe from medieval feudalism to the modern age, occurring roughly from 1500 to 1800, left the Jewish world virtually unchanged. As Edward H. Flannery writes: "For the Gentile, the Middle Ages were ended; for the Jew, fixed in the historical process, the old instabilities and vexations endured to the very threshold of the nineteenth century. A period of prodigious developments for one was for the other a time of wandering, stagnation, and isolation." [5]

The ghetto seemed to work out as the solution of the problem of complete integration as over against expulsion. It was the old dilemma: on the one hand, Jews as unbelievers and heretics were undesirable; on the other, they had to be tolerated as witnesses to the Christian faith. While the ghetto served to unite and protect the Jews, it resulted inevitably in a retrogression of mind and spirit. In this prison, quarantined from the outside world, Jews became provincial, insular, and hidebound; their minds were taken up with trivial and inconsequential matters, with petty details of piety and ritual. The ghetto, in fact, inflicted permanent damage to both body and soul. The Jew lost his dignity and high purpose. Forced into degrading occupations and confined in overcrowded unsanitary houses, he became soured and in self-defense resorted to trickery and deceitful dealings. He developed a martyr-complex and became clannish. If there is any truth in the modern Jew's reputation for being crafty and acquisitive, it was nourished

[5] Edward H. Flannery: *The Anguish of the Jews* (New York: The Macmillan Company, 1965), p. 145.

in this period. The stereotype which made the Jew an object of derision indeed had its origin in the age of the ghetto. The Christian world reduced the Jews at this time to their most degraded state. They were compelled to become seclusive and were forced to grasp what they could in order to survive.

The area of the Jewish quarter was seldom increased. It was therefore necessary, as the population grew, to expand upward, piling additional stories upon the already unsafe structures. On certain occasions, such as the feast days, some of the houses collapsed and they were always in danger of complete destruction by fire. Dress was regulated in every detail including the amount of jewelry that could be worn. There were laws governing all the family and synagogue festivals, designating the amount and variety of food to be eaten and the kind of gifts to be made. City officials confiscated and burned Jewish books at will, and in some communities possession of the Talmud was a criminal offense. During the Christian Passion Week Jews were not allowed on the city streets. They were forced on specific dates to attend "conversionist sermons." In Germany Jewish marriages were held under strict control in order to keep the birthrate down. As a rule only the eldest child was allowed to marry and have a home. Most of the professions were denied the Jews but they were permitted, and encouraged, to continue in the practice of medicine, where they were eminently successful and where they were employed by the ecclesiastical and state rulers. Ghetto life was centered in the synagogue and the school, which were the two saving factors in medieval Judaism.

Poland and Italy

Throughout the period of the ghetto the wanderings continued as Jews moved more and more to the East, particularly to Poland and Lithuania, where they found secu-

rity and equal status. Although a good portion of the Polish Jews had originally migrated from southern Europe, it was the German Jews who were responsible for the cultural, economic, and spiritual progress in that country. German refugees from the Crusades, the Black Death, and other massacres were hospitably received and their superior abilities won for them a prominent place in the Polish economy. Coming to such a backward country, they rapidly assumed leadership in the field of finance and business. They were eagerly sought by kings and nobles and were appointed to high court posts. In the Charter of Casimir the Great (1364) the Jews were given equality with the nobility in legal cases of murder or injury.

Although the relative remoteness of Poland had at first isolated the Christian populace from the anti-Semitism of Western Europe, by the fourteenth century the clergy came to resent the influence of Jews in governmental positions. Councils were called and decrees were issued. By the fifteenth century the usual accusations of ritual murder and profanation of the Host were heard, the Badge of Shame appeared, and Jewish privileges were curtailed by the government. In 1484 the Jews were ordered to leave Warsaw and Cracow. But in spite of the rising hostility in Poland, events there took a somewhat different turn from the usual sequence in the West. The Jews were firmly established in the economic and administrative structure of the country and were so solidly integrated in the Polish culture that expulsion was out of the question. The Jewish population, as Poliakov says, became "a state within a state," an independent hegemony.[6] In the sixteenth century the Jews controlled most of the commercial and financial life. Furthermore, Poland became the world center of Judaism and remained as such until modern times. In spite of the opposi-

[6] Léon Poliakov: *The History of Anti-Semitism* (New York: The Vanguard Press, 1965), pp. 248, 249.

tion of the clergy, Polish Jews were respected and were not reduced to menial occupations as in Western Europe. They owned land, were wealthy, and were active in the world of learning. There were no ghettos and the wearing of the badge was not enforced. Jews were prominent in commerce and foreign trade, industrial enterprises and agricultural management. As bankers, importers, exporters, and retailers they constituted in fact a new middle class, an autonomous, self-governed society. In these circumstances learning, particularly Talmudic study, flourished as it had nowhere else except in Spain. Sixteenth-century Polish Judaism reached such cultural heights that it became the main stream of influence for all later European Jewry.

The Golden Age of Poland however was not to endure. The anti-Semitic uprising, called the Deluge, differed considerably from that of Western Europe. It had its source among the Ukrainian peasants, who were of the Greek-Orthodox religion and who despised both Catholic nobles and their Jewish agents. A further cause for anti-Judaic sentiment was the suspicion of Jewish collusion with the Socinians, a Unitarian sect which, theologically speaking at least, had much in common with Judaism.[7] Cossacks and Tartars, sweeping through southeast Poland, massacred Poles and Jews in the most barbarous manner. The invaders were joined by the Czar's troops and a Polish-Russian war followed, with the result that by 1658 no Jewish community was left unharmed. It has been conservatively estimated that Jewish victims of the Deluge numbered at least 100,000. Poland never regained her cultural position as one of the principal states of Europe. The Jewish hegemony ceased to exist and the surviving Jews migrated westward into every section of the continent, thus by their leadership

[7] For a thorough history of the Socinians in Poland, see Earl Morse Wilbur: *A History of Unitarianism: Socinianism and Its Antecedents* (Boston: Beacon Press, 1945), Vol. I.

helping to bring about what Graetz called the "Polonizing" of Europe.

In spite of the intolerance of the Papacy toward Jews in other countries, Italy during the Middle Ages was comparatively free from mass persecution. The country was split into independent provinces and free cities in which the official church regulations were for the most part ignored. The Jews enjoyed a considerable degree of religious autonomy as well as a free choice of occupation. They participated in every profession except agriculture. They were druggists, ministers at court, goldsmiths, surgeons, scientists, astronomers, merchants, importers, exporters, and metal workers. As an integral part of the Renaissance culture, they became painters, poets, sculptors, dramatists, actors, and musicians. Women occupied positions of influence in secular life. Intermarriage was fairly common. The Renaissance Jews, as Max Dimont says, contributed to everything but crimes of violence.[8] Even in usury there was no feeling against the Jews, since the Christian bankers, as a matter of fact, charged more interest. Jewish physicians were greatly esteemed, being employed by the nobility and even the Popes. The philosophical, literary, and scientific ability of Italian Jews was given free play in the favorable environment of the Renaissance. An earlier Jewish poet, Immanuel of Rome, a friend of Dante, was a freethinker and wrote on secular themes, satirizing the stupidity of certain Talmudists who despised secular learning. He was later condemned by the rabbis as a heretic and his works were banned.

Thus we see that Italy as far as Jews were concerned was different from other countries. The anti-Semitic uprisings connected with the Crusades and the Black Death did not occur there. The reasons for this favorable situation and the late appearance of anti-Semitism were partly

[8] Max Dimont: *Jews, God, and History* (New York: Simon and Schuster, 1962), p. 253.

economic. The Italian Jews never became inordinately
wealthy and although they engaged in usury they were not
known distinctively for their prominence in this calling.
Consequently two of the typical causes for anti-Semitism
elsewhere were absent. A further reason for Jewish immunity
to persecution in Italy was the tolerant attitude of the Pa-
pacy, which, although it issued edicts against Jews in general
at the urging of princes, nobles, and bishops, protected
Jews in the papal states in their rights as citizens. Until the
Reformation the spirit of Gregory the Great and the elev-
enth-century *Constitutio* seemed to prevail. Most of the
Renaissance Popes were on friendly terms with leading Jews
and several employed them as personal physicians. The
change came with Paul IV (1555–59), who symbolized
the inevitable reaction of the Renaissance Popes to liber-
alism. The ultraconservative Paul restored the ghetto in its
worst form and published two bulls which reinstated all
the anti-Judaic laws of the Middle Ages. These laws brought
the Jews to their lowest state of degradation in the history
of Italian Jewry.

Russia

Jews did not enter Muscovite Russia until the latter
half of the fifteenth century, during the reign of the Grand
Duke Ivan III. They came from Lithuania and Western
Europe. One of the immigrants was a Jewish scholar named
Scharia who came to Novgorod from Kiev in 1470. He con-
verted some of the orthodox Christians, among whom were
two Novgorod priests. They moved to Moscow where they
converted many Christians to the Jewish faith. The Judaiz-
ing of Scharia was based on a semi-Christian belief or Jewish
heresy reminiscent of the fourth-century Photinians in By-
zantium. The followers exalted Jesus, but only as a prophet,
and denied all Christian supernaturalism. The heresy infil-
trated Ivan's court and high ecclesiastical circles as well as

the populace. The movement became fairly widespread but was finally checked by the Church following a council in 1504 which ordered the execution or imprisonment of all apostates. The heresy however went underground, emerging from time to time to influence minor sects in Russia.[9]

S. M. Dubnow tells of a peculiar incident which occurred in Moscow in 1490.[10] A Jew named Leon arrived from Venice and became court physician to Ivan III. The Duke's son was seriously ill and when the physician was asked if the boy would recover, he replied: "I shall not fail to cure your son; if I do fail, you may have me put to death." Soon afterward the boy died, whereupon Ivan ordered Leon to be beheaded. He was put to death in the public square in Moscow. Both Scharia and Leon were probably regarded as sorcerers.

Throughout the seventeenth and early eighteenth centuries Jews were not permitted to enter Muscovite Russia, with certain exceptions such as those permitted by Peter the Great, who allowed them to live in the provinces. Generally the rulers, especially the czarinas, held strictly to the policy of exclusion not only of Jews but other heretics such as Lutherans, Calvinists, and Roman Catholics. In the late eighteenth century under Catherine II the Jews were confined to the provinces, including the newly won part of Poland. This area was called the Pale of Settlement which

[9] Later the Scharian sect combined with the Sabbathian heresy and in the nineteenth century reappeared as the Dukhobor movement. The Sabbathian (or Sabbatean) movement, founded by the fanatical Kabalist and false Messiah Sabbati Zevi (1626–1676), was a reaction to Talmudic Judaism which emphasized the intellectual or rational approach to truth. Sabbateanism, stressing mysticism and intuition, defined Judaism in terms of feeling, something above and beyond Talmud and Torah. It became a perverted, primitive, sex-motivated cult and gave way to Hasidism, an ecstatic, mystical faith minus the historical foundations of true Judaism. The founder of Hasidism was Bal Shem Tob (1700–1760).

[10] S. M. Dubnow: *An Outline of Jewish History* (New York: M. N. Maisel, 1925), Vol. III, p. 175.

existed until 1917. Treatment of Jews in the Pale alternated from the liberal regimes of Alexander I and II to the xenophobic rule of Catherine II and Nicholas I. The static condition of Russian Jews down to the middle of the eighteenth century was due not only to Czarist tyranny but to the reactionary character of the Jews themselves.

In spite of the cultural changes that followed in the wake of the Renaissance—the rise of capitalism, invention, discovery, science, religious reform, and rationalism—the mass of people in Europe, particularly the ghetto Jews, lived in an unchanging society, untouched by the new influences. Strangely enough, the anti-Semitism of the post-Renaissance period flourished most where the Jews no longer existed. The anti-Judaic development, which extended into the twentieth century, assumed a literary form. This is the subject of our next chapter.

ANTI-SEMITISM IN LITERATURE

England

IN THE FIRST PART of this book we were concerned with the anti-Judaism of early Christianity as seen in the New Testament and the apologetic writing of the Fathers. We next observed that throughout the Middle Ages the common hatred of Jews induced by the earlier theological polemic found expression in overt action, with restrictive laws, forced conversion, systematic persecution, genocide, inquisition, and expulsion. Following the expulsion of Jews from the various countries, anti-Semitism then took an abstract or literary form not unlike the theological treatises of early Christianity. This form of hatred, sometimes called pure or classical anti-Semitism, had already appeared in the late Middle Ages. It was an image of the Jew that was not considered remarkable; on the contrary, it was assumed, taken for granted, and became more firmly fixed as time passed, whether Jews were present or not. In fact, it flourished more in their absence, feeding on the growing body of literature about the "unbelievers" and "Christ-killers." As art and literature developed through legends, plays, ballads, and satires, the caricature of the Jew grew in an increasingly exaggerated form.

This pejorative image of the Jew reached its most fa-

natical expression in a period that otherwise was noted for its tolerance and liberal thought. It was the era—from the sixteenth to the twentieth century—that gave birth to modern philosophy, the Renaissance, the Reformation, the French Enlightenment, the American Revolution, the English Industrial Revolution, nineteenth-century science, and twentieth-century communication. But in spite of the growth of a saner and more rational viewpoint in the modern world, there were prominent thinkers in every field who kept alive the theological and economic forms of anti-Semitism and also aided the newly developing racial and ethnic type.

In England the two most common sources of the anti-Jewish theme—usury and ritual murder—were reflected in the earliest literature. Chaucer's *The Prioress' Tale* is based on the story of the murder of the child Hugh Lincoln which was supposed to have taken place, according to Matthew Paris, a thirteenth-century chronicler, in 1255. The legend, however, had appeared in England before 1200. The ballads of Sir Hugh and the miracle play performed at Lincoln in 1316 must have been familiar to Chaucer. There are over thirty extant versions of the tale, in most of which the child is miraculously restored to life. Chaucer used a source that was probably written around 1200.[1] It will be noted that reference is made in the first stanza to the Jewish practice of usury.

> Ther was in Asye, in a greet citee,
> Amonges Cristene folk, a Jewerye,
> Sustened by a lord of that contree
> For foule usure and lucre of vileynye,
> Hateful to Crist and to his compaignye;
> And thurgh the strete men myghte ride or wende,
> For it was free, and open at eyther ende.

. . .

[1] Chaucer (c. 1340–1400) wrote *The Canterbury Tales* between 1386 and 1389.

Oure firste foo, the serpent Sathanas,
That hath in Jues herte his waspes nest,
Up swal, and seide, "O Hebrayk peple, allas!
Is this to yow a thyng that is honest,
That swich a boy shall walken as hym lest
In youre despit, and synge of swich sentence,
Which is agayn oure lawes reverence?"

Fro thennes forth the Jues han conspired
This innocent out of this world to chace;
An homycide therto han they hyred,
That in an aleye hadde a privee place;
And as the child gan for-by for to pace,
This cursed Jew hym hente and heeld hym faste,
And kitte his throte, and in a pit hym caste.

I seye that in a wardrobe they hym threwe
Whereas thise Jewes purfwn hire entraille.
O cursed folk of Herodes al newe,
What may youre yvel entente yow availle?
Mordre wol out, certeyn, it wol not faille,
And namely ther th'onour of God shal sprede,
The blood out crieth on youre cursed dede.

· · ·

This poure wydwe awaiteth al that nyght
After hir litel child, but he cam noght;
For which, as soone as it was dayes lyght,
With face pale of drede and bisy thoght,
She hath at scole and elleswhere hym soght,
Till finally she gan so fer espie
That he last seyn was in the Juerie.

· · ·

With torment and with shameful deeth echon.
This provost dooth the Jewes for to sterve
That of this mordre wiste, and that anon;
He nolde no swich cursednesse observe.
Yvele shal he have, that yvele wol deserve.
Therefore with wilde horse he did hem drawe,
And after that he heng hem by the lawe.

Upon this beere ay lith this innocent
Biforn the chief auter, whil masse laste,
And after that, the abbot with his covent
Han sped hem for to burien hym ful faste;
And whan they hooly water on hym caste,
Yet spak this child, when spreynd with hooly water,
And song *"O Alma redemptoris mater."*

. . .

O yonge Hugh of Lyncoln, slayn also
With cursed Jewes, as it is notable,
For it is but a litel while ago;
Preye eeek for us, we synful folk unstable,
That, of his mercy, God so merciable
On us his grete mercy multiplie,
For reverence of his mooder Marie. Amen.[2]

In the sixteenth century a satirical poem appeared entitled *Ship of Fools*. This lampoon describes the various classes of people of that era including the Jews who were characterized in the traditional manner:

> The cursed Jewes despysynge Christis lore
> For their obstinate and unrightewise crueltie
> Of all these folys must be set before.

The original author was Sebastian Brandt (1458–1521), a German, who wrote *Das Narrenschiff* in 1494 in the Swabian dialect. Coming just after the invention of printing, it became immensely popular and was translated in England by

[2] Text from Edwin Johnson Howard and Gordon Donley Wilson: *The Canterbury Tales* (Oxford, Ohio: The Anchor Press, 1942), pp. 26–30. See also W. W. Skeat: *The Canterbury Tales* in *The World's Classics* (London: Oxford University Press, 1963). Similar characterization of the Jews is found in Roger of Wendover's *Flores Historiarum* (1228) (reproduced later by Matthew Paris in his *Chronica Majora*, in *Piers the Plowman*, and in John Gower's *Confessio Amantis*). For a discussion of anti-Semitism in early English ballads and morality, miracle, and mystery plays see Hijman Michelson: *The Jew in Early Christian Literature* (Amsterdam: H. J. Paris, 1926), pp. 54–56.

Alexander Barclay in 1509 and by Henry Watson in 1517.[3]

Barclay's edition is not a translation but an adaptation applied wholly to the English people. It is both a valuable picture of the social and moral conditions of English life and, written midway between Chaucer and Spenser, a classic reference for a study of the development of the English language. As a candid criticism of Church and State, it ranks with the works of Erasmus. Each of the 125 poems is a censure of "the errours and vyces of this our royalme of Englonde;" a work undertaken "only for the holsome instruccion commodyte and doctryne of wysdome, and to clense the vanyte and madness of the folysshe people of Englonde." In denouncing the Jews, Barclay includes his own people who, he says, are second to none in their questionable dealings.

> Thoughe the Jewes lyve in errour and darknes
> Gyuen to usury (as labourynge men oft sayes)
> Yet ar they more gyven to pytye and mekenes
> And almes than Christen men ar now adayes
> In usury we ensue the Jewes wayes
> And many other synnes fowle and abhomynable
> Rennynge without mesure whiche is intollerable
>
> For his usury, the Jew is out exyled
> From Christen costes yet of us many one
> With the same vyce is infect and defyled

In spite of the avid interest of Humanist scholars in Hebrew and Old Testament studies, the collaboration of Jewish teachers and Protestant scholars, and the relatively benevolent attitude of Calvinists toward Judaism, the thoroughly entrenched prejudice against Jews as usurers showed itself even in lexicons such as Murray's *Oxford Dictionary*, which defines the word "Jew" as "a name of opprobrium

[3] A later two-volume edition of the Barclay translation was published by T. H. Jamieson (Edinburgh: William Paterson, 1874). The quotations herein used are taken from this edition (Vol. II, pp. 166, 168).

or reprobation; specifically applied to a grasping or extortionate money-lender or usurer, or a trader who drives hard bargains or deals craftily."

The prejudice against Jews as moneylenders is perpetuated by many English dramatists, starting with Marlowe (1564–1593) and Shakespeare (1564–1616). The dramatic portrayal of the Jew as a usurer, villain, and hater of Christians, appeared first in Christopher Marlowe's *Jew of Malta.* Barabas, the wealthy Jew, is evicted from his home, which is confiscated and made into a nunnery. He instructs his beautiful daughter to gain admission into the nunnery as a convert in order to rescue a sum of money which he had concealed in his house. The daughter drops the money from a balcony whereupon Barabas holds the bags tightly and cries:

> O my girl, my gold, my fortune, my felicity!
> Strength of my soul, death to mine enemy!
> Welcome the first beginner of my bliss!

Not satisfied with his success, he seeks revenge, but is tricked by a courtesan who informs the governor of his misdeeds. Barabas escapes death at the hands of the governor and joins the Turks in the siege of Malta. As head of the invading forces, he plans to gain favor with the Christians by plotting to destroy the Turks and after their downfall to remain as governor. The Christians pretend to go along with this plot, but instead send Barabas to his death.

Shakespeare's *Merchant of Venice,* which really should have been called the *Jew of Venice,* reveals several interesting parallels to Marlowe's play. The leading characters of both dramas, Shylock and Barabas, are Jewish usurers whose end in life is the accumulation of money; who complain of mistreatment by their enemies, the Christians; who can be ruthless in retaliation; and who have beautiful daughters whom they love dearly. On the other hand, Shakespeare, at

least in the opinion of some critics, was not content with presenting the malevolent Jew but intended to press home the unjust treatment of Jews in general, to show that the Jew had a right to resent the intolerance of Christians, and to show that he was a human being with sensitivity and affection.

> He hath disgraced me . . . laughed at my
> losses, mocked at my gains, scorned
> my nation, thwarted my bargains,
> cooled my friends, heated my enemies,
> and what's his reason? I am a Jew . . .
> Hath not a Jew eyes? Hath not a
> Jews hands, organs, dimensions, senses,
> affections, passions?
>
> If a Jew wrong a Christian, what is his
> humility? Revenge. If a Christian wrong
> a Jew, what should his sufferance be
> by Christian example? Why, revenge.
> The villainy you teach me, I will
> execute: and it shall go hard, but
> I will better the instruction.

William Hazlitt, the famous dramatic critic, was convinced that Shakespeare's intention was to create an atmosphere of sympathy for Shylock and therefore a more favorable attitude toward all Jews.

> If you prick us, do we not bleed?
> If you tickle us, do we not laugh?
> If you poison us, do we not die?

The theme of "the pound of flesh" had appeared in numerous forms. One of these stories, and perhaps Shakespeare's chief source for Shylock, was Giovanni Fiorentino's *Il Pecorone* (1378), in which the usurer was a Jew. In the earlier sources the person demanding the pound of flesh was not a Jew; in fact, in one version the *victim* was a Jew.

It is in Fiorentino's story that the moneylender was for the first time made a Jew.[4] The forfeiture is again found in *The Orator,* a French work by Alexander Silvoyan, translated by Anthony Munday and published in 1598. In this book a Christian merchant owed a Jew 900 crowns which he promised to pay in three months or surrender a pound of his flesh. The time having elapsed, the Jew demanded the forfeit. The lower judge in the case ordered the Jew to cut a pound of the merchant's flesh, but if he cut either more or less, his own head would be cut off. The Jew appealed to the higher judge; then the play takes up the ensuing trial. Shakespeare, if he knew the story, made no use of the plot except the original demand of the Jew. Theodore Percy in his *Reliques of Ancient English Poetry* (1866) reproduces an early ballad showing "the cruelty of Gernutus, a Jew, who, lending to a merchant an hundred crowns, would have a pound of his flesh because he could not pay him at time appointed."[5]

In the half-century following the first edition of the *Merchant of Venice,* there were at least nine plays featuring a Jew of the Shylock type—preoccupied with his money-lending, plotting revenge on his Christian debtors, and claiming his pound of flesh.[6]

[4] See G. Friedlander: *Shakespeare and the Jew* (London: G. Routledge and Sons, 1921), p. 54.

[5] The incident of the three caskets is also found in several pre-Shakespearean ballads and plays. Shakespeare probably was influenced in his characterization of Shylock by the Lopez case (1594) in which the judge who tried Lopez referred to him as "that vile Jew," "the murderous Jewish doctor," "mercenary," and "corrupt." Shakespeare apparently identified Shylock with Lopez and named Shylock's enemy Antonio, the name of Dr. Lopez's foe. See Montague F. Modder: *The Jew in the Literature of England* (Philadelphia: Jewish Publication Society of America, 1939), p. 25.

[6] Among these were Robert Greene and Thomas Lodge: *Tragicall Raigne of Selimus, Emperor of the Turks* (1594); John Marston: *Jack Drum's Entertainment* (1601); and John Day, George Wilkins, and William Rowley: *The Travels of Three English Brothers* (1607).

All of these carry two contradictory themes: the popular prejudice against the Jewish usurer and murderer of children and, at the same time, a protest, at least in a mild manner, of the inhumanity of Christians to Jews.

The Jews who returned to England in the early part of the seventeenth century were chiefly *marranos*. Reference to them as "accursed ones" was made by Robert Burton (1577–1640) in his *Anatomy of Melancholy*. Francis Bacon (1561–1626) in his essay on usury suggested that the Jews wear a distinctive sign because they were guilty of Judaizing. John Dryden (1631–1700) in his *Absalom and Achitophel* satirizes the Jews thus:

> A headstrong, moody, murmuring race
> As ever tried th' extent and stretch of grace;
> God's pampered people, whom, debauched with ease,
> No king could govern nor no God could please.

Thomas Browne (1605–1682) in his *Religio Medici* represents the popular English resentment of the Jews because of their refusal to be converted to Christianity:

> It is beyond wonder how that contemptible and degenerate issue of Jacob, once so devoted to ethnic superstition and so easily seduced to the idolatry of their neighbors, should now in such an obstinate and peremptory belief adhere unto their own doctrine, expect impossibilities and, in the face and eye of the Church, persist without the least hope of conversion.

The portrayal of the Jew in eighteenth-century literature bore little resemblance to the actual Jew who participated in English life. The prejudiced view of Jews, which continued to appear not only in minor writers but among the literary elite, was a reflection of the suspicions of the local tradesmen and the superstitions of the town and rural population. Leaders in national finance and politics were beginning to respect the Jews as highly valuable and in-

telligent citizens. But the legends of the Middle Ages and the gossip of the marketplace prevailed. Rarely does the poet or dramatist transcend the dogmas of his day. Most of the writers of this age were faithful mirrors of the times, not universal thinkers. Daniel Defoe (1659–1731) speaks of "the execrable Jews, crucifying the Lord of Life," "that dog of a Jew," "perjurers," and "murderers." Alexander Pope (1688–1744) wrote a libelous satire in which he prays that Christians may be kept "from the hands of such barbarous and cruel Jews, who, although they abhor the blood of black puddings, yet thirst after the blood of white ones." The writings of Jonathan Swift (1667–1731) abound in denunciations of "the stiffnecked and rebellious people" who "reap great profit by their infidelity."

The phrase "Jews, Turks, Infidels, and Heretics" seems to have been a universal one and is found in many English authors including Jonathan Swift, Laurence Sterne, and George Granville, as well as in the Book of Common Prayer. It is also found in French and German authors from the sixteenth to the eighteenth century. Richard Brinsley Sheridan (*The Duenna*), David Garrick, and Charles Lamb displayed the prejudice current in the eighteenth century.

As might be expected, the literature of the nineteenth century, reflecting the improved social, political, and religious condition of English Jewry, became more sympathetic, although there were those writers who were unable to throw off the yoke of traditional hatred. Influenced by the evangelical movement in religion, the political and industrial reform, and by the cultural achievement of English Jewry, the Romantic poets—Wordsworth, Coleridge, Southey, Scott, Shelley, and Byron—show an understanding and admiration of the Jews not found in previous literature. Historians like Dean Milman (*History of the Jews*), William Brown (*Antiquities of the Jews*), and W. E. H. Lecky (*History of Rationalism in Europe*) were all highly sensitive to

the Jewish genius as well as to the unjust treatment of the Jews throughout their history. A friendly attitude toward the Jews is seen in Matthew Arnold's "On Heine's Grave" and Algernon Charles Swinburne's "On the Russian Persecution of the Jews." Toward the close of the nineteenth century English literature became increasingly sympathetic toward Jews, partly because of the new outbreak of persecution on the continent. The high point of this new literary appreciation of Judaism and Jewish thought is found in the poems of Robert Browning (1812–1889), who joined Lecky in vigorously protesting the bigotry of Christianity and at the same time honoring the intellectual and spiritual genius of the Jewish people. His satirical poem "Holy Cross Day" was prompted by the seventeenth-century rule in Rome that once a year the Jews were forced to attend a "conversion sermon." The poem was prefaced by a quotation from the diary of a bishop's secretary in which it was stated that "as it was of old cared for in the merciful bowels of the Church, that, so to speak, a crumb at least from her conspicuous table here in Rome, should be, though but once yearly, cast to the famishing dogs . . ." [7] The poem describes the Jews' reaction to this annual occurrence:

> By the torture, prolonged from age to age,
> By the infamy, Israel's heritage,
> By the Ghetto's plague, by the garb's disgrace,
> By the badge of shame, by the felon's place,
> By the branding-tool, the bloody whip,
> And the summons to Christian fellowship,—
>
> We boast our proof that at least the Jew
> Would wrest Christ's name from the Devil's crew.[8]

Browning's interest in Jewish history and philosophy is conspicuous in "The Ring and the Book," "The Privilege

[7] Quoted in Montague Frank Modder: *op. cit.*, p. 257.
[8] *The Complete Poetical Works of Browning* ed. by Horace E. Scudder (Boston: Houghton Mifflin Company, 1895), p. 282.

of Burial," "Philippo Baldinucci," "Johanan Hakkadosh," and "Rabbi Ben Ezra." The last, one of the best known of all of his poems, goes to the heart of the Hebrew legacy to Western civilization: the moral imperative and the teleological principle of hope:

Grow old along with me!
The best is yet to be,
The last of life, for which the first was made:
Our times are in his hand
Who saith, "A whole I planned,
Youth shows but half; trust God: see all, nor be afraid!

Poor vaunt of life indeed
Were man but formed to feed
On joy, to solely seek and find and feast;
Such feasting ended, then
As sure an end to men;
Irks care the crop-full bird? Frets doubt the maw-crammed beast?

Then, welcome each rebuff
That turns earth's smoothness rough,
Each sting that bids nor sit nor stand but go!
Be our joys three-parts pain!
Strive, and hold cheap the strain!
Learn, nor account the pang; dare, never grudge the throe

So, take and use thy work:
Amend what flaws may lurk,
What strain o' the stuff, what warpings past the aim!
My times be in thy hand!
Perfect the cup as planned!
Let age approve of youth, and death complete the same! [9]

Shylock and Fagin are the classic examples of Jewish caricatures in English literature, but neither Shakespeare nor Dickens can be accused of anti-Semitism. The total im-

[9] *Ibid.*, pp. 383–4.

pact of *The Merchant of Venice* was an exaggerated picture of the moneylender, but Shakespeare came to his defense as a human being. Dickens' consuming interest in *Oliver Twist* was to expose the degrading laws in London at the time and the miseries endured by thousands of children in the city. His use of the character of Fagin was not to malign him as a Jew but to expose the underground thieves, one of whom was Fagin, who happened to be a Jew. The novelist was equally caustic in his denunciation of Christian villains. The perceptive reader cannot fail to notice that Fagin is not very Jewish. He is, in fact, an outcast, belonging to no synagogue, is unfriendly to rabbis, and is separated from his people.

In reply to a letter of protest from a Jewish woman, Mrs. Eliza Davis, Dickens wrote that although many Jews in his time were engaged in such criminal practices, "all the rest of the wicked *dramatis personae* are Christians," and continued, "I have no feeling toward the Jewish people but a friendly one. I always speak well of them, whether in public or in private, and bear testimony to their perfect good faith in such transactions as I have ever had with them. And in my *Child's History of England*, I have lost no opportunity of setting forth their persecution in old times. The Jews are a people for whom I have a real regard and to whom I would not willingly have given an offense or done an injustice for any worldly consideration."

What is written is written. Dickens may later have had qualms about the inclusion of Fagin in his novel. Evidence of this apologetic feeling is evident in *Our Mutual Friend* in which Mr. Riah, "the gentle Jew," was apparently used as an offset to Fagin. In the effort to make amends Dickens went possibly too far since Mr. Riah is as faultless as Fagin is diabolical. Both are extreme and unlikely personalities.

In summary, it seems fair to say that anti-Semitic literature in England was to a great extent balanced by the

favorable point of view. On the whole, English Jewry flourished after the readmission and has through the subsequent years enjoyed a measure of freedom not found in European countries. English Jews became a vital part of British life, contributing to its cultural, commercial, and political advancement. The reason for the success of the assimilative process has been well stated by Cecil Roth.

> That this has been possible is due in no slight measure to the process of Anglo-Jewish history—a gradual acceptance based on common sense rather than on doctrine, consolidating itself slowly but surely, and never outstripping public opinion. Hence it has been possible for the English Jews to exemplify how men can enter a society by methods other than descent, and to absorb traditions which are not those of their physical ancestors. If their reaction to privilege has been to deserve it, it is because they have the good fortune to possess as their inheritance two noble histories.[10]

The anti-Semitism of English literature was after all not an activated one. It was a gimmick used by authors to catch the public eye but who, without malice aforethought or willful design, were guilty of perpetuating a medieval prejudice. It was not a source of action like much of the German philosophical writing that issued in the worst persecution in all history.

France

After the expulsion in 1394 the only Jews to be found in France for several centuries were *marranos* and Jews who had become loyal Christians. It is safe to say that in the sixteenth and seventeenth centuries the average Frenchman had not seen a real Jew in his lifetime. In spite of this, and probably because of it, the derogatory characterization of Jews had become so axiomatic that dictionaries defined

[10] Cecil Roth: *A History of the Jews in England,* 3rd ed. (Oxford: Clarendon Press, 1964), p. 270.

a Jew as "one who sells at exorbitantly high prices and, in general, anyone seeking to gain money by sharp dealings."

The description of Jews as wicked, perverse, the epitome of evil, was not seen as something exceptional or as something requiring proof, but was considered axiomatic— a fact demonstrated by the inclusion of deprecatory statements in seventeenth-century church catechisms.

> Did Jesus have enemies? Yes, the carnal Jews. To what point did the hatred of Jesus' enemies go? To the point of causing his death. What became of the Jews? They were reduced to servitude and scattered throughout the world. What has become of them since? They are still in the same state.[11]

The Reformation was a minor influence in France but it led to a small philo-Semitic movement through the new interest in the Old Testament and Hebrew studies. Théodore de Bèze (1519–1608), co-leader with Calvin of French Protestantism, laboring under the ambivalent idea that the Jews were forever guilty of deicide and must be punished, but, as foreordained witnesses to the divine plan of salvation in Christianity, must be tolerated and protected from undue persecution, maintained a dualistic and confused view, as seen in his prayer:

> Lord Jesus, it is true that thou justly punish the scorn that is directed against thee; and this ungrateful people has deserved thy severe punishment. But Lord, remember thy covenant and look upon these unhappy creatures favorably because of thy name. As for us who are the most wretched of men, yet whom thou nevertheless judge worthy of thy pity, grant that we may advance in thy grace, so that we may not be for them instruments of thy wrath, but that we may rather

[11] Quoted by Léon Poliakov: *The History of Anti-Semitism,* Vol. I, trans. by Richard Howard (New York: Vanguard Press, 1965), p. 180, from the catechism of Abbé Fleury (*Catechisme historique*), which in the course of two centuries went into 172 editions. For pamphlets and tracts vilifying the Jews of this period see Poliakov, pp. 184–197.

become capable of bringing them back into the true way by virtue of thy Holy Spirit.[12]

Richard Simon (1638–1712) one of the seventeenth-century forerunners of modern Biblical Criticism, likewise held this contradictory attitude toward Judaism. In his earlier studies he took the historical view and recognized the importance of Jesus as a Jew, the New Testament as written by Jews, and Judaism as the parent religion to which the best in Christianity was indebted. Later he came to share the common French hatred of "this miserable nation."

Blaise Pascal also assumed a contradictory posture and was baffled by the role of "the mysterious Jew."

> It is a wonderful thing and worthy of particular attention to see this Jewish people existing so many years, always in misery, for it is necessary as a proof of Jesus Christ, both that they should continue to exist, and that they should be miserable because they crucified him.

To the modern mind this is queer logic but, appearing in the writings of an intellectual like Pascal, it only demonstrates how deeply the traditional theological argument for anti-Semitism had penetrated the consciousness of Christendom. A mathematical genius is not necessarily a philosophical genius. Trained in the a priori deductive reasoning of Scholasticism, Pascal was unable to argue without resorting to a questionable major premise. Consider his proof of the validity of transubstantiation:

> How I hate these follies of not believing in the Eucharist, etc.! If the Gospel be true, if Jesus Christ be God, what difficulty is there ? [13]

Pascal accepted the Catholic tradition in its entirety and devoted himself to a casuistical proof of its truthfulness and

[12] From *Nouveau Testament Grec* with commentary by Bèze (1589).
[13] *The Provincial Letters, Pensées, and Scientific Treatises,* trans. by W. F. Trotter (Chicago: Encyclopaedia Britannica, Inc., 1955), p. 212.

of the falseness of the Jewish religion, a procedure which
contains many contradictions.

> The Jewish religion is wholly divine in its authority, its dura-
> tion, its perpetuity, its morality, its doctrine and its effects.
> . . . No sect or religion has always existed on earth but the
> Christian religion. . . . The synagogue did not perish be-
> cause it was a type. But because it was only a type, it fell
> into servitude. The type existed till the truth came in order
> that the Church should be always visible, either in the sign
> which promised it, or in substance. . . . God made use of
> the lust of the Jews to make them minister to Jesus Christ
> who brought the remedy for their lust. . . . The Jews, who
> have been called to subdue nations and kings, have been the
> slaves of sin; and the Christians, whose calling has been to
> be servants and subjects, are free children. . . . The Church
> has three kinds of enemies: the Jews who have never been of
> her body; the heretics who have withdrawn from it; and the
> evil Christians, who rend her from within.[14]

The anti-Semitic propaganda of seventeenth- and eight-
eenth-century France took many forms—ballads, canticles,
sermons, pamphlets, catechisms, and dogmatic treatises, all
of which sustained and increased a hatred of the Jews in the
public mind. All reiterated the axiom that the Jews were the
enemies of God and agents of Satan, predestined to eternal
punishment for their murder of Christ and for their rejec-
tion of the true religion. Prominent among anti-Judaic writ-
ers of this period were Bousset, Boucher, Bourdalone, Flé-
chier, Massilon, and de Montfort. More remarkable than any
of these, however, was the attitude of the rationalists of the
Enlightenment. It is surprising, for instance, to encounter
anti-Semitic statements in the writings of Voltaire (1694–
1778), champion of civil rights, religious liberty, tolerance,
and reason. To be sure, his vitriolic assaults on the Jews and

[14] *Ibid.*, pp. 279, 280, 291, 294, 295, 335.

Judaism are to be understood only as an integral part of his campaign against all superstition, parochialism, and unreason, Jewish or Christian. But this can hardly excuse his apparent belief in the ritual murder legend and his characterization of the Jews as "the vilest of people, ignorant and barbarous, obtuse, cruel, and absurd, a people who have long united the most sordid avarice with the most detestable superstition and the most invincible hatred for every people by whom they are tolerated and enriched." [15]

Arthur Hertzberg contends that "some of the greatest founders of the liberal era modernized and secularized anti-Semitism." [16] He singles out Voltaire, Diderot, and d'Holbach as guilty of the grossest prejudice. Although anti-Semitic statements, particularly those related to the trustworthiness of the Old Testament, can be authenticated, assuredly it would be unfair to indict the whole Enlightenment as prejudicial against Jews. The total impact of the liberal movement in France was, in fact, quite the opposite. Montesquieu and Mirabeau were entirely free from anti-Judaism; and, as has been pointed out, Hertzberg's case against Diderot is exceedingly fragile.[17]

The early Socialists in France, opposed to the commercialism of the time, blamed the Jews for the increasing materialism. Charles-Marie Fourier (1772–1837), the leader of the group, saw every Jew as a Shylock and the Jews on the whole as a race of ruthless exploiters. Those who followed Fourier made the most of the popular image of the Jew as a greedy moneylender and thus catered to the masses. The following quotation from Toussenel, a socialist of the Fourier school, is typical of this view of the Jews:

[15] *Dictionnaire Philosophique,* article on "Juifs," XLI, p. 152. Diderot, Rousseau, and d'Holbach held similar views.

[16] Arthur Hertzberg: *The French Enlightenment and the Jews* (New York: Columbia University Press, 1968).

[17] *Saturday Review,* August 17, 1968, p. 20 (Letter by Leon Schwartz).

Like the masses of the people, I apply the odious name of
Jew to all the people who lived by the manipulation of
money, to all the exploiting parasites who live by the sweat
of others. A Jew, a money-lender, a businessman, these are
all synonymous to me . . . I did not find in my mother-
tongue another name than Jew with which to stigmatize
those that I wanted to condemn.[18]

The identification of the Jews with capitalism and the evil
world of banking was the recurring theme of later well-
known Socialist writers, notably Pierre Leroux (1797–1871)
and Pierre-Joseph Proudhon (1809–1865).

The anti-Jewish utterances of the French rationalists
were more or less incidental and were of little consequence
compared with the fanatical and devastating crusade of
Edouard Drumont in the late nineteenth century. His book
La France Juive (1886) is the culmination of Jew-hating in
its most mendacious form. At the same time, it was the pro-
totype of modern ethnic and political anti-Semitism, which
contributed to the world-conspiracy theory and which led
ultimately to Nazism. Drumont regarded himself as a Mes-
siah, the deliverer of France and the world from the inter-
national intrigue of the Jews, to whom he attributed all the
economic ills of his country and whom he accused of plotting
to destroy Christianity. With the Inquisition as his inspira-
tion he had little trouble gaining the support of the Catholic
press and the clergy. His book went into 140 editions in a
decade and was translated into several European languages.
The desperate economic condition of the people made them
all the more susceptible to his campaign against the Jews
who, he said, owned more than half the wealth of France.[19]

[18] Quoted by Jacob Bernard Agus in *The Meaning of Jewish History*
(New York: Abelard-Schuman, 1963), Vol. II, pp. 343–344.
[19] The number of Jews in France at this time amounted to only one-
fourth of one percent of the total population and most of them were poor.

Gathering up the various forms of anti-Semitism—religious, economic, and ethnic—Drumont, along with the German philosophers, Kant, Hegel, Fichte, and Herder, helped pave the way for the twentieth-century Aryan racial theory. Because of his scurrilous attacks, based on pure myths and pious legends, he made Jew-hating an indispensable ingredient of the Catholic religion. He was regarded as an apostle inspired by God to save Christianity. "A will from above," he said, "told me to speak and I have spoken. In standing against the perfidious Jews, I am defending the handiwork of the Lord. Christ saw the integrity of my soul and rewarded me by enabling me to learn Total Truth." Not even the Nazi propagandists could approach the incontinent and obscene utterances of this charlatan whom Malcolm Hay appropriately called "one of the godfathers of Belsen." With the exception of two or three French intellectuals his ruthless scurrility was eagerly devoured by the French people. One of his favorite themes was the ritual-murder accusation in which he constantly referred to Jews "who, met together for ritual murder, look at each other with merry glances while, from the open wound of their victim, issues pure and scarlet the Christian blood destined for their sweet bread of Purim."

In Drumont's later work *La Fin d'un monde* he continued in the same vein, urging the pillaging and imprisonment of wealthy Jews. As the representative of Christ, he informed his readers that he had "taken up the defense of the oppressed against the thieves and exploiters of the poor." The total effect of Drumont's writing was to make medieval anti-Semitism a modern French tradition and to provide the setting for the cause against Dreyfus and to strengthen the theme of Jewish world-supremacy. Brainwashed by the Church, the French people, inheritors of the French Revolution, remained bigoted, provincial, and xenophobic toward all forms of secularization and liberalism.

Germany

The continuation of medieval anti-Semitism in France is understandable but its tenacious grip on the Humanists and Reformers of Germany is indeed anomalous. In spite of their interest in Hebrew studies they accepted the traditional doctrine that the Jews must be kept alive as testimony to the truth of the Gospel, but must be made to live in perpetual misery. Johann Reuchlin (1455–1522), foremost Hebraist of the Renaissance-Reformation, defended the Talmud against the conservative Catholic attack and with the support of Leo X finally won the day. But when it came to the Jewish people, he called them a "barbarous and obstinate race."

In the early days of the Reformation, Martin Luther (1483–1546) saw in the anti-Catholic position of the Jews good reason for thinking that they would turn to Protestantism as a more desirable form of the Christian religion. In this he too held to the Patristic doctrine that the Jews must be tolerated as apostates with the expectation of their conversion. This was the basis of his earlier defense of Jewry. In 1523 he published a pamphlet called *That Jesus Christ was born a Jew* in which he tried to demonstrate that Jesus was the true Messiah and in which also he denounced the Catholic hierarchy for persecuting the Jews:

> . . . Our fools, the popes, bishops, sophists, and monks—
> the crude asses' heads—have hitherto so treated the Jews that
> anyone who wished to be a good Christian would almost
> have had to become a Jew. If I had been a Jew and had seen
> such dolts and blockheads govern and teach the Christian
> faith, I would sooner have become a hog than a Christian.
>
> They have dealt with the Jews as if they were dogs rather
> than human beings; they have done little else than deride
> them and seize their property. When they baptize them they
> show them nothing of Christian doctrine or life, but only
> subject them to popishness and monkery. . . .

I hope that if one deals in a kindly way with the Jews and instructs them carefully from Holy Scripture, many of them will become genuine Christians and turn again to the faith of their fathers, the prophets and patriarchs. . . .

When we are inclined to boast of our position we should remember that we are but Gentiles, while the Jews are of the image of Christ. We are aliens and in-laws; they are blood relatives, cousins, and brothers of our Lord.[20]

Luther's disappointment at the failure of Jews to turn to Christianity and the conversion of some Christians to Judaism caused him to turn against the Jews with a vehemence that betrayed his religion and disgraced him personally. In his book *Against the Jews and Their Lies* (1542) he called the Jews' attention to the fact their temple and religion "were destroyed over 1460 years ago. Give this nut to the Jews and let them break their teeth on it. For the cruelty of divine wrath shows all too clearly that they are surely in error and on the wrong path."

Luther attacked the Jews from all sides—ethnic, economic, racial, and religious. He regarded them not as Germans, but as aliens. "The Jews, being foreigners, should possess nothing and what they do possess should be ours. . . . To this day we do not know what brought them into this country." Resorting to the pious approach, he continues:

Know, O adored Christ, and make no mistake, that aside from the Devil, you have no enemy more venomous, more desperate, more bitter, than a true Jew who truly seeks to be a Jew. . . . Now, whoever wishes to accept venomous serpents, desperate enemies of the Lord, and to honor them, to let himself be robbed, pillaged, corrupted, and cursed by them, need only turn to the Jews. O God my beloved Father, have pity on me who in self defense must speak so scandalously against thy wicked enemies, the Devils and the Jews. You know I do so in the ardor of my faith.

[20] *Luther's Works*, ed. by Walther I. Brandt (Philadelphia: Muhlenberg Press, 1962), Vol. 45, pp. 200, 201.

He urged that their synagogues be burned, their books confiscated, that they be forbidden to worship in their own way, that they be made to work with their own hands, and that they be expelled from the employ of all princes.

Luther's imprecations were continued in a later pamphlet *Schem Hamphoras.* "It is as easy to convert a Jew as to convert the Devil. A Jewish heart is as hard as wood, as iron, as the Devil himself. In short they are the children of the Devil, condemned to the flames of Hell." He sinks to lower depths of obscenity in his sardonic ridicule:

> Cursed *goy* that I am, I cannot understand how they manage to be so skillful, unless I think that when Judas Iscariot hanged himself, his guts burst and emptied. Perhaps the Jews sent their servants with plates of silver and pots of gold to gather up Judas' piss with the other treasures, and then they ate and drank his offal, and thereby acquired eyes so piercing that they discover commentaries in the Scripture not to be found by us cursed *goyim*.[21]

We have quoted enough from Luther's diatribes to suggest that the failure of the Jews to turn to Christianity was not the only reason for his change of attitude. His disillusionment with the Protestant Reformation, especially its left-wing violence, and his internal conflicts contributed to his mental deterioration. He became subject to hallucinations and apocalyptic fears, seeing the Devil everywhere and obsessed with the imminent end of the world. He had his psychopathic moments when he called God the Devil, Christ an adulterer, and Christianity an absurd religion. Enmity

[21] Modern English editions of Luther's works tend to play down or omit completely his anti-Semitism. The Muhlenberg edition omits both *Von den Juden und Ihren Lügen* and *Schem Hamphorus.* In the Introduction to Volume 45, referring to the earlier pamphlet *That Jesus Christ was born a Jew,* the editor writes: "Luther has often been charged with anti-Semitism; however, there is no evidence of it in this treatise." The other two abovementioned treatises (than which no more acrimonius anti-Jewish utterances have ever been penned) are found in the Weimar edition (1883).

seemed to radiate from him. He could tolerate only those who acquiesced in his views. His invectives against the Pope and fellow-reformers were even more violent than those against the Jews. When Zwingli was killed in battle, Luther rejoiced that "that swine Zwingli" was dead. When it was clear that Erasmus would not go along with Luther's revolutionary tactics, the latter wrote: "He who crushes Erasmus cracks a bug which stinks even worse when dead than when alive." The scholar of Rotterdam was "the fiercest of Christ's foes; such an enemy of Christ does not appear more than once in a thousand years." His vehemence knew no bounds as he exclaimed: "When I pray 'Blessed be thy holy name,' I curse Erasmus and his heretical congeners who revile and profane God."

Perhaps we should assign such obscene outbursts to the unbalanced makeup of a genius. In view of Luther's role in history, it would be shortsighted to limit one's evaluation of him to certain psychological aspects of his personality, but there can be no doubt that the sensual often overcame the intellectual in this passionate, violent, demon-possessed prophet. It was natural that the Jews would be the object of his scorn, especially after their refusal to turn to Protestantism. "If I find a Jew to baptize," he once said, "I shall lead him to the Elbe bridge, hang a stone around his neck, and push him into the water, baptizing him in the name of Abraham."

As the events between 1521 and 1541 changed Luther's Reform, he himself became a changed man. The Peasants' Revolt, schisms within the Reformation party, and the mystical and communistic developments in Germany compelled him to resort to force and to side with the rulers in putting down the common people. The Lutheran Reformation became an authoritarian movement and its leader spoke now of slavelike obedience instead of human freedom. Although there was no connection between this disastrous develop-

ment and Judaism, Luther saw one and attributed the turn
of events to the Devil and the Jews, just as medieval priests
blamed the Black Death on them. From a theological point
of view the Lutheran principle of justification by faith stood
opposed to the typical Jewish doctrine of justification by
"works" or moral acts—a conflict which added to the grow-
ing national antipathy to the Jews.

Turning to the philosophical and historical literature of
Germany in the eighteenth and nineteenth centuries, we
should not expect any appreciable amount of anti-Semitism
in view of the presumably long-range and universal frame of
reference of the philosopher and historian. We should, in
fact, be prepared for a detached, objective *Weltanschauung*,
one that is independent of religious traditions. It comes as a
surprise, therefore, to learn that Kant and Hegel accepted
the popular Christian position on Judaism and its place in
history. Kant took a non-philosophical position in dealing
with the historical reality of Judaism. He was content to fol-
low the unhistorical attitude of both official and popular
Christianity in seeing Judaism only as a legalistic system,
which disregarded human will and human values. In his
mind the rule of statutory law excluded the primacy of mo-
rality as a conscious act of volition. This view ignores the
essence of Judaism—the moral imperative—to use Kant's own
description of ultimate reality. His negative evaluation of
Judaism also reveals a failure to achieve the synoptic view
as over against the one-sided acceptance of tradition.[22]

Philosophy is supposed to synthesize two contradictory
traditions in a field of values that is higher than either. Kant
espouses the well-established tradition that Judaism repre-
sents justice or law, while Christianity is defined as love or
grace, one of Paul's oversimplifications. To be unable to ar-
rive at a comprehensive conception that subsumes contra-

[22] See Nathan Rotenstreich: *The Recurring Pattern* (New York: Hori-
zon Press, 1964), pp. 16–20.

dictory traditions shows an absence of the critical process which must always precede any synthesis. More specifically, Kant objects to Judaism on the grounds that its *raison d'être* —the Law—is not based on reason but on divine revelation. As a superimposed legislation, the Jewish system, he maintains, lacks a truly ethical base. True, the Mosaic Code was considered a supernatural revelation, similar to the revealed word of other religions, but it must be remembered that the biblical criterion for the Hebrews was the Law *and the Prophets.* Contrary to Kant, the juridical and moral elements cannot be considered as mutually exclusive. It is righteousness that God expects from his people, not prescribed ritual.

> I hate, I despise your feasts,
> and I take no delight in your
> solemn assemblies.
> Even though you offer me your
> burnt offerings and cereal of-
> ferings,
> I will not accept them,
> and the peace offerings of your
> fatted beasts
> I will not look upon.
> Take away from me the noise of
> your songs;
> to the melody of your harps I
> will not listen.
> But let justice roll down like waters,
> and righteousness like an ever-
> flowing stream.
> (Amos 5:21–24)

> For I desire steadfast love and not
> sacrifice,
> the knowledge of God, rather
> burnt offerings.
> (Hosea 6:6)

With what shall I come before
 the Lord,
and bow myself before God on
 high?
Shall I come before him with burnt
 offerings,
 with calves a year old?
Will the Lord be pleased with
 thousands of rams,
 with ten thousands of rivers of oil?
Shall I give my first-born for my trans-
 gression,
 the fruit of my body for the sin of
 my soul?
He has showed you, O man, what is
 good;
 and what does the Lord require of
 you
but to do justice, and to love kindness,
 and to walk humbly with your God?
 (Micah 6:6–8)

 Kant implies that a juridical type of God is not a moral God; that the Jewish religion is based on specific laws rather than universal principles; that it is a visible organization, not a spiritual movement; and that there was no organic connection between Judaism and Christianity. On the contrary, the religion of Judaism consists of three universal principles which constitute its contribution to Christianity: monotheism or the worship of one God, ethics or the moral criterion in religion, and teleology or the philosophy of hope.

 Kant further holds that, unlike Judaism, Christianity is a rational religion based on principles ascertained through pure reason rather than experience. This is a strange observation in view of Jesus' consistently pragmatic, experiential ethics. "By their fruits ye shall know them." Christianity, founded not by Jesus but by Paul and the early apologists

and theologians, was a system that was anything but rational. It was a religion based on supernatural a priori assumptions and offered salvation through sacramental works.[23]

From an emotional or personal standpoint Hegel rejected Judaism as a "race of slaves" destined to be forsaken by God. Philosophically he agreed with Kant in calling Judaism a "non-spiritual" entity, a legalistic religion governed by "statutory commands, dead formulas."[24] God is the Lawgiver; the people are slaves under bondage to the Law. According to Hegel, a people whose religion is made up entirely of external laws cannot have a metaphysics.

Unlike Kant, Hegel saw some continuity between Christianity and Judaism, but his discussion of the connection was always disparaging to the latter:

> While the Jews thought they had satisfied God with their external ceremonies, it was impressed on the Christians that everything depended on the frame of mind in which two people performed the same action . . . in Judaism, only actions were commanded, the Christian church goes farther and commands feelings.[25]

Hegel recognized at least the contribution to Christian thought of the idea of the Kingdom of God. In his later writings he shifted the emphasis from laws to God himself and saw Judaism as a God-centered religion. His description of the Hebrew idea of God as transcendent rather than immanent, alien and apart from men, is for the most part correct. Here again Judaism and Calvinism were alike in worshiping a God of power and sovereignty, creator and ruler of the universe. As a result of this alienated view of God, said

[21] Rotenstreich, *op. cit.*, believes that Kant wielded considerable influence on the embryonic movement for the reform of Judaism by emphasizing the necessity of doing away with its legal and ritual aspects.

[24] Georg W. F. Hegel: *Early Theological Writings*, trans. by T. M. Knox (Chicago, 1948), pp. 68–69.

[25] *Ibid.*, p. 140.

Hegel, Judaism lacks the mystical element, the experience of the unity of man and God (the *unio mystico* of the Oriental religions). But if this is so, it must also be borne in mind that the very absence of mysticism in Judaism made that religion more ethical in its emphasis.

The chief criticism of Judaism by Kant and Hegel was that it is a religion of law. Their anti-Semitism was theoretical and cannot be considered as affecting the political life of Germany as was the case in the racist philosophy of Johann Gottlieb Fichte (1762–1814). Fichte was one of the chief sources of the Teutonic Aryan myth. He extended Kant's *Categorical Imperative* to a nonrational level where the forces of good opposed the forces of evil. The good are those whose lives are governed by the inner imperative of intuition, while the evil are those who are guided by external reason. This theory led Fichte into the camp of the anti-liberals who were opposed to the democratic movement, rationalism, and individualism. To him the Jews were the embodiment of liberalism and were the enemies of the emerging German nationalism. He used the ancient idea of the "Chosen People and the separateness of the Jews to develop the racial anti-Semitism which generated the Nazi philosophy. Sharing in the maturation of this stream of thought were Johann Gottfried von Herder (1744–1803) and Friedrich E. D. Schleiermacher (1768–1834).

Historiography

In our consideration of anti-Semitism in literature, it remains for us to mention briefly the opinions of two historiographers: Oswald Spengler (1880–1936) and Arnold J. Toynbee (1889–). Perhaps the writings of these two men regarding Judaism should be termed "controversial" rather than explicitly anti-Semitic since their approach is strictly historico-philosophical. But it is difficult to relieve them of an implicit anti-Judaic point of view. Toynbee's at-

titude as set forth in *A Study of History* was so unacceptable to Jewish scholars that he felt compelled to write a volume of revision and partial retraction.[26]

Both historians hold that contemporary Judaism is merely a remnant that, as a historical movement, ran its course and died out. Spengler calls Judaism a "fellah" religion, a primitive faith with no real history, characterized by rigidity rather than development. Like Toynbee, he compares Judaism with the Parsees of India, the modern remnant of the Persian religion of Zoroastrianism.

> Both Jewry and Persia evolve from tribal groups into nations of Magian cast, without land, without unity of origin, and (even so soon) with the characteristic ghetto mode of life that endures unchanged today for the Jews of Brooklyn and the Parsees of Bombay alike. . . . While Western man, from the days of the Saxon emperors to the present, has (in the most significant sense of the words) *lived* his history, and lived it with a consciousness of it that no other Culture can parallel, the Jewish Consensus ceased to have a history at all. Its problems were solved, its inner form was complete, conclusive, and unalterable.[27]

Toynbee, while laying claim to a universal outlook on history and the history of religions, is neither universal nor historical in his treatment of Judaism. His keyword, the equivalent of Spengler's "fellah religion," is "fossil." "From the Gentile standpoint," he writes, "modern Jewry is the 'fossil' remnant of a society that is extinct." [28]

> The scattered survivors of Jewry are left with the cold consolation of remembering that their forefathers volunteered

[26] Arnold J. Toynbee: *A Study of History: Reconsiderations* (London: Oxford University Press, 1961), Vol. XII.

[27] Oswald Spengler: *The Decline of the West*. Translation of *Der Untergang des Abendlandes* by Charles Francis Atkinson (New York: Alfred A. Knopf, 1928), Vol. II, pp. 315, 319.

[28] Arnold J. Toynbee: *A Study of History* (London: Oxford University Press, 1933–1939) Vol. II, p. 55.

on a forlorn hope and went down to destruction in a splen-
did failure. . . . The medium in which all their Syriac fos-
sils have been preserved is a religious medium; their religious
idiosyncrasies, which have safeguarded their identities and
perpetuated their existence in their fossil state, have also
exposed them to religious discrimination at the hands of the
alien societies in the midst of which they have managed to
survive; this penalization has taken the usual form of exclu-
sion from certain walks of life; and it has evoked the usual
reaction in its victims.[29]

The analogy drawn between Judaism and the Parsees
as remnants is defective in several ways. The Parsees, since
their migration to India, have been confined to Bombay,
whereas the Jews have been for over two millennia scattered
over the earth as a competing religion with Islam and Chris-
tianity. Furthermore, there is no comparison between the
tiny isolated sect of the Parsees and the influential religion
of Judaism both in history and the world today. Finally, the
attitude of the two cultures is vastly different: Judaism rein-
terpreting its history and adjusting to succeeding phases of
civilization and the Parsees resting content with their tradi-
tional existence.

In some respects Toynbee's "fossil" theory shows a de-
pendence on Augustine, who held that the Jews survived
their political downfall in order to serve as a living witness
to victorious Christianity. Toynbee, on the other hand, sees
no meaning in the survival of the Jews as a remnant. In his
book of reconsiderations, he defends his use of the term "fos-
sil" as a relic of the Syriac civilization in its development be-
fore the "intrusion of Hellenism." Otherwise, he modifies his
former views. He is apparently caught in the dilemma of de-
fining Judaism as either ethnic or religious. In this he is no
different from many contemporary Jewish leaders and, in his
case, he insists that the two views are compatible. In his re-

[29] *Ibid.*, pp. 286, 402.

appraisal Toynbee makes some concessions and at least is generous enough to quote his critics in detail and with respect. He feels that the ossification of Jewish religious observances made possible the continuity of the movement.

> In the two cases of the Jewish community and Judaism and the Parsee community and Zoroastrianism, the word "fossil" evidently does provide an apt metaphor for conveying the two important facts that the religious observances of the two communities have become ossified and that these ossified observances have served as an effective social cement. They have enabled the participants in each of these two communities to keep their communities in existence, and this for many centuries running, without having a state of their own or even a country in which they were at home and in a majority.[30]

He also concedes the developmental nature of Judaism and at times refers to Judaism as a "great religion." In his previous volumes he had tended to define the Jewish concept of God as purely tribal. Later, he recognized the universalistic character of God as taught in II Isaiah, Deuteronomy, Job, and the post-biblical period.

There is the danger of exaggerating the importance of Toynbee's phrases in the light of his total work, but in the instances cited, it must be said, he was unfortunate in his choice of words. In lending himself to the traditional Christian view that the Jews had a history only up to the advent of Christianity and survived that only as a necessary witness to the Christian gospel, Toynbee denies the Jewish people their rightful place in the history of Western civilization.

[30] Toynbee: *A Study of History: Reconsiderations*, Vol. XII, p. 297.

THE CHRISTIAN BARRIER

Unchanging Dogma

IN OUR LAST TWO CHAPTERS we turn to a consideration of the contemporary scene as it bears on Jewish-Christian relations. Overt or active anti-Semitism exists in Russia, in varying degrees in other European countries, in Argentina, and in the United States among extremist right-wing groups. America has never provided a fertile soil for the growth of political-racial anti-Semitism, but in the period following World War I many anti-Jewish movements sprang up throughout the country. Foremost among the fanatical right-wing groups was the Ku Klux Klan, which was revived in the early 1920's. In the same period Henry Ford's *The Dearborn Independent,* inspired by the faked *Protocols of Zion,* spread a hatred of Jews as aliens and monopolizers of American business. Ford's magazine was followed by a flood of anti-Jewish literature. In the 1930's the attack became political, as Jews were blamed for the spread of international communism. This was the era of such frenetic organizations as the Silver Shirt Legion, the Khaki Shirts, and the American Vigilante Intelligence Organization. It was the period of Gerald B. Winrod; Gerald L. K. Smith; Louis V. McFadden; the American Führer, Fritz Kuhn; and the demagogue Father Cough-

lin with his *Social Justice.* This brand of anti-Semitism appears in times of economic crisis and although it does not take deep root, it is a warning. A more endemic anti-Semitism is that of social discrimination, a hostility that does have a historical European tinge in that it arises not so much from the feeling that the Jew is culturally and intellectually inferior but from the knowledge that he is superior. But even this is hopefully on the wane; at any rate, it is not so significant as the unconscious anti-Semitism with which we are here concerned. This is purely a theological matter. Generally, American anti-Semitism is of the passive or implicit type and applies to the entire body of conservative Christianity—and that means the vast majority of Christians. This anti-Semitism is inherent in the doctrine, hymnology, art, and ritual of the Church. In spite of the ecumenical spirit, Vatican II, the New Testament interpretation of liberal scholars, and the results of Historical Criticism, there has been no change in the Christological beliefs of the Church —Protestant, Roman Catholic, or Orthodox—and there is little likelihood of any modification in the foreseeable future. The basic dogmas of the Church stand as an impassable wall before Judaism and reduce whatever *rapprochement* exists to a tolerant coexistence or surface congeniality.

The offense of Christianity has remained constant from the fourth century to the present hour. It consists in the belief in the trinity (however rationalized), the deityship of Jesus (however interpreted), the incarnation, the atonement, and the primacy and uniqueness of the Church as the sole instrument of salvation. The only organized groups who reject the traditional beliefs of Christianity are the Unitarian-Universalists, Religious Humanists, and liberal Friends. To these can be added an increasingly large number of individuals who hold nominal membership in Protestant denominations but do not accept their beliefs. Christians who hold to the traditional dogmas do not think they are in any way

anti-Jewish. The ideology, which they fell heir to and which they defend, has no necessary relation to the racial hatred of the professional or political anti-Semite. But their anti-Jewish attitude is a potential danger because the religious education of the orthodox churches is only a transmission of an inherited tradition that has remained immune to the theological reconstruction and historical interpretation of modern liberal scholars. The biblical material on the Pharisees and Jesus, the rejection of Jesus by the Jews, the Crucifixion, and the atoning significance of Jesus' death are taught in a noncritical manner and can only result in the belief on the part of younger people that the Jews are a hostile group. Moreover, the biblical and early-church situation is usually identified with the present. Again, it is necessary to remind ourselves that such incipient prejudice cannot be related to contemporary aggressive racial anti-Semitism.

On the other hand, recent studies have shown that the image of the modern Jew as a Christ-killer, as beyond salvation or in need of conversion to Christianity, is far from dead in the churches. Of the 3000 church members interviewed in the Glock-Stark studies, it was found that of those who definitely were anti-Semitic well over one-fourth had a theological or religious background for their anti-Semitism.[1] Generally, anti-Semitic tendencies increase in direct ratio to orthodox Christian belief, a natural consequence, since a dogmatic acceptance of the New Testament, with its implication of the uniqueness of the Christian revelation, would lead both to a feeling of superiority regarding Christianity and hostility or condescension toward Judaism. It is also clear that until Christian education learns to place the New Testament in its historical setting and to see it as a fallible human document and until Christians themselves develop a

[1] See Charles Y. Glock and Rodney Stark: *Christian Belief and Anti-Semitism* (New York: Harper and Row, 1966), the first volume of a projected six-volume study.

more liberal spirit, seeing themselves as equal members of a pluralistic society, anti-Semitism will continue to flourish.

Olson's study also indicates, with certain exceptions, a direct relation between prejudice and traditional theological presuppositions.[2] The Fundamentalist position on Judaism is ambiguous. Whereas it condemns contemporary anti-Semitism and teaches that "God has not abandoned the Jews," it often projects its generalizations from the distorted New Testament views to the present day. As Olson says, it unconsciously transfers the reference to Pharisees "from a few to all Pharisees, from all Pharisees to all Jews in the time of Jesus, and from all first-century Jews to Jews of any time or place."[3] The Conservatives tend to distort the Jewish image, regarding Judaism as a false religion and the Jews as unbelievers. They hold to the biblical and Patristic dualism of divine judgment on the Jews (dispersion) and their preservation. By their rejection of Christ they believe the Jews forfeited their place as God's people.[4]

Liberals and Neo-Orthodox are clearly anti-ethnocentric, have a more favorable attitude toward Jews, emphasize the morality, Godliness, and wholesome family life of Jews, and work for a better relationship between Christianity and Judaism.[5] On the other hand, there are important theological differences between the Liberal Unitarian-Universalist and the Neo-Orthodox Presbyterian curricula. The one is purely monistic, believes in the immanence of God, is non-trinitarian, is concerned with Jesus exclusively as a human

[2] Bernard Olson: *Faith and Prejudice: Intergroup Problems in Protestant Curricula* (New Haven: Yale University Press, 1963), a comprehensive survey based on the curricula of four Protestant groups—Liberalism: The Beacon Press Curriculum of the Council of Liberal Churches; Neo-Orthodoxy: Christian Faith and Life and other curricula of the United Presbyterian Church; Conservative: the Concordia Publications of the Lutheran Church —Missouri Synod; Fundamentalist: curricula of the Scripture Press.

[3] *Ibid.*, p. 176.
[4] *Ibid.*, p. 43.
[5] *Ibid.*, p. 42.

being, holds that man as a son of God is potentially good, and rejects the ideas of revelation, the Bible as inspired, and Christianity as unique. The other is trinitarian, holds to the transcendence of God as separated from creation, believes in the divinity of Christ, defines man as a sinner alienated from God, and accepts the ideas of incarnation, special revelation, and the uniqueness of the Christian faith.[6] The Liberals regard history entirely as a human phenomenon whereas the Neo-Orthodox see God as revealing himself in history and at times intervening in the historical process. The Calvinistic idea of God's transcendent sovereignty, as held by the Neo-Orthodox group, makes for a fatalistic, dogmatic, and authoritarian philosophy. Religion thus becomes a matter of obeying external sanctions and laws independent of human will. According to this view, the salvation of the world does not lie in the human activization of potential goodness but in God's action in history, with the advent of Christ as the intermediary between God and man. Moral values are irrelevant to Neo-Orthodox theologians because man is a sinner in the eyes of God, and human judgments about "good" and "bad" are quite presumptuous.

Manifestly the theological position of Neo-Orthodoxy is far to the right of that of the Liberal churches. It is also clear that the Calvinistic rigidity of Neo-Orthodoxy must have a bearing on its views of non-Christian groups. The more two movements have in common in their world-views and values, the more congenial will be intergroup attitudes. Regardless of how progressive Neo-Orthodoxy is on social and political issues, Liberalism, theologically speaking, is much more favorably oriented toward Judaism. A dogmatic trinitarianism and an exclusive theism inevitably create conflict and cleavages in contemporary society.

The subject of Jews and the crucifixion of Jesus, despite an enlightened leadership in Protestant and Catholic

[6] *Ibid.*, p. 47.

churches, continues to be the main reason for tension and cause for Jewish concern. The Olson studies show that forty-three percent of Conservative lessons teach that the Jews killed Jesus and thirty-six percent of the Fundamentalist curricula contain that accusation, whereas the Neo-Ortho-dox and Liberal materials contain no such assertion. As we have previously pointed out, the Fundamentalist-Conservative picture of the Jews as transmitted from biblical teaching does not necessarily result in active hostility, but the presentation does make a distorted and deplorable impression on the minds of young people. More damaging to inter-group relationships is the adult Fundamentalist-Conservative belief that universal salvation is found only through the atoning death of Christ. The death of Jesus for the Neo-Orthodox constitutes a condemnation on all men as sinners; for the Liberals it is a martyrdom, typical of any prophet, and has no theological import. As for the rejection of the supernatural character of Jesus, the Liberals are on the side of the Jews.

The empirical studies of Glock and Stark show that belief in the traditional Christological tenets of the church bodies follows an ascending scale from the Congregational to the Catholic Church. This is seen in such beliefs as the unqualified divinity of Jesus as Son of God, the Virgin Birth, and the dependence of salvation strictly on the acceptance of Jesus Christ as Saviour.[7] A similar range is evident in the beliefs that the Jews were solely responsible for the crucifixion of Jesus, that Pilate wanted to spare Jesus, and that the Jews cannot be forgiven for what they did unless and until they accept Jesus as the true Saviour.[8]

[7] The Unitarian Universalist group understandably rejects completely such beliefs.

[8] For detailed statistics see Glock and Stark, *op. cit.*, pp. 7, 9, 23, 41, 54, and 62. The degree of orthodoxy in Protestantism—and it is consistent throughout the above-mentioned beliefs—rises in the following sequence: Congregational, Methodist, Episcopal, Disciples of Christ, Presbyterian,

The particularism of orthodoxy, which regards the Christian revelation as the only true faith is inevitably accompanied by two factors: the desire to convert the rest of the world to the true religion and a hostile attitude toward those who reject conversion. The latter reaction has an ancient background in the Jewish rejection of Christ. The particularist translates the ancient situation to the present and feels that the Jews are still guilty and are still suffering divine vengeance.

In view of our suspicion that there is at least some causal connection between theological dogmatism and secular anti-Semitism, it remains for us to consider what can be, and what has been, done about orthodox Christian beliefs. It is obvious from recent studies that the chief remedy for anti-Semitism—active or passive—is a radical reform of Christian education. This need was stated unqualifiedly by Lowell D. Streicher:

> Christian education relating to the Jewish people is in need of reform in two directions: first, to overcome contemporary American Christendom's abysmal ignorance in relation to the Jews—their history, religion and culture; second, to demolish once and for all the theological foundations of Christian anti-Semitism. The second goal cannot be attained apart from the first—a fact which most sincere opponents of anti-Semitism have overlooked.[9]

Protestant Ecumenicism

Attempts at better understanding between Judaism and Christianity often take the form of a rationalization of Christian doctrine by way of a "rejudaizing" process, which usually results in ambiguous casuistry. The incarnation and

American Lutheran, American Baptist, Missouri Lutheran, Southern Baptist, Sects. Generally, the Greek and Roman Catholic percentage of orthodox belief runs higher than the Protestant.

[9] Lowell D. Streicher: "Christian Education and the Jewish People," an article in *The Christian Century*, February 8, 1967.

atonement theories, for instance, are justified on the grounds
that they are implicit in Old Testament passages, that they
fit into Hebrew categories of thought. This amounts to a
proof-texting or prophetic verification. The "picture theol-
ogy" of the Old Testament, we are told, refers repeatedly to
a representative of God on earth—the Son of Man, the She-
kinah, Israel herself. The pictorial image or manifestation
of God took form in the sinless Jesus; thus the ontological gap
is bridged (!). The same logic is pursued in the argument
for the atonement. The Hebrew sacrificial system prepared
the way for the idea of a mediator between God and man.
The sinfulness of man necessitated the atoning role of Jesus.[10]
How appealing this mode of "bridge-building" is to Jews is
to be questioned. Many Christian theologians want to have
their theological cake and eat it too.

The logical solution to the problem of religious anti-
Semitism is the complete repudiation of traditional Christian
theology as found in the creeds, the hymnology, and the rit-
ual. With an ingrained line of thought that has 1900 years
behind it, a body of belief that to the average Christian *is*
Christianity itself, the possibility of modification is indeed
remote. A less ambitious but desirable goal would be the
attempt to turn to account the current emphasis on religious
liberty which might prevent beliefs from developing into
action. The only organized modern movement to reject en-
tirely traditional Christology was the Unitarian-Universalist
schism at the beginning of the nineteenth century. Individual
leaders and members of moderate groups have given up
certain beliefs such as the Virgin Birth and the bodily res-
urrection, but officially the denominations remain doctrinally
intransigent.

Greater progress is seen in the recent repudiation of the
accusation of deicide. Although the exoneration of Jews, an-

[10] Cf. George A. F. Knight: *Jews and Christians: Preparation for Dia-
logue* (Philadelphia: Westminster Press, 1965), pp. 108–136.

cient and modern, from the responsibility for the death of
Jesus was halfhearted in Vatican II and did not permeate
the ranks of the lower clergy or find true acceptance among
conservative Protestant bodies, it was an unprecedented
move in the right direction. The ecumenical movement as
a whole has fostered a new feeling of good will and inter-
faith communication. This wave of togetherness has also re-
sulted unfortunately in a false optimism, a feeling that the
problem of anti-Semitism is no longer serious. The continued
teaching of anti-Semitic beliefs in church-school curricula
and the outbreaks of active anti-Semitism among fringe
groups should warn us of the danger of complacency. Bigotry
and prejudice are still with us. The American Jewish Com-
mittee (1967) reported that twenty-two percent of the
American population had anti-Semitic attitudes. As a socio-
logical study, this report probably did not include beliefs
and feelings, thus resulting in a lower percentage than is
actually the case. It was conceded that "although openly
expressed prejudice is becoming less and less respectable in
our society, the study may have understated the actual prev-
alence of bigotry." [11]

The average Christian regards the theological system to
which he is committed as his "faith," a sacrosanct entity that
cannot be changed. The term "Higher Criticism" to him has
a negative, heretical connotation and is dangerous to his re-
ligion. This point of view is not confined to laymen but is
held by most conservative and fundamentalist clergymen.
Even relatively liberal ministers and professors of religion
refuse to assume any responsibility in combating traditional
biblicism. Because of the sociologically and theologically or-
iented curricula of seminaries today the majority of gradu-
ates know little or nothing of the findings of textual and lit-
erary criticism, early Christian extra-biblical literature, the
history of the canon, and the historical interpretation of the

[11] *The New York Times,* May 28, 1967.

Bible, much less Rabbinic and Talmudic Judaism. Many college teachers of religion still see Judaism through the pages of the New Testament as a purely legalistic, static movement.

As long as the Christian Church clings to its preposterous claim to be the true church and to possess a monopoly on truth, it will logically continue to regard all dissent as heresy and find it necessary to oppose it or convert its followers. The assumption that Christianity constitutes the only path to salvation has always been and remains the key to Jewish-Christian tension. The current efforts for coexistence and goodwill are too limited in their aims. An authentic expression of brotherhood would recognize the validity of non-Christian faiths. Jewish-Christian understanding depends upon pluralism becoming a way of life in religion as it is in other fields of activity.

The recent Protestant and Catholic attempts to establish a better rapport and mutual respect have been significant and must be recognized with gratitude, but the fact remains—and this is the primary obstacle to Jewish-Christian understanding—that these efforts have not gone far enough; their goals are too circumscribed. The doctrinal basis for genuine reconciliation has really not been confronted. After all the official statements and resolutions condemning anti-Semitism and pleading for friendship with the Jewish people, the dogma of Jesus' divinity and Messiahship remains intact. Accompanying this doctrine is the corollary belief that Judaism and the Old Testament were merely a preparation for Christ and Christianity, that Christianity is "Judaism come of age." Most of the organized efforts at better human relations with Judaism are maintained with the sole hope of the conversion of the Jews to Christianity. In other words, the aim of this friendship is the ultimate disappearance of Judaism. This is called "the unity in Christ's Church." The world meetings of the various churches in-

variably end with the statement that "the division will be healed when all Israel recognizes Jesus of Nazareth as its Messiah." [12]

The same statement has appeared in the official documents of the National Council of Churches of Christ in the United States of America and the World Council of Churches. At the First Assembly of the World Council of Churches in Amsterdam (1948), the Protestant Commission on the Witness of Israel issued a paper which declared that the refusal of Jews to embrace Christianity is a sign of unfaithfulness and that "the aim of general conversion cannot be anything less than the spiritual destruction of Jerusalem." A similar pronouncement was given at the 1961 meeting of the World Council of Churches in New Delhi, India.

Vatican II

Although the Vatican Council was one of the most significant events in the history of the Roman Catholic Church, the critical observer could not escape the impression that its achievements have been vastly overrated by the press. Its final resolutions on the Jewish problem left much to be desired. Liberal Protestants and Catholics observed with amazement the presumption of the Council in arrogating to itself the privilege of absolving the Jewish race today of the responsibility for the death of Christ nineteen centuries ago. Jews the world over were shocked at the idea of the Council playing God and deciding that the Jews be forgiven for a crime they never committed. It seems incredible that, with all the buildup and sanguine expectations attending the historic meeting on the issue of the Jews, the Curia and reactionary Italian cardinals were allowed to emasculate the original draft and finally put through such a halfhearted

[12] Bulletin on "The Relationship of the Church to the Jewish People," Lutheran World Federation's International Consultation at Lagumkloster, Denmark, 1964.

statement. The first draft had said: "The Jewish people should never be persecuted as a people, rejected of God or accursed or guilty of deicide." The final text omitted the word "deicide." The fact that the word had been used or that there should have been any debate on the question is appalling to any intelligent person.

The first draft read: "This synod, in her rejection of injustice of whatever kind and wherever inflicted upon men . . . deplores, indeed condemns, hatred and persecution of Jews, whether they arose in former or in our own days." The later version omitted the word "condemns," retaining "deplores." After the Catholic Hitler and his cohorts had murdered six million Jews, the Second Vatican Council lacked the courage to condemn anti-Semitic persecution! Even the softened tone of the revised statement—"What happened to Christ in his passion cannot be attributed to all Jews without distinction, then alive, nor to the Jews of today"—implies that many of the Jews were guilty. The phraseology of the first draft, like the official statements of Protestant World and National Councils, reiterated the expectation of "Christian unity in Christ," when Jews presumably will embrace Christianity. The final draft reads: "By His Cross Christ reconciled Jew and Gentile, making both one in Himself." This nullifies any expression of respect for non-Christian religions as equally valid paths to God. Both Protestant and Catholic official statements on the Jews retain the orthodox belief that the death of Jesus was theologically necessary—ignoring the fact that it was a purely historical circumstance in which the execution was an act of the Roman government.

The impetus for the Vatican Council came from Pope John XXIII and it is safe to say that the reactionary Curia would have had less influence in the final resolution if he had lived. The chief advocate of reform was Cardinal Bea, who introduced the original document with the hope that the whole matter would be kept within the religious frame

of reference, entirely free from political entanglements. He did not reckon with the delegates from the Near East, the representatives of the Arab governments, the Greek Orthodox and Coptic Churches, the Vatican Secretariat of State and the head of the Curia, Cardinal Ottaviani! Immediately upon the publication of the original draft Moslem outcries were heard in all Arab countries; a Cairo newspaper warned that the Pope on his planned visit to Israel might be assassinated by a Jew. The pressure of the bishops from Arab countries was so strong that the final resolution on non-Christian religions was high in its praise of Islam, acknowledging "all that is holy and true" in the Moslem faith; whereas the statement on the Jews was now guardedly and begrudgingly worded, a statement that was highly disillusioning to Jewish observers. As Paul Blanshard writes:

> The long wrangle over the wording of the various texts was humiliating to Jews throughout the world. Without courting the role, they had been forced into a position in which they looked like supplicants for justice at the Vatican Council. When the Council hemmed and hawed about the wording of a simple statement that might have been dashed off in a few hours, world Jewry reacted strongly, if not always publicly.[13]

It must be said that the fourth and final draft on the Jewish issue was condescending at best, a unilateral pronouncement instead of a humble and conciliatory confrontation. It contained no hint of guilt or remorse but assumed, as Catholicism always has, that Judaism was superseded by Christianity and reaffirmed that "the Church is the new people of God."

What made for further consternation were remarks made by Pope Paul after Vatican II. It was clear throughout

[13] *Paul Blanshard on Vatican II* (Boston: Beacon Press, 1966), p. 131.

the meetings of the Council that the ultraconservative Paul, with Ottaviani's support, would try to undo much of the achievement of Cardinal Bea and the liberals. His continued personal anti-Semitism was shown in a Passion Sunday speech in April, 1965, where he said that it is "a grave and sad page because it narrates the conflict, the clash between Jesus and the Hebrew people, a people predestined to await the Messiah, but who, just at the right moment, not only did not recognize Him but fought Him, strove against Him, calumniated Him, and finally killed Him." [14]

Paul's anti-Jewish bias was revealed shortly after becoming Pope. In his letter (1963) defending the attitude of Pius XII toward the Jews, he not only justified but praised Pius for his conduct. The letter came to light in connection with the uproar provoked by Rolf Hochmuth's play *The Deputy*, which had exposed the weakness of Pius in remaining silent throughout the Nazi genocide. "History will show," Paul wrote, "how vigilant, persistent, disinterested, and courageous that conduct [of Pius XII's] must be judged to have been, when viewed in its true context in the concrete conditions of that time. . . . Hochmuth's play . . . entirely misrepresents him . . . it is not true that Pope Pius XII's conduct was inspired by a calculating political opportunism." [15] As Blanshard comments, "the letter contains the implicit admission that at the most inappropriate moment for silence in all history the head of the Roman Catholic Church did keep silence." [16] In spite of worldwide mounting opinion against Pius, in 1965 Paul initiated the process of canonization of his former chief. Both the Hitler-Vatican Pact of 1933, which virtually gave the blessing of the Church to the Nazi regime, and the previous Mussolini-Vatican Con-

[14] *The Christian Century*, May 5, 1965, p. 571.
[15] *Commonweal*, February 28, 1964.
[16] Blanshard: *op. cit.*, p. 140.

cordat revealed the pro-Axis position of Pius XII and his
predecessor.[17]

Since Vatican II most of Paul's declarations on doctrinal
and disciplinary subjects have been authoritarian warnings
against change. His heated defense of the doctrine of origi-
nal sin, his failure to carry out the desires of John and the
progressives for modification of the Vatican position on birth
control, his insistence on the continuation of clerical celi-
bacy, his intransigence on Mariolatry, and his threatening
attitude toward the 1968 meeting of the Synod left the im-
pression with Catholic and Protestant liberals that he tried
to sabotage the accomplishments of Vatican II.

The American bishops and cardinals for their part, al-
though they had been at the forefront of the progressive
wing at Vatican II, at home became ambivalent in their po-
sition, operating on the basis of expediency, and, on the
whole, lagged behind the more liberal Catholic press. The
feeling grows among many laymen that no real reform is
possible as long as the Church is governed by an authoritar-
ian hierarchy.

At long last, and reluctantly, Pope Paul in 1968 ac-
cepted the resignation of Ottaviani, the chief opponent of
Aggiornamento, Grand Inquisitor of the modern Holy Office
and enemy of religious freedom, whose motto was *semper
idem* ("always the same"). Paul's later action in accepting
the resignation of a half-dozen old and conservative mem-
bers of the Curia was welcomed as the beginning of a real
updating of that organization.

The Challenge to Christianity

True ecumenicism now demands something more than
discussion, "dialogue," and interfaith conferences where
each party rehearses his own beliefs with a view to peace-

[17] For further evidence of the mutual advantages of the 1933 Pact for
the Nazi regime and the Vatican, see Blanshard, *op. cit.,* pp. 143–146.

ful coexistence but with no doctrinal changes. Ecumenical progress can only wait upon the Christian surrender of the idea that Jesus supplanted Moses, that the New Testament replaced the Old Testament, and that Judaism is an archaic religion that served its purpose as a preparation for "the true and final religion." The Church must meet the objections of Judaism to Christianity: its polytheism, its false use of the term "Messiah," its claim that universal salvation is found only through Jesus Christ, its degrading estimate of man as born in original sin, its offense to God and man in the immoral doctrine of the atonement, its otherworldliness, and its elevation of Jesus above the human realm.

Time does more than make ancient good uncouth. It makes it inadequate and sterile—a positive hindrance to progress. The task of both Judaism and Christianity today is to keep goodness alive, to meet new occasions with new insights. Time and change do not abrogate moral law but they do demand new interpretations and applications of it. The Constitution of the United States is maintained by a process of reinterpretation by the Supreme Court, the decisions of which keep that document contemporary with the needs of the Republic. The greatness of the Constitution is its adaptability. The Torah and the Sermon on the Mount possess a like adequacy but they must be reread in a way that challenges our times. They must be redefined, reevaluated, reexperienced vitally in each generation. They must be interpreted in terms of relevant principles, rather than a set, patterned morality.

Almost all informed Christians today are against bias and many participate in community activities that are designed to improve Jewish-Christian relations. The cultivation of a friendly attitude toward people of another faith is a worthy cause, but the mere profession of goodwill is not enough. The times demand something beyond "dialogue." Interfaith movements concentrate on the things that unite

us but they neglect to face the things that divide—the theoretical rationale of ill will that lies in Christian scripture, education, and literature.

What is needed in the Christian world is a twofold line of action: an intelligent attempt to learn what contemporary Judaism is and a drastic revision of Christian ideology as it bears on the question of Jews and Judaism.

From Marcion in the second century to Toynbee in the twentieth, Christians have been taught that Judaism is a product of the Old Testament only, that it ceased to be a vital religion with the coming of Christianity and today exists merely as a static remnant of the ancient faith. Judaism today in all its forms—Orthodox, Conservative, Reform—represents a composite of several periods of history: the Biblical, the Rabbinic, the Talmudic, the Medieval, and the Modern. Rooted in the Law and the Prophets of the Hebrew Bible, for over two millennia it has been enriched in turn by the Wisdom literature of the Hellenistic Age, the extra-canonical literature (Apocrypha and Pseudepigrapha), the Essenic literature, the Misnah, the Gemara, the Midrash, the literature of the Hasidim, and the medieval codes. The curricula of Christian seminaries should include a study of these varied influences that have gone into the making of modern Judaism.

Christian educators and ministers should become more intimately acquainted with biblical and historical Judaism so as to avoid the unfair practice of contrasting the best in Christianity with the worst in Judaism. Pulpit and church classroom usually present the God of the Old Testament as a God of vengeance and judgment and the God of the New Testament as one of fatherly love. The religion of the Old Testament is depicted as a sterile legalism and that of the New Testament as a religion of the spirit. The sayings of Jesus are quoted as original with him, a new and unique revelation of truth, whereas most of them are found in the Old

Testament, the Apocrypha, or the early rabbinic teaching. Teaching about Jesus continues to divorce him from his rabbinic and Pharisaic background, when the fact is that practically all of his ethical teaching was Pharisaic doctrine.

It is perhaps too much to expect that the Christian Church, even its more liberal groups, will attempt any thoroughgoing revision of its traditional ideology for the simple reason that for most Christians the Christological doctrines *are* Christianity. But although these doctrines as expressed in the Apostles' and Nicene creeds, in the hymns, and liturgical readings will probably not be discarded, there is a reasonable expectation that they will be used less and less frequently, at least in interfaith gatherings, where to refer to Christ as the "Saviour of the world" or to dismiss the meeting with a trinitarian benediction would be an affront to non-Christians present. There are some sensitive Christian leaders who do not use the traditional creeds and who do not call for the singing of mawkish hymns about the blood of Jesus. As their number increases, goodwill attains more meaning.

THE JEWISH DILEMMA

Assimilation and Survival

THE PROBLEM of modern Jewry is that of preserving its genius without allowing the myths of Christian anti-Semitism to be turned into realities. The history of Judaism can be interpreted in two ways: to Jewish Fundamentalists and Zionists the Jews are a separate ("holy") and unique race with a divinely appointed destiny as the "chosen people" of God; their will to survive is inspired by their hope of return to the homeland and the achievement of nationhood. To independent and liberal Jews their history is that of an integrated Diaspora community, not an alien race deprived of a homeland; they see anti-Semitism as a misunderstanding evoked in part by the exaggerated Jewish claims to uniqueness; and they deny that they have any supernatural sanction as the chosen ones. This polarization has never been more discernible than in our own day. The question facing world Jewry is this: which of the two pictures is primary—assimilation or segregation, religion or nationalism, humanism or tribalism; in short, Judaism or Israel? Both interpretations have their champions, from Maimonides to Morris R. Cohen and from Halevi to Ben-Gurion, and both have seen their fulfillment in our time in America and Israel respectively.

The foregoing confessedly is an oversimplification, for the lines are not so sharply drawn as it appears. The Jews in America are rather thoroughly assimilated, it is true, but there can never be complete integration because Jews would then cease to be Jews. Conversely, if political nationalism should become the only goal of the Jews, they would lose their religious heritage. Living in a pluralistic environment in America, where groups for the most part have been acculturated, the Jews do not have the problems that have always been present in Europe. The Jews are not American citizens because of any governmental edict of emancipation; they have always been free and are citizens by choice. There is indeed segregation, both self-imposed and by discrimination, and, with the current racial tensions, there is a noticeable increase in anti-Semitism among the extremist minorities. But the fight against group discrimination is an all-American fight to be fought by and for all the people through legislation, not as the struggle of any one group. There is no need for Jews today to prove their equality or to strive for status. These things have long since been achieved. The pattern of American living makes it possible and natural for Jews to occupy the top positions in our national government without being pointed out as Jews and it is not at all unlikely in the future that a Jew could be our president. The Jewish genius has expressed itself in every phase of American culture.

In view of American egalitarianism and freedom the question arises: will the acculturation water down the Jewish self-consciousness to the point of disappearance? Some feel that that is improbable. Intermarriage and conversion are too infrequent to be an important factor and, in spite of the assimilative trend, social grouping continues. Jewish togetherness is not always the result of discrimination but often stems from natural choice, and the resultant groupings do not prevent friendships with Gentiles. It is also argued

from the religious standpoint that the current revival of Jewish piety, the widespread study of the Hebrew language, and the renewed interest in the Jewish way of life are a guarantee of survival in America.

On the other hand, those who believe in the inevitability of anti-Semitism fear that even in America some economic or political crisis will bring a wave of persecution that will destroy the Jewish community. There is an abundance of precedent in European history for this possibility. Immediately following the Golden Age of Spanish Jewry, the Arabs and Jews were expelled from Spain. After the days of the Weimar Republic, when Jews were so favorably situated in Germany, they were suddenly destroyed by the Nazi regime. Some say, given the right conditions, it could happen here. As over against this point of view, it might be said that if American Jewry disappears it will not be because it has fallen upon evil times but because it has fared *too* well. The great danger here is that of a total assimilation in which the Jewish culture would be dissolved.

Neither of these alternatives is a realistic prediction. There is little likelihood that American Jewry will disappear either voluntarily or by force.[1] Nevertheless, a certain erosion of the Jewish community can result from the more amicable Jewish-Christian relationship and the almost unconscious tendency of assimilated Jews to neglect traditional observances. The increased cultural integration of American Jews is noticeable in the academic world where they occupy professorial rank in the best universities and in suburban communities where they have settled in vast numbers.[2] Like

[1] See Salo W. Baron, "Patterns of Survival," in Nahum M. Glatzer, ed.: *The Dynamics of Emancipation* (Boston: Beacon Press, 1965), pp. 230–233.

[2] See Albert I. Gordon: *Jews in Suburbia* (Boston: Beacon Press, 1959).

many of their fellow Americans of the middle class, Jews are on the move away from the large cities. The exodus to suburbia has become for upper-middle-class families both an avenue to prestige and an opportunity for better living conditions with more room, cleaner air, superior schools, and attractive synagogues. Along with the stepped-up migration of the Jews to the suburbs have gone synagogues, Hebrew schools, and Jewish social organizations. They experience little or no discrimination, because the atmosphere of well-being and affluence among suburbanites makes for less prejudice. They know that they are accepted as Americans and not aliens and that overt anti-Semitism is the exception rather than the rule. It is true, however, that some anti-Jewish feeling shows up here and there among real estate agents, school boards, businessmen, and town politicians. Some suburban communities are completely Gentile. There are others that are almost exclusively Jewish, owing to the withdrawal of Christians when a few Jewish families have entered. Hostility and tension do exist, but Jews today are likely to be more outspoken in their public criticism of discrimination and particularly of the violation of the principle of church-state separation. This is because relations in the suburb are more intimate and the situation is more susceptible to change.

One of the major sources of tension in both city and suburb is the issue of religion in the public school. Most Christians, being in the majority, take for granted the traditional observances of Christmas and other religious holidays. Jewish children are expected to go along with the singing of Christmas carols, the presentation of pageants, the depiction of the Nativity in art, and Christological references in prayers. Jewish parents rightly object to this violation of the Constitution and believe that sectarian instruction should be restricted to home and church and synagogue.

Parochialism in the public school has no place in democratic America. Christian talk of human brotherhood is hollow as long as this cause of divisiveness is allowed to continue.

If the Jews in America can become integrated and at the same time retain some measure of distinction, what will that distinction be? While the Jews in Israel run the danger of becoming secular nationalists, those in America face the danger of becoming just another denomination. We have questioned the appellation of "nation" or "race" as applied to the Jews. There are some, on the other hand, who would be reluctant to define Jewry as a faith or a religion. To such it must be emphasized that Judaism cannot be dissociated from its monotheism, its prophetic principles of ethical responsibility, justice, sense of purpose, and the dignity of the individual. With this in mind Joachim Prinz concludes that "the Jews are neither a race nor a nation nor a faith; they are a historic, social and religious phenomenon *sui generis*." [3] As far as the United States is concerned the Jews belong to a religious tradition which in turn is an integral part of the American tradition.

For the Zionists the history of European Jewry, climaxed by the Nazi horror, is proof enough of the failure of the Diaspora and they see the state of Israel as the only possible future for the Jews. Although the German disaster turned many independent American Jews toward political nationalism, the belief that anti-Semitism is inevitable and escape to the land of Israel the only solution is an unacceptable idea to the vast majority of American Jews. They feel that political Zionism only helps to perpetuate the suspicions of European anti-Semites who in the nineteenth century claimed that with the Jews religion was purely secondary and was used only as a cover-up for their nationalistic ambitions, a temporary means, the end being their survival as

[3] Joachim Prinz: *The Dilemma of the Modern Jew* (Boston: Little, Brown and Company, 1962), p. 200.

a national entity. Most American Jews have faith in their people that they will steer a reasonable course between a total neglect of their heritage and an arrogant ethnocentrism. They reject the pessimistic outlook of Zionists. Nevertheless, the issue of political nationalism persists.

The American Jews and Zionism

What should be the attitude of free and independent American Jews toward the state of Israel? Here again is a polarization, with one group insisting that Jews outside of Israel have a moral obligation to support Israel financially, politically, and morally, and the other, equally emphatic in its advocacy of complete separation from Israeli nationalism. On the one hand, there are those who feel that unless non-Israeli Jews identify themselves with the new state and look to it as a sacred shrine to which they can make pilgrimages, they will cease to be completely Jewish; they will have betrayed their history. Ben-Gurion has repeatedly stated: "I still do not believe it possible to enjoy a full Jewish life outside of Israel." [4] On the other hand, many American Jews, following the lead of the American Jewish Committee, feel that the "full Jewish life" can be lived here in a free country. Here Jews are *free* to be as orthodox or as progressive as they please. They can live in Jewish communities, build Jewish institutions of welfare and education, and adhere strictly to the Torah, while at the same time they can mingle with non-Jewish fellow-Americans and contribute to the cultural well-being of the country. The Jews who are happy in American Jewry could never conform to the overpowering theocratic rule of orthodoxy in Israel, where Reform Judaism is stifled and where even archaeology is regarded as heresy. Chaim Liberman gives a satirical description of the overpiousness of daily life in contemporary Jerusalem:

[4] He reiterates this view in his volume, *The Jews in Their Land* (New York: Doubleday, 1966).

. . . Even the walls speak Hebrew . . . As you arrive in Israel you have the impression that you have walked into a divine service. Wherever you go, wherever you are, people seem to be praying. You enter a store to buy something, and what you hear is prayers. You take a bus, and the people sitting around you are praying. A boy walks with a girl, and they pray. Children play in the street, and they pray. Why, you enter a bank, and there is a cashier bent over rolls of bank notes, praying. In the midst of all this, if you hear someone speak another language, you can barely restrain yourself from crying out: It is not permitted to talk during the divine service! [5]

The complaint of integrationist Jews is that the fanatical leaders of political Zionism have forced upon Jews everywhere the idea that they are a part of an ethnic, racial, and political entity and that their homeland is Israel. In the opinion of many intellectuals the Eichmann trial, conducted by Israel instead of an international tribunal, only emphasized the attempt of the government of Israel to act for Jewish people throughout the world and resulted in a resuscitation of dormant anti-Semitism in all countries. The position of the integrationists has been well stated by the American Council for Judaism, which was founded before the establishment of the state of Israel. The following promise is made in the *Statement of Principles*:

In the light of our universalistic interpretation of· Jewish history and destiny, and also because of our concern for the welfare and status of the Jewish people living in other parts of the world, we are unable to subscribe to or support the political emphasis now paramount in the Zionistic program. We cannot but believe that Jewish nationalism tends to confuse our fellow-men about our place and function in

[5] *Jewish Newsletter,* April 23, 1956.

society and also divert our attention from our historic role
to live as a religious community wherever we may dwell.[6]

In the spirit of such universalistic Jews as Spinoza,
Moses Mendelssohn, Isaac Berr, Isaac M. Wise, and Morris
R. Cohen the members of the Council declared unequivo-
cally that American Judaism is a religion, not a nationality;
that the homeland of the American Jews is the United States
of America, not Israel; and that their loyalty is to the Amer-
ican democracy and to the universal values in which it is
rooted. They opposed the establishment of a national Jew-
ish state in Palestine and objected to the idea that the Jews
of the world are homeless. Most Reform Jews clearly distin-
guish between historic Jewish Messianism, which was purely
religious, and modern political Zionism, which is purely
secular.

The *Manifesto* of the American Council for Judaism
contained the following statement:

> The day has come when we must cry "Halt." The condition-
> ing of American Jewry by a Jewish flag and a Jewish army
> and a state in Palestine and a dual citizenship in America,
> is more than we can accept. The secularist creed has over-
> reached itself. We have been watching with anxiety the sec-
> ularization tendencies in American-Jewish life, the absorp-
> tion of large numbers in Jewish nationalistic endeavors, the
> intrusion of the Palestine issue as an irritating factor in intra-
> community relations, the persistent public expression of ex-
> tremists who presume to speak for all American Jewry, the
> efforts to cultivate and promote the sense of psychological
> difference between American Jews and their fellow Ameri-
> cans which plays into the hands of our enemies, the un-
> remitting efforts of certain groups to put American Jews be-
> hind programs of international political pressure, the reduc-

[6] Samuel Halperin: *The Political World of American Zionism* (Detroit:
Wayne State University Press, 1961), p. 85.

tion to secondary importance of the traditional religious basis of Jewish life. . . . We refuse any longer to be religious acrobats. We cannot pact with the untenable position in society which nationalism as a creed imposes upon us.[7]

It is clear that any discussion of the Jewish dilemma must be conducted against the backdrop of two contemporary phenomena: the building of the state of Israel (which was in part, at least, the result of the near annihilation of European Jewry) and the equally impressive vitality of American Judaism. The one is an example of the will to survive as an ethnic group; the other, a demonstration of Jewry as a religion and a proof that the synagogue is still the focal point of the Jewish world. Both nationalism and religion must therefore be taken into consideration as we consider the difficult, if not unanswerable, question "Who or what is a Jew?" Both factors involve inner tensions and outward pressures. Throughout their history the Jews have had to react to two external stimuli: on the one hand, Gentile hostility, which aroused their inclination to ethnic self-consciousness; and on the other, freedom and acceptance, which dissolved partitions and called forth the contribution of Jewish genius to society at large. There have always been prophets who have preserved the balance and kept the Jews either from extinction by assimilation or from fanatical retreat into a ghetto of ethnic and religious orthodoxy. Existing side by side in American Jewry are the noblest ideals of a humanistic society and the most parochial life of exclusiveness; the desire for a cooperative fellowship with other groups and the tendency to retreat behind the curtain of traditional dogma and ritual. As Jacob B. Agus says: "Wherever the balance of nationalism and religion in their own tradition and in the mentality of their neighbors shifted toward the poles of racism and fundamentalism the Jews have always

[7] *Ibid.*, pp. 332, 333.

suffered." [8] Assimilated Jewry in America cannot afford to regard itself as just another religious group; the Jews in the nation of Israel cannot consider themselves just a secular state.

The uneducated, emotionally charged masses, reacting still to the genocidal hate of Nazi Germany, are inclined to take refuge in their racial heritage; the sophisticated assimilated Jew rejects the racist dogma as unscientific, recognizing that it exaggerates the ethnic differences. Generally speaking, the liberal Jew in the United States sees himself as an American belonging to the Jewish faith just as his neighbor is an American and a member of the Christian church. He unites with his fellow-Americans of whatever background in the cultivation of the good society. Whatever ethnic loyalties he has are dissipated in the wider pluralistic supranational environment of American life. Whereas assimilation in Germany ended in tragic failure—even when intellectual Jews regarded themselves as Germans first and Jews second—in the humanistic atmosphere of America the integrated life of Jewry is highly successful. Liberal Christians are through with the traditional anti-Semitic theology of orthodox Christianity and liberal Jews are no longer obsessed with the idea of uniqueness. Both share in the building of a common culture.

The Search for Identity

If the previous statement is representative of American Jewry—and it is hard to estimate how prevalent it actually is—there exist nevertheless many diverse points of view, all differing slightly in their definition of the genius and essential character of the Jewish people. American Judaism has been described as a people in quest of a definition. This is good and bad, but the merits of the situation outweigh the

[8] Jacob B. Agus: *The Meaning of Jewish History* (New York: Abelard-Schuman, 1963), Vol. II, p. 484.

defects, for such a condition is a guarantee of its viability and health.

Some authorities, like Theodore Herzl, Henry P. Mendes, and Chaim Weizmann, maintain a purely ethnic and nationalistic view of Judaism, while others, such as Waldo Frank, identify Judaism with religion, recalling the prophetic elevation of religious Israel above political Israel.[9] The writings of Arthur A. Cohen and Jacob Neusner reveal an intellectual Fundamentalism or neo-Orthodox point of view in Judaism; on the other hand, Ben Zion Bokser and Morris R. Cohen see Judaism as a cultural movement, both secular and religious, and emphasize its humanistic and universal principles. Eliezer Berkovits (Orthodox) believes in the divine revelation of the Torah, in a supra-rational faith, and in the ritual commandments as binding on the good Jew, whose sole duty is to "do the will of God" regardless of the nature of the commandment. Jacob B. Agus (Conservative) sees Judaism as a cultural tradition, a viable, re-creative movement, experiencing repeated periods of self-renewal and shifts in the accepted bases of religious authority: Prophetism, Pharisaism, Philonic philosophy, medieval Rationalism, Hasidism, and the modern expressions of Ultra-Orthodoxy, Moderate Orthodoxy, Reform, Conservatism, nonliteral Orthodoxy, and Reconstructionism. Solomon B. Freehof (Reform) denies that the 613 Commandments or any other laws are God-given mandates and asserts that Jewish thought and theology will have to recognize the widespread nonobservance of Jewish laws and evolve a new system of practice. Ira Eisenstein (Reconstructionist) rejects unequivocally the traditional pattern of Jewish thought —the "chosen-people" idea, the divinely revealed Torah, the centrality of God's relation to Israel throughout its history, the Messianic Age, the resurrection of the dead, and eternal

[9] Throughout this chapter the present tense is used in defining the views of Jewish leaders even though some are deceased.

reward—and calls for a revision of Judaism in the direction of secularism, a focusing of interest on the here-and-now and on man; and naturalism, an experience of the divine in life within the natural world. Mordecai M. Kaplan, the founder of Reconstructionism, represents a modern, humanistic approach to Judaism, seeing God as the universal force which makes for righteousness; reason and experience as the source of truth; and Judaism as an instrument for the "self-fulfillment of Jews both as Americans and as Jews." Bernard J. Bamberger (Reform) has "a positive religious viewpoint" that is rooted in Jewish history and that regards purpose and value as the primary areas of religious experience. He rejects the divine origin and absolute authority of the Torah, regards the Jews as chosen in the sense of their unique history and present responsibility, and feels that Judaism must remain an ethical, nontheological religion distinct from historical Christianity. Eugene B. Borowitz (Reform) sees the essence of Judaism as people, not ideas; as responsible human action, not theological speculation; as the realization of God's will here and now, not in the hereafter. Maurice N. Eisendrath (Reform) differentiates Judaism from classical Buddhism, Christianity, and Islam in its exaltation of intellect, in its stress upon the importance of this world and the sanctification rather than the rejection of nature, in its drive toward justice, in its faith in man, and in its hope for the future of the world. Arthur Herzberg (Conservative) believes that the heart of Judaism lies in the concept of the Chosen People, that this is a fact, not to be proved or rationalized but to be taken on faith, that the Jews are "a people dwelling apart," a people who wait for the Messiah. Immanuel Jakobovits (Orthodox) adheres to the traditional belief that the Pentateuch as it exists today is identical with the Torah revealed by God to Moses on Mount Sinai, that it is eternally binding on the Jewish people, that their ultimate hope is redemption and the fulfillment of the Messianic

prophecy. Nahum Goldmann, an avid Zionist, insists that American Jews must have "a double loyalty" and are responsible for supporting Jewish political nationalism in Israel. Lessing Rosenwald considers himself an American by nationality and a Jew by religion; and believes in a thoroughgoing assimilation with non-Jewish Americans.

Jewish Reconstructionists, Existentialists, and Humanists represent a more radical revision of traditional religion than the Reform movement, but not as radical as the corresponding groups in Protestantism. Their aim is to interpret biblical and Talmudic literature in a mythical, symbolic way while squaring the concept of deity and Jewish monotheism with the facts of the twentieth-century world. It is difficult for them to reconcile the God of the Covenant, the protector of Israel, with the murder of six million Jews. Rabbi Richard L. Rubenstein in a collection of essays, *After Auschwitz*, argues that Hitler's holocaust was evidence enough that "the transcendent, theistic God of Jewish patriarchal monotheism" is dead. The Jewish "Death of God" movement, however, is not atheistic in the sense of radical Humanism but is a shift from a personalized deity to an impersonal cosmic theism and emphasizes the psychological values of ritual and ceremony rather than the idea of divine revelation. Jewish revisionism is a small fringe movement, but it can serve as a healthy antithetic force against the inertia of extreme orthodoxy.

All these representatives of modern Jewry—nationalist or Diaspora Jew, humanist or ethnic, religious or secular, ethical or ritualistic, assimilationist or segregationist—hold certain principles in common. They all have a teleological point of view of some variety; they all give centrality to the ethical criterion in religion; and they all identify the source of human values with God and the cosmic order. But there is a manifest disparity in their interpretation of the identity and destiny of modern Jewry. Orthodoxy regards the Law

as absolutely binding and denies the evolutionary character of Judaism. Conservative Judaism holds to the sanctity and divine authority of the Law, but maintains that Judaism has been, and must continue to be, influenced by cultural changes. Reform Judaism rejects the national or political element in Judaism, recognizes the necessity of change, denies the absolute authority of the Torah, and has a flexible position toward the rituals. All Judaism can be divided into two broad categories: the traditionalists and the modernists. Both of these agree in the metaphysical questions of God, man, and the universe. But divergence occurs in the interpretation of the institutions and literature of Judaism. The traditionalists accept the Torah and the Talmud as unchangeable and the ritualistic observances as obligatory. The modernists take the historical-critical position regarding Jewish literature and ceremony, making room for modern thought in their interpretation.[10]

This situation poses the question: Is unity possible or even desirable? Ecumenicism and denominational mergers in the Protestant Church have already demonstrated that the price of unity is uniformity. Organic merging of theologically divergent groups always dulls the edge of intellectual progress and the compromise is usually made by the more liberal party in the union. Dissent and multiformity of interpretation are signs of vitality. Judaism has no central authoritative body to define the Jewish religion; it has no Pope or hierarchy to set the limits of belief and action for Jews, and no official manual of doctrine and polity. Historic institutions and literature are variously interpreted by individuals and groups. Some Jews are ultra-orthodox and others are skeptics or rationalists. Therefore there are healthy tensions within Jewish intellectual life. The Jews have no

[10] For further divisions in Judaism see Jacob B. Agus: "The Concept of Israel," an article in *Torah and Gospel*, ed. by Philip Scharper (New York: Sheed and Ward, 1966), pp. 263–276.

organized united front to combat anti-Semitism or any other danger. But all Jews belong to a spiritual heritage and express their experience of truth in different ways.

The Challenge to Judaism

What are the prerequisites both for an improved rapport with Christianity and the continued growth of Judaism in a way that is consistent with its agonizing but enduring past? It seems reasonable to assume that some concession to the present intellectual milieu is necessary, that Orthodox Judaism will have to rid itself of the fear of scientism. It will also have to redefine in a clearer fashion its definition of "the chosen." Ethnic and cultural anti-Semitism, which has an even longer history than the theological type, was originally provoked and continuously nourished by the orthodox Jewish dogma of uniqueness. The insistence on being a peculiar people, set apart, aroused an anti-Semitic feeling among the Alexandrian Greeks; and throughout the history of the West it has incited a Judeophobia whenever Diaspora Judaism was on the point of experiencing a cultural synthesis. The Jewish consciousness of being the chosen people, different from all others, had a double-barreled effect: it made possible the survival of the Jews as a strong cultural group and also resulted in their exclusion by Gentiles as an alien people. "The doctrine of a chosen people," writes Jacob Bernard Agus, "is manifestly ethnocentrism with a mystical halo. It is inevitably a belligerent claim to supremacy, affirming not only the right to collective existence, but the unique importance of its communal character and destiny." [11] Many Jews and Christians of the liberal school would see the solution of this problem in a cultural assimilation and in the recognition that the Jews do not

[11] Jacob Bernard Agus: *The Meaning of Jewish History* (New York: Abelard-Schuman, 1963), Vol. 2, p. 347.

represent a nation or a race but a cultural and religious community.

One might say that the "uniqueness" theory has been emphasized so long and so vigorously by the Jews themselves that the Gentiles finally believed it and then went on to create a mythology about it. Their exclusion or segregation of the Jews was therefore justified in their minds as a defense measure. Needless to say, extreme Jewish nationalism has never helped to mitigate the problem. The self-segregating tendency of Jewish ethnocentrism has been condemned by leading Jewish liberals. Bernard Lazare, for instance, writes:

> Modern Judaism claims to be but a religious confession; but in reality it is an *ethnos* besides, for it believes it is that; for it has preserved its prejudices, egoism and its vanity as a people, a belief which makes it appear a stranger to the peoples in whose midst it exists, and here we touch upon one of the most profound causes of antisemitism. . . .[12]

European Christians in the nineteenth century inherited a stereotype of the Jews as an alien, aloof, and clannish group with peculiar dress, diet, dialect, and customs. Western anti-Semitism was built upon the idea that Jews are racially and anthropologically different from other peoples, an idea which has some support in biblical references to the "holy seed" and which was preached by religious leaders from the ancient Ezra to the medieval Halevi. Gentile hostility was aggravated by the popular resentment of the financial success of European Jewry in the modern industrial age. The populace must have a myth with which to bolster its prejudices and overcome the counsel of reason. Thus Ger-

[12] Bernard Lazare: *Antisemitism: Its History and Causes,* trans. from the French (New York: The International Library Publishing Company, 1903), p. 267.

man racism made its appeal to the people as a defense against
the "outsiders," the "liberals." Finally European Jews in
the face of unprecedented persecution and possible exter-
mination reestablished a national home in Israel. This was
accomplished by political Zionists, aided by religious Zion-
ists with their faith in the uniqueness of Judaism.

Although Judaism possesses, probably more markedly
than any other faith, a moral and spiritual accent which can
and must find expression in the present and the future, like
Christianity, it was born and grew up in a mythologically
oriented culture. Its ancient mythology still hangs like a
millstone around the neck of orthodox religion and today
hinders its cultural growth in the midst of a scientifically
minded society. It is here that the spirit of a Maimonides, a
Spinoza, an Einstein can bridge that gap and free ethical
Judaism from its bondage to an anachronistic legalism and
help it to stand forth as a religion in which God is not the
judge and lawgiver but the cosmic force making for right-
eousness, and man a co-creator and co-worker with God in
this process. Torah and Talmud have been the salvation of
Judaism in the past, but their literal observance today is
keeping Jews from living in the twentieth century. The ir-
relevant conformity to the laws of the Halakah in such
ritualistic requirements as the Shemittah results only in tech-
nical evasion and legalistic casuistry.

The Jews' stake in the infallibility of the Torah as the
law of Moses automatically precludes any scholarly ap-
praisal of the Pentateuch or purely historical approach to
the Bible, just as the Christological claims of orthodox Chris-
tians make impossible any genuine accord with Judaism. The
enlightened Jew can no more accept the idea that every
word of the Torah was divinely inspired than an educated
Protestant can believe that the New Testament is a unique
revelation from the hand of God.

Judaism has its own bibliolatrous lag. Distinguished

writers, editors, and critics casually refer to the Garden of
Eden and the Flood as actualities in history. In any context
other than the Bible such stories would be recognized im-
mediately as myths. Like all religions, Judaism claims cosmic
sanction and primacy for itself. Books by well-known liberal
scholars, appearing, for instance, in 1967, have on the title
page 5728 as the time of publication, dating it from the
Creation, 3761 B.C.E.—this in spite of the fact that cities
with an advanced civilization existed in Sumeria before
4000 B.C.E. Furthermore, the beginning of Israel, considered
either as a nation, culture, tribe, or religion, cannot possibly
have occurred before 1400–1200 B.C.E., depending on the
dating of Moses. Such is the unconscious use of the Bible as
scientific authority by otherwise highly sophisticated people.

If the Jew in America can express his distinctiveness in
the prophetic values of universality, the dignity of the indi-
vidual, the moral imperative, and the teleological principle,
he will be perpetuating the basic ideals of democratic
America. If, on the other hand, he fails in this contribution
he not only betrays his Jewish heritage but alienates him-
self from the mainstream of American life. The well-being
of the Western world desperately needs the dynamic of the
Jewish genius.

From the standpoint of theology, Judaism is much less
burdened than Christianity. Modern Jews long since recog-
nized the difference between theology and faith. From
ancient times, the Jewish religion was comparatively free
from such doctrinal disputes as the *homoousios-homoiousios*
controversy which split early Christianity into two camps.
Unlike Christianity, Judaism was not changed under the
influence of the otherworldly philosophy of Neo-Platonism
or the mysticism of the Mystery-Religions. The chief external
influences absorbed by Judaism were the Arab learning in
medieval Spain and the rational philosophy of prewar Ger-
many—strengthening factors that guarantee its resistance

to contemporary changing winds of doctrine. The danger today for educated Jews is that the basic values of organic Judaism will be neglected in the atmosphere of freedom and assimilation.

The act of freeing oneself from irrelevant observances must be accompanied by a renewed commitment to the ethical and universal ideals that have always been the essence of Judaism. Release from a literal belief in Jewish sacred texts must be followed by the critical discrimination that separates eternal values from parochial beliefs. In place of blind faith in the certainty of revelation the modern Jew must learn to live by what Chaim Potok calls "provisional absolutes," a readiness to change religious assumptions when proved inadequate or palpably false. The future of Judaism will be assured if its leaders believe in a universe that has meaning and translate that meaning into action. Ceremonial rites that are not fused with meaning for the individual and that do not enhance the personality will not be acceptable to future generations of pragmatically minded people. For the Jew who feels at home in his American environment and is also faithful to the teaching and institutes of basic Judaism, the idea of the "Chosen" implies service rather than superiority. In our pluralistic society he does not claim that Judaism is the only way to salvation, but recognizes the validity of all faiths that exalt the same cosmic values. The good Jew rejects the current philosophy of meaninglessness and absurdity. His Jewish heritage compels him to search for meaning in life, for that is the source of his behavior.

Tensions still exist within Judaism. Some people hold to the idea of religion as a ceaseless search for new horizons of cosmic reality and human values; while others see religion as a fixed entity, revealed once and for all in antiquity. The effort toward a wide fellowship of kindred minds with mutual respect and understanding exists along with the desire to retreat into ethnic isolation. Here again the ca-

pacity of Judaism to confront these polarities and to accept diversity without surrendering its historic world-view is its salvation.

The Jewish-Christian tensions can best be eased by going beyond conversation to the common cause of achieving an improved social, economic, and moral life in America. As to the modification of theological beliefs, we have repeatedly asserted that Christianity has far more to do than Judaism. Jewish people have no desire to convert Christians; the Church, on the other hand, from the first has been a missionary enterprise dedicated to the task of getting Jews to accept Jesus as the Messiah. The goal of Jews should be to emphasize broad principles of living rather than particularistic beliefs and to respect the right of all people to follow their religious convictions.

Because of the secularized life of non-Orthodox Jews in the state of Israel and the increasing assimilation in the United States, the fear is often expressed that Judaism cannot change enough to meet contemporary needs and therefore faces possible extinction.[13] Those who have this feeling reckon without the inner strength of Judaism and its power to adjust to cultural changes as demonstrated in the last two millennia.

The future effectiveness of both Judaism and Christianity ultimately turns on the ontological argument. The issue boils down to this: Is God a tribal deity or a universal reality? Is he interested in revealing himself only at a certain point in time, at a certain place, through a certain man, to a certain people? Is God concerned only with Hebrew history or Christian history? Is God the God of this planet only

[13] See Georges Friedmann: *The End of the Jewish People?*, trans. from the French, *Fin du Peuple Juif?* (New York: Doubleday and Company, 1967).

or is he the cosmic consciousness? The fact is that neither Christian nor Jew can now get along with the God of primitive cosmology or with an anthropomorphic deity who deliberately intervenes in the process of earthly history. No longer can we hold to our antiquated views as special or unique, when the same or similar views are held by practically all other religions, ancient or modern. If theologians were to take seriously the findings of the history of religions, the facts of history, and the life of reason, they would have to make some drastic changes in their ideas of God, man, and the universe. We can no longer rub shoulders with other cultures in our shrunken world and still claim to have the final or the only religion. Only a cosmic universal faith can raise man above the particularisms of the cult. Only a common faith in a true monotheism and its moral imperative can unite people on a supra-sectarian level. To stay below that level is to rest content with the shibboleths and intolerance of tribal religion. The space age should teach us that God is not found in "far-off realms of space" or "heights of upper air" but in the soul of man. This simple but profound truth can serve as common ground for Jew and Gentile, East and West, black and white. The spirit of the Space Age may help men to grow up metaphysically, to abandon our ethnocentric and geocentric theology and to substitute a spiritual religion for a physical one. The religion of Judaism, with its continuity, its teaching of the Higher Immanence, its ethical humanism, and its faith that "the best is yet to be," has much to contribute in the fight for survival, not only of itself but of the Western world.

BIBLIOGRAPHY

THIS BIBLIOGRAPHY is confined to those works consulted or referred to in the preparation of the book and is designed for the use of the layman rather than the specialist.

Abrahams, Israel, *Jewish Life in the Middle Ages*. New York: Meridian Books, 1958.

——, *Studies in Pharisaism and the Gospels*. Cambridge: University of Cambridge Press, 1917–1924.

Adler, M., *Jews of Medieval England*. London: Jewish Historical Society of England, 1939.

Agus, Jacob Bernard, *The Meaning of Jewish History*. 2 vols. Philadelphia: Jewish Publication Society of America, 1961.

Allport, Gordon W., *The Nature of Prejudice*. Cambridge, Massachusetts: Addison-Wesley, 1954.

Angus, Samuel, *Environment of Early Christianity*. London: Duckworth and Company, 1914.

——, *The Mystery Religions and Christianity*. London: Duckworth and Company, 1914.

——, *Religious Quests of the Graeco-Roman World*. London: John Murray, 1929.

Arendt, Hannah, *The Origins of Totalitarianism*. New York: Harcourt, Brace, 1951.

Baer, Yitzhak, *A History of the Jews in Christian Spain*. 2 vols. Philadelphia: Jewish Publication Society of America, 1961.

Baron, Salo W., *Modern Nationalism and Religion.* New York: Harper and Brothers, 1947; New York: Meridian Books (paperback), 1960.

———, *A Social and Religious History of the Jews,* 2nd ed., 10 vols. New York and London: Columbia University Press, 1952–1965.

Bentwich, Norman, *The Jews in Our Time.* Baltimore: Penguin Books, 1960.

Berger, Elmer, *The Jewish Dilemma.* New York: Devin-Adair Company, 1945.

Berkovits, Eliezer, *Judaism: Fossil or Ferment.* New York: Philosophical Library, 1956.

Blanshard, Paul, *Paul Blanshard on Vatican II.* Boston: Beacon Press, 1966.

Brandt, Walther I. (ed.), *Luther's Works.* 55 vols. Philadelphia: Muhlenberg Press, 1962.

Bratton, Fred Gladstone, *A History of the Bible.* Boston: Beacon Press, 1959.

———, *Maimonides: Medieval Modernist.* Boston: Beacon Press, 1967.

Cardozo, Jacob Lopes, *The Contemporary Jew in the Elizabethan Drama.* Amsterdam: H. J. Paris, no date.

Case, Shirley Jackson, *The Historicity of Jesus.* Chicago: University of Chicago Press, 1912.

Chaucer, Geoffrey, *The Canterbury Tales,* ed. by Edwin J. Howard and Gordon D. Wilson. Oxford, Ohio: The Anchor Press, 1942.

Clinchy, W. R., *All in the Name of God.* New York: John Day, 1934.

Daube, David, *The New Testament and Rabbinic Judaism.* London: Athlone Press, 1956.

Dimont, Max I., *Jews, God, and History.* New York: Simon and Schuster, 1962.

Donaldson, Alexander and James (eds.), *The Ante-Nicene Fathers.* Grand Rapids: William B. Eerdmans Publishing Company, 1956.

Drews, Arthur, *Die Christusmythe.* Jena: 1909.

Dubnow, S. M., *An Outline of Jewish History.* 3 vols. New York: Max N. Maisel, 1925.

Enslin, Morton Scott, *The Prophet from Nazareth.* New York: McGraw-Hill Book Company, 1961.

Finkelstein, Louis (ed.), *The Jews: Their History, Culture, and Religion.* New York: Harper and Brothers, 1949.

Fisher, Herbert Albert Laurens, *A History of Europe.* 2 vols. London: Eyre and Spottiswoode, Ltd., 1952.

Flannery, Edward H., *The Anguish of the Jews.* New York: Macmillan, 1965.

Friedlander, G., *Shakespeare and the Jews.* London: G. Routledge and Sons, 1921.

Friedmann, Georges, *The End of the Jewish People?*, trans. from the French, *Fin du Peuple Juif?* New York: Doubleday and Company, 1967.

Gilbert, Arthur, *A Jew in Christian America.* New York: Sheed and Ward, 1966.

Glatzer, Nahum N., *Franz Rosenzweig: His Life and Thought.* Philadelphia: Jewish Publication Society of America, 1953.

Glazer, Nathan, *American Judaism.* Chicago: University of Chicago Press, 1957.

Glock, Charles Y., and Stark, Rodney, *Christian Belief and Anti-Semitism.* New York: Harper and Row, 1966.

Goguel, Maurice, *Jesus the Nazarene, Myth or History?*, trans. by F. Stephens. London: T. Fisher Unwin, 1926.

Goldstein, Morris, *Jesus in the Jewish Tradition.* New York: Macmillan, 1950.

Gordis, Robert, *Judaism in a Christian World.* New York: McGraw-Hill Book Company, 1966.

Gordon, Albert I., *Jews in Suburbia.* Boston: Beacon Press, 1959.

Graeber, I., and Britt, S. H., *Jews in the Gentile World: The Problem of Anti-Semitism.* New York: Macmillan, 1942.

Graetz, Heinrich, *History of the Jews.* 6 vols. Philadelphia: Jewish Publication Society of America, 1901–1908.

Grayzel, Solomon, *The Church and the Jews in the Thirteenth Century.* Philadelphia: Dropsie College, 1933.

———, *A History of the Jews.* Philadelphia: Jewish Publication Society of America, 1967.

Gregory of Nyssa, *Oratio in Christi resurrectionem,* in J. P. Migne, *Patrologia graeca,* Vol. XLVI.

Guignebert, C. A. H., *The Jewish World in the Time of Jesus.* London: Kegan Paul, Trench, Trubner, 1939.

Halperin, Samuel, *The Political World of American Zionism.* Detroit: Wayne State University Press, 1961.

Handlin, Oscar, *Adventure in Freedom.* New York: McGraw-Hill Book Company, 1954.

Harnack, Adolf, *Mission and Expansion of Christianity,* trans. by James Moffatt. New York: G. P. Putnam's Sons, 1904–1905.

Hay, Malcolm, *Europe and the Jews.* Boston: Beacon Press, 1961.

Hegel, Georg W. F., *Early Theological Writings,* trans. by T. M. Knox. Chicago: Encyclopaedia Britannica, Inc., 1948.

Herford, Robert Travers, *Judaism in the New Testament Period.* London: Lindsey Press, 1928.

———, *The Pharisees.* New York: Macmillan, 1924.

Hertzberg, Arthur, *The French Enlightenment and the Jews.* New York: Columbia University Press, 1968.

———, *The Zionist Idea.* New York: Meridian Books, 1960.

Hirsch, Selma, *Fears Men Live By.* New York: Harper and Brothers, 1956.

Inge, William Ralph, *Outspoken Essays,* First Series. New York: Longmans, Green and Company, 1920.

Isaac, Jules, *Has Anti-Semitism Roots in Christianity?* New York: National Council of Christians and Jews, 1961.

———, *The Teaching of Contempt.* New York: Holt, Rinehart and Winston, 1964.

James, Montague R. (ed. and trans.), *The Apocryphal New Testament.* Oxford: Clarendon Press, 1924, 1926.

Jamieson, T. H. (ed.), *The Ship of Fools,* trans. by Alexander Barclay. 2 vols. Edinburgh: William Patterson, 1874.

Kamen, Henry, *The Spanish Inquisition.* New York: The New American Library, 1965.

Kaufman, Walter, *From Shakespeare to Existentialism.* Boston: Beacon Press, 1959.

———, "Toynbee: The Historian as a False Prophet," *Commentary,* April, 1957.

Kagan, Henry Enoch, *Changing the Attitude of Christian Toward Jew*. New York: Columbia University Press, 1952.

Kilpatrick, G. D., *The Trial of Jesus*. London: Oxford University Press, 1952.

Kisch, Guido, *The Jews in Medieval Germany*. Chicago: University of Chicago Press, 1949.

Klausner, Joseph, *From Jesus to Paul*. London: Allen and Unwin, 1943.

Knight, George A. F. (ed.), *Jews and Christians: Preparation for Dialogue*. Philadelphia: Westminster Press, 1965.

Lazare, Bernard, *Antisemitism: Its History and Causes*, trans. from the French. New York: The International Library Publishing Company, 1903.

Lea, A. C., *A History of the Inquisition in Spain*. 4 vols. New York: Macmillan, 1906–1907.

Loewenstein, Rudolph M., *Christians and Jews*. New York: International Universities Press, 1951.

Lowenthal, Marvin, *The Jews of Germany*. New York: Longmans, Green and Company, 1936.

Mann, Jacob, *The Jews in Egypt and Palestine Under the Fatimid Caliphs*. 2 vols. London: Oxford University Press, 1920–1922.

Marcus, Jacob Rader, *The Jew in the Medieval World*. New York: Meridian Books, 1960.

Margolis, Max L., and Marx, Alexander, *A History of the Jewish People*. Philadelphia: Jewish Publication Society of America, 1927.

Marlowe, Christopher, *The Jew of Malta*. London: Nicholaus Varasour, 1633.

Maycock, A. L., *The Inquisition*. London: Constable, 1926.

Menuhin, Moshe, *The Decadence of Judaism in Our Time*. New York: Exposition Press, 1965.

Michelson, Hijman, *The Jew in English Literature*. Amsterdam: H. J. Paris, 1926.

Modder, Montague F., *The Jew in the Literature of England*. Philadelphia: Jewish Publication Society of America, 1939.

Moehlman, Conrad H., *The Christian-Jewish Tragedy: A Study in Religious Prejudice*. Rochester: Leo Hart, 1933.

Montefiore, C. G., *Rabbinic Literature and Gospel Teachings.* London: Macmillan, 1930.

Moore, George Foot, *Judaism in the First Centuries of the Christian Era.* 3 vols. Cambridge: Harvard University Press, 1927–1930.

Muilenburg, James, *The Way of Israel.* New York: Harper and Row, 1961.

Myers, Gustavus, *History of Bigotry in the United States.* New York: Random House, 1943.

Neuman, Abraham, *The Jews in Spain.* 2 vols. Philadelphia: Jewish Publication Society of America, 1942.

Olson, Bernhard E., *Faith and Prejudice: Intergroup Problems in Protestant Curricula.* New Haven: Yale University Press, 1963.

Parkes, James, *Antisemitism.* Chicago: Quadrangle Books, 1963.

———, *The Conflict of the Church and the Synagogue.* London: Soncino Press, 1934.

———, *The Emergence of the Jewish Problem, 1878–1939.* Oxford: Oxford University Press, 1946.

———, *The Foundations of Judaism and Christianity.* Chicago: Quadrangle Books, 1960.

———, *A History of the Jewish People.* Chicago: Quadrangle Books, 1962.

———, *The Jew in the Medieval Community.* London: Soncino Press, 1938.

———, *The Jewish Problem in the Modern World.* Oxford: Oxford University Press, 1946.

———, *Judaism and Christianity.* Chicago: University of Chicago Press, 1948.

Pascal, Blaise, *The Provincial Letters, Pensées, and Scientific Treatises,* trans. by W. F. Trotter. Chicago: Encyclopaedia Britannica, Inc., 1955.

Philo Judaeus, *The Embassy of Gaius,* trans. by C. D. Yonge. Bohn Library.

Pinson, Koppel, *Essays on Anti-Semitism.* 2nd ed. New York: Conference on Jewish Relations, 1946.

Poliakov, Léon, *The History of Anti-Semitism,* Vol. 1, trans. from

the French by Richard Howard. New York: The Vanguard Press, 1965.

Purdy, W. A., *The Church on the Move*. New York: The John Day Company, 1966.

Radin, Max, *The Trial of Jesus of Nazareth*. Chicago: University of Chicago Press, 1931.

Reichert, Irving Frederick, *Judaism and the American Jew*. San Francisco: The Grabhorn Press, 1953.

Rotenstreich, Nathan, *The Recurring Pattern: Studies in Anti-Judaism in Modern Thought*. New York: Horizon Press, 1964.

Roth, Cecil, *A Bird's Eye View of Jewish History*. New York: Union of American Hebrew Congregations, 1954.

———, *A History of the Jews in England*. Oxford: Clarendon Press, 1949, 1964.

———, *History of the Marranos*. 2nd rev. ed. Philadelphia: Jewish Publication Society of America, 1959.

———, *Magna Bibliotheca Anglo-Judaica: A Bibliographical Guide to Anglo-Jewish History*. London: The Jewish Historical Society of England, University College, 1937.

———, ed., *The Ritual Murder Libel and the Jew*. London: The Woburn Press, 1935.

———, ed., *The World History of the Jewish People; Second Series: Medieval Period; Volume Two: The Dark Ages*. New Brunswick: Rutgers University Press, 1966.

Sachar, Abram L., *A History of the Jews*, 5th ed. New York: Alfred A. Knopf, 1965.

———, *Sufferance Is the Badge*. New York: Alfred A. Knopf, 1940.

Sachar, Howard M., *The Course of Modern Jewish History*. Cleveland: World Publishing Company, 1958.

Samuel, Maurice, *The Professor and the Fossil*. New York: Alfred A. Knopf, 1956.

Sandmel, Samuel, *We Jews and Jesus*. Oxford: Oxford University Press, 1965.

Schaff, Philip (ed.), *Nicene and Post-Nicene Fathers of the Christian Church*. Grand Rapids: William B. Eerdmans Publishing Company, 1956.

Scharper, Philip (ed.), *Torah and Gospel: Jewish and Catholic Theology in Dialogue*. New York: Sheed and Ward, 1966.

Schoeps, Hans Joachim, *The Jewish-Christian Argument: A History of Theologies in Conflict*. New York: Holt, Rinehart and Winston, 1963.

Schwarz, Solomon, *The Jews in the Soviet Union*. Syracuse: Syracuse University Press, 1951.

Scudder, Horace E. (ed.), *The Complete Poetical Works of Browning*, Cambridge ed. Boston: Houghton Mifflin Company, 1895.

Shakespeare, William, *The Merchant of Venice*, in Henry Norman Hudson (ed.), *The Complete Works of William Shakespeare*, Vol. 3. New York: Current Literature Publishing Company, 1909.

Silver, Abba Hillel, *Where Judaism Differed*. New York: Macmillan, 1961.

Simon, Marcel, *Verus Israel*. Paris: E. de Boccard, 1948.

Spengler, Oswald, *Decline and Fall of the West*, trans. by C. H. Atkinson. New York: Alfred A. Knopf, 1926.

Stendahl, Krister (ed.), *The Scrolls and the New Testament*. New York: Harper and Brothers, 1957.

Toynbee, Arnold J., *Christianity Among the Religions of the World*. New York: Charles Scribner's Sons, 1957.

———, *A Study of History*. 12 vols. London: Oxford University Press, 1961.

Tractenberg, Joshua, *The Devil and the Jews*. New Haven: Yale University Press, 1943.

Trattner, Ernest R., *Understanding the Talmud*. New York: Nelson, 1955.

———, *As a Jew Sees Jesus*. New York: Charles Scribner's Sons, 1931.

Yates, George A. (ed.), *In Spirit and in Truth: A Jewish Christian Symposium*. London: Hodder and Stoughton, 1934.

Zeitlin, Solomon, *Who Crucified Jesus?*, 2nd ed. New York: Harper and Brothers, 1947.

Zukerman, N., *The Wine of Violence: An Anthology*. New York: Association Press, 1947.

INDEX